THE EDWARDIAN ERA

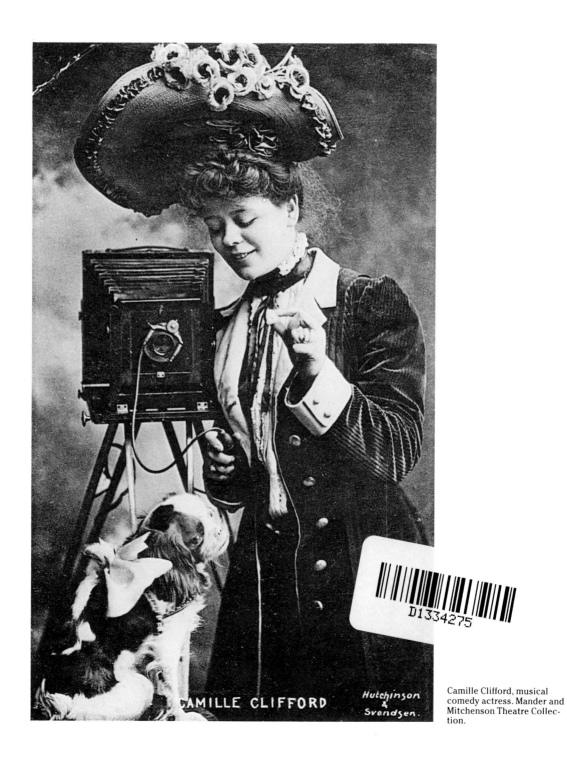

Camille Clifford, musical
comedy actress. Mander and
Mitchenson Theatre Collec-
tion.

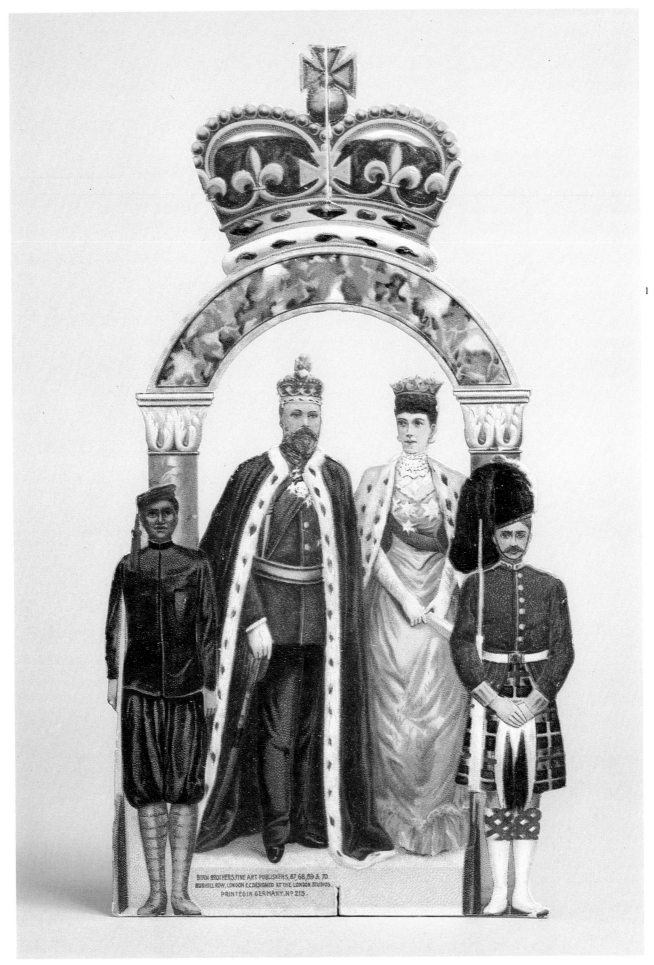

1. Coronation souvenir. 1902.
Museum of London.

The Edwardian Era

Edited by
Jane Beckett and Deborah Cherry

Phaidon Press
and
Barbican Art Gallery

Jane Beckett and Deborah Cherry would like to thank all the people in public galleries, museums, libraries and private collections who have helped them, particularly Elspeth King, Rozina Visram, Julie Smith, Gaby Porter, and Jill Liddington; all the contributors for important, helpful and encouraging discussions and their support; their students for their enthusiasm and ideas; all the staff at the Barbican Art Gallery for administering the project; Jane Hawksley for editing the manuscript; and the DOTs.

Jane Beckett would like to acknowledge the British Academy for a Thank-Offering to Britain Award to undertake research on the Edwardian period.

Ziggi Alexander would like to thank J. A. Rogers, J. P. Green, P. Fryer and friends. Lucy Bland would like to thank Susie Balfour, Deirdre Bland and Angela McRobbie for their helpful comments. Annie E. Coombes would like to thank Alex Potts, Lynda Nead and Michael Orwicz for generously giving their time and criticism, Don Knight for sharing his wonderful collection of Franco-British memorabilia, and Elisabeth Aquilina, archivist at the Hammersmith Local History Library, for her invaluable assistance. Jane Hawksley would like to thank Hugh Rolo, Rosa Rolo and Katie Simmons.

Title-page: Max Beerbohm. *Edward VII in highland dress.* 1900. Michael Parkin Fine Art Ltd. Photograph courtesy Spink & Son Ltd.

Published to accompany the exhibition *The Edwardian Era,* selected by Jane Beckett, Deborah Cherry and John Hoole and organized by Brigitte Lardinois and Jane Alison, at the Barbican Art Gallery, London, from 12 November 1987 to 7 February 1988.

Phaidon Press Limited, Littlegate House, St. Ebbe's Street, Oxford OX1 1SQ

First published 1987
©1987 Barbican Art Gallery, City of London

British Library Cataloguing in Publication Data

The Edwardian Era.
 1. Art, British 2. Art, Edwardian—
Great Britain
 I. Beckett, Jane II. Cherry, Deborah
 III. Barbican Art Gallery
 709'.41 N6768

 ISBN 0-7148-2434-8
 ISBN 0-7148-2435-6 Pbk

Editor: Jane Hawksley
Design and typesetting: CGS Studios, Cheltenham
Printed in Great Britain by Balding + Mansell Limited, Wisbech

Contents

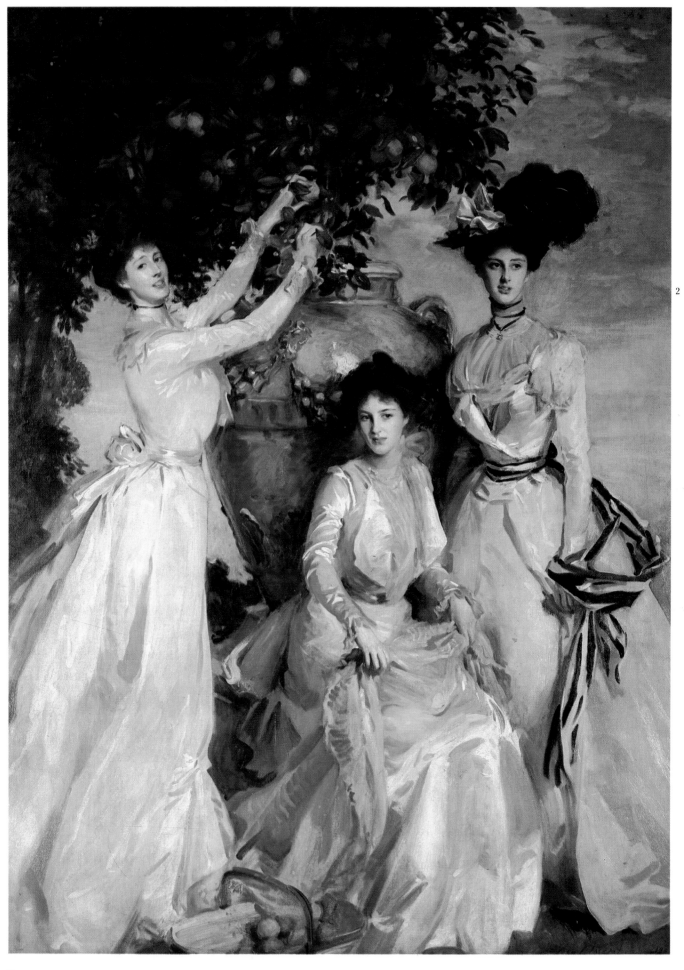

2

6

Foreword

The Edwardian Era, as an exhibition, will in time be judged either as a curious success or as a magnficent failure. In a manner rarely adopted before in this country, the selectors have concentrated upon using the visual imagery produced during the reign of Edward VII (1901–1910) to provide the foundation for an exhibition that is a cultural and a socio-political study rather than an art-historical analysis.

This approach to the exhibition-making stems from a conviction that the art of any period is made within a particular cultural context and is best seen and communicated within a reconstruction that provides such a context. While the exhibition attempts to create a structure that shows the diverse cultural characteristics of Britain during the period of Edward VII's reign, the accompanying book focuses upon the social and political currents that underlie the same period. Together they shed a clarifying light over a reign of nine years that was as crucial to Britain's future as it was short in span.

The desire for a new perspective has grown in recent years. Relentless attention has been paid to the cultural and social progress of the years immediately prior to the outbreak of war in 1914. But a comparative lack of analytical attention has been given to the first decade of the century, when all the symptoms became apparent of the illness which reached its most virulent state during the years 1914–18. The Edwardian period was the aftermath of the Victorian age, and the watershed of the modern age; a decade when in Britain all the expansionist and imperialist features of the previous century were still displayed to excess and all the political tensions and economic frailties of the present century were becoming apparent.

It is a period which has also attracted an increasingly glamorous array of misconceptions. In the latter half of the century the world of film and television has cast a romantic haze over its first decade. From such a distance, sentimental hindsight has given the period a stability to which, in these seemingly more turbulent times, it has been reassuring to look back. However, historic reflection should now allow us to judge that the symptoms of the malaise inherited from the Victorian period by the Edwardians have tempered the development of Britain throughout this century and still affect the tenor of contemporary life in every way.

Barbican Art Gallery wishes to extend its thanks to the many people who have helped us undertake the massive exercise of examining the Edwardian era in a new light. Jane Beckett and Deborah Cherry have worked enthusiastically on this project for the last three years and join with me in thanking the many lenders who have contributed works to the exhibition, in particular Her Majesty Queen Elizabeth II, and the many researchers whose efforts have made this study so wide-ranging and challenging.

John Hoole
Curator, Barbican Art Gallery

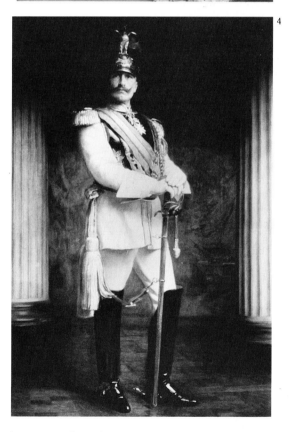

2. John Singer Sargent. *The Acheson Sisters*. 1902. The Duke of Devonshire and the Trustees of the Chatsworth Settlement. Edwardian portraits of the upper classes drew upon eighteenth-century British portraiture, so creating a lineage and history of wealth and tradition. Portraits by Reynolds and Gainsborough were viewed as a high point of British culture and formed a distinctive part of international exhibitions, representing an imperialist history of white rule and power. These women, the Ladies Alexandra Stanley), Mary (Ward) and Theodosia (Cadogan), daughters of the fourth Earl of Gosforth, are represented in nature, signifying not only the traditional base of aristocratic power in land ownership, but also linking femininity to nature, in opposition to masculine culture and dominance of the state and government.

3. Sir Luke Fildes. *King Edward VII*. 1901–4. National Portrait Gallery, London.

4. John Watson Nichol. *Kaiser Wilhelm II, Emperor of Germany*. 1903. Crown Estate Commissioners with the help of the Institute of Directors. During the early years of Edward's reign, the Kaiser, Edward VII's nephew, was a prominent and popular figure in British society, and royal visits were made to Germany. But fears of competition from German manufacturing and the development of the German navy were fuelled by the popular press, and anti-German feeling ran high by the end of the period.

CHRONOLOGY 1900-1910

The events which are listed are intended as a rough chronological guide to the Edwardian period; inevitably there are many events which are not included.

1900

Labour Representation Committee is formed with trade unions and socialist societies; soon becomes the Labour Party. Scottish Workers' Parliamentary Elections Committee formed. Pan-African Congress held in Westminster Town Hall. Maud Gonne MacBride founds Inghinidhe na Eireann, revolutionary Irish women's movement. Conservatives led by Lord Salisbury re-elected in the 'Khaki' election in October (Conservative and Liberal Unionist 402, Liberal 184, Labour 2, Irish Nationalist 82). Boer War in progress.

1901

Death of Queen Victoria and succession of Edward VII in January. Edward VII declared the first ruler of 'the British dominions beyond the seas'. Census of United Kingdom records a population of 41.5 million; by 1911 the population is 45.25 million. Trade Union membership, at 2 million, doubles to 4.1 million by 1914. Co-operative movement in Britain has nearly 2 million members. Seebohm Rowntree finds twenty-eight per cent living in chronic poverty in York. In the Taff Vale Case the House of Lords finds the Amalgamated Society of Railway Servants liable for damages during the strike action and trade unions were no longer immune from paying damages to employers resulting from strike action. Factory Act restricts the hours of labour of children working at home. Glasgow International Exhibition visited by 11.5 million visitors. British Academy founded. Concentration camp tactics started against Boers. Emily Hobhouse reports on the conditions in the camps. The final defeat of the Boers leads to the Peace of Vereeniging in May 1902.

1902

In July Salisbury resigns and A.J. Balfour becomes Prime Minister. Coronation of Edward VII in August, postponed from June because of his illness. The Education Act abolishes elected School Boards; elementary and secondary education are under control of county and borough councils, financially supported by local rates. Nonconformists' campaign of refusal to pay local government rates. School system of physical training implemented.

1903

Women's Social and Political Union founded in Manchester, under the leadership of Emmeline Pankhurst. Soon becomes a focus for militant action in the campaign for women's suffrage as against the constitutional, non-militant activities of the National Union of Women's Suffrage Societies, formed from the nineteenth-century women's suffrage societies in 1897 under the leadership of Millicent Garrett Fawcett. The WSPU has strong representation in Scotland, the first branch being established in 1906, and by 1908 when the Scottish Headquarters are opened in Glasgow a national network had been built up. Glasgow women artists are active in banner-making. In 1910 the Scottish Federation of the NUWSS is established with sixteen societies. Socialist Labour Party is formed. Labour and Liberal party organizers make a secret pact on electoral co-operation. Letchworth Garden City founded. Final volume of Charles Booth's *Survey of Life and Labour of London* (1887-1903) published. In May, Joseph Chamberlain declares his conversion from a policy of Free Trade to one of select tariffs; this splits the Conservative Party and reunites Liberals. Tariff Reform League founded. Irish Land Purchase Act gives financial support and the right to own land to renters. Report of Physical Deterioration Committee leads to a set of health reforms. Edward VII's visit to Paris and the *Entente Cordiale* of 1904 mark a shift to Anglo-French rather than Anglo-German alignment in foreign affairs.

1904

Empowerment of Children Act bans employment of children between nine at night and six in the morning. Workers Educational Association formed. Harmsworth relaunches the *Daily Mirror* as the first halfpenny illustrated daily newspaper. The importation of Chinese labour to work the Rand mines in South Africa leads to anti-Conservative feeling. Russian-Japanese War 1904/5. In October Russian fleet accidentally attacks a Hull trawler at Dogger Bank. Bradford exhibition to encourage West Yorkshire's textile industries; Cartwright Hall Art Gallery opened.

1905

Aliens Act limits Jewish immigration, driven by persecution from Eastern Europe; those without financial support or considered of 'bad character' could be refused. Indian Home Rule Society formed in London to rid India of British rule. Sinn Fein (Ourselves Alone) founded in Dublin. Christabel Pankhurst and Annie Kenney of the WSPU interrupt Liberal party political meeting in Manchester, leading to their arrest and imprisonment. Unemployed Workmen Act permits local authorities to set up labour exchanges and co-ordinate the distribution of public relief funds. 'From Sullivan to Coleridge-Taylor' festival of British music at Crystal Palace. The introduction in London of motor buses, which slowly replace horse-drawn buses. In December Balfour resigns; succeeded by Lib-

eral government, with Campbell-Bannerman as Prime Minister, Asquith as Chancellor, Lloyd George at the Board of Trade and John Burns at the Local Government Board.

January strikes and demonstrations throughout Russia and mutiny on the cruiser Potemkin. In August the Tsar promises the convocation of Parliament (Duma). Continued wave of strikes and unrest and emigration overseas until 1914.

1906

In January Liberal landslide victory at the General Election : Liberals 400, Conservatives 157, Irish 83, Labour 29. Women's suffrage demonstration at the opening of the new Parliament in February. Suffrage activity continues throughout the year; in October there are many arrests following a march to Parliament. In November the first of many celebration banquets is held for women released from Holloway Prison. Election of black councillors: H. S. Williams, Progressive councillor in Marylebone, and J. R. Archer, Labour member in Battersea (J. R. Archer was elected Mayor of Battersea in 1913). Sir M. Bhownagree retires as MP but joins D. Naoroji and Mahatma Gandhi in complaint to the Colonial Secretary over the treatment of Indians in South Africa. George Edwards refounds the agricultural labourers' union in Norfolk. Mary Macarthur forms the National Federation of Women Workers; *The Woman Worker* is published from 1907. Trades Disputes Act restores immunity to Trade Union Funds and permits picketing. Unemployment demonstrations and march from Liverpool to London for the right to work. *Forward*, Scottish independent Labour weekly, starts. Local authorities are allowed to provide free school meals for undernourished children.

1907

The music-hall strike against the syndicates of owners over pay and conditions is widely supported and many like Marie Lloyd and 'Little Tich' refuse to perform. Medical inspection becomes mandatory for school authorities. Under the Qualification of Women Act women, already district councillors, now become councillors, aldermen, mayors, and chairs of city and borough councils. Dr Garrett Anderson becomes the first woman mayor at Aldeburgh (1908). In February women suffrage campaigners march on the occasion of the opening of Parliament: the 'Mud March'. Artists' Suffrage League and Actresses Franchise League founded. The democratic Women's Freedom League founded under the leadership of Charlotte Despard. The WFL was active in campaigns for the improvement in women's pay and working conditions. The WSPU paper, *Votes for Women*, published from October. The paper *The Women's Franchise* published. Victor Grayson elected Independent Socialist for Colne Valley.

In Ireland rising political and industrial militancy with the Belfast dock strike, and the rise of Sinn Fein. Convention signed between Britain, France and Russia. Elinor Glyn's *Three Weeks* published. Lily Elsie stars in *The Merry Widow*, which runs to 778 performances.

1908

In April Asquith becomes Prime Mininster, with Lloyd George as Chancellor and Churchill at the Board of Trade. Miners secure an eight-hour day through the Mines Eight Hour Day Act. The Children Act revised existing laws, including those covering prevention of cruelty, juvenile smoking, treatment of young offenders and exclusion from pubs. Several successful strikes over pay and conditions. Unemployment at its worst for a decade. Large hunger marches of the unemployed. Two spectacular women's suffrage marches in London, that of the NUWSS on 13 June and that of the WSPU on 21 June, when over 30,000 women marched in Hyde Park, London. In July women's suffrage demonstration of over 100,000 at Woodhouse Moor, Leeds. Suffrage caravan tours throughout Britain. Active suffrage participation in the by-elections in Scotland. In Dublin the militant Irish Women's Suffrage League formed by Hanna Sheehy Skeffington and Magaret Cousins, in contrast to the constitutional Irish Women's Suffrage and Local Government Association founded in 1876. Queen's University, Belfast, and University College, Dublin, founded. Annie Horniman opens the Gaiety Theatre, Manchester. Franco-British exhibition at Shepherd's Bush, London. *Take me on the Flip Flap* sung by Florrie Forde becomes popular song. *Scouting for Boys* published. Membership of the Boy Scouts, founded in 1907, was over 100,000 in two years. Girl Guides founded in 1909.

1909

Old Age Pensions from January: 5s. a week for those over 70 with a weekly income of less than 10s.; 7s. 6d. for a married couple; those receiving poor relief or with known criminal record disqualified. International Women's Suffrage Alliance Quinquennial Congress with procession of women's trades and professions. Suffrage Atelier founded. March by WSPU and NUWSS in Edinburgh. Imprisoned suffragettes begin hunger strikes, and force feeding is introduced . The NUWSS paper, *The Common Cause*, founded in Manchester in April. Osborne judgement, upheld in the House of Lords, makes it illegal for trade unions to levy compulsory contributions from members for the support of the Labour Party; leads to the introduction of payment for MPs in 1911. Trades Board Act sets up minimum wage in the tailoring, box-making, lace-making and chain-making industries. Local Government Board, with Arthur Newsholme as

Medical Officer, campaigns for water-closets in town housing, infant welfare and maternity clinics. Report of the Poor Law Commission, set up in 1905, whose members include Fabian socialists Beatrice and Sidney Webb. Visit of the Tsar leads to major protest demonstrations. Lloyd George's budget – which raises income tax to eight per cent on the highest unearned incomes and death duties to fifteen per cent, increases tax on drink and levies small Land Value duties on leasehold property, undeveloped land and unearned increments – is vetoed by the House of Lords in November. In the consequent constitutional crisis a general election is called. Pioneer aeroplane flight across the Channel by Blériot. Captain Scott leaves for Antarctica. *Our Miss Gibbs*, starring Gertie Millar, begins successful run at Gaiety Theatre. George Du Maurier's play *An Englishman's Home* – like Erskine Childers' *The Riddle of the Sands* (1903), W. Le Queux's *Invasion of 1910* (serialized in the *Daily Mail*) and P. G. Wodehouse's spoof *The Swoop or How Clarence Saved England* (1909) – takes the theme of the invasion of Britain. Proposal accepted for the Union of British Cape and Natal with the Boer Republics of Transvaal and Orange River for the formation of the Union of South Africa.

1910

In the January general election the Liberals returned without an overall majority (Liberals 275, Conservatives 273, Labour 40, Irish 82). Irish Parliamentary Party holds the balance of power; John Redmond is hostile to women's suffrage and anxious to avoid any issue which might adversely affect the granting of Home Rule to Ireland. In April suffrage bazaar in Glasgow. On 6 May death of King Edward and succession of George V.

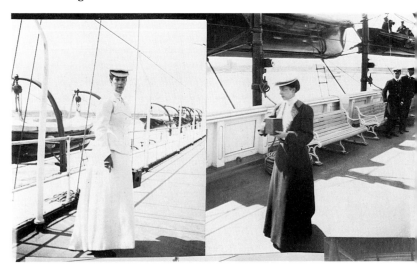

5

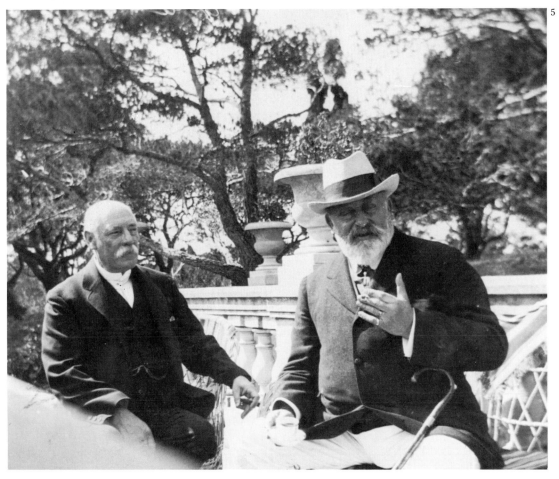

5. King Edward VII (right) and General Sir Henry Grant, Governor of Malta, Verdala Palace, Malta, 24 April 1909. Photograph by Queen Alexandra, from her photograph album. Inscribed in the Queen's handwriting: 'April 24 Friday. Lunch with Governor and Lady Grant at Verdalor. Sat and walked in the garden afterwards.' Reproduced by gracious permission of Her Majesty The Queen.

6. Two snapshots showing Queen Alexandra (left) and Princess Victoria with their cameras during a Mediterranean cruise in 1905. Photographer unknown. Reproduced by gracious permission of Her Majesty The Queen. Both Queen Alexandra and Princess Victoria were keen photographers, and compiled photograph albums recording public and private events.

7. Frederick Morgan and Thomas Blinks. *Queen Alexandra with her grandchildren and dogs*. 1902. Reproduced by gracious permisssion of Her Majesty The Queen. Queen Alexandra is seen near the kennels at Sandringham with Prince Edward, Prince Albert and Princess Mary. Mr Brunsden, the kennelman, is in attendance.

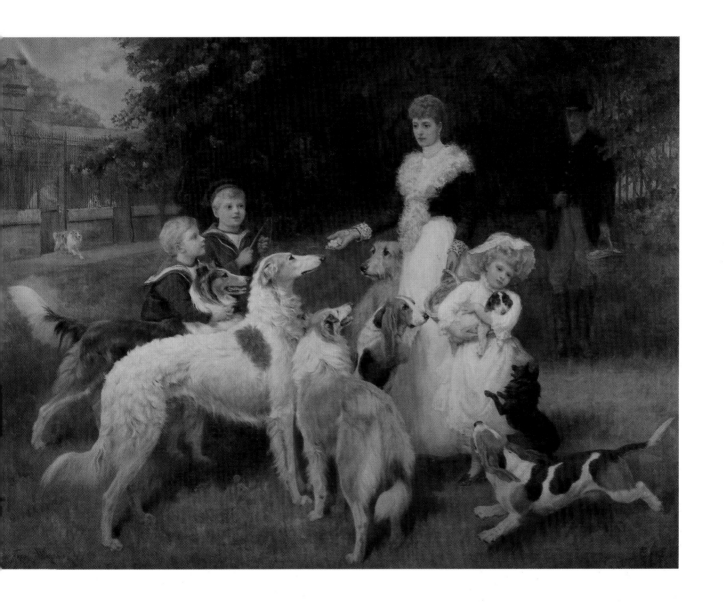

8. Unofficial photographs, mostly by Princess Victoria, of the official visit of Tsar Nicholas II, Emperor of Russia, to Britain in 1909. Princess Victoria's photograph album. Reproduced by gracious permission of Her Majesty The Queen.
From top left: Princess Victoria with the Tsar's daughters. Tea on the lawn at Barton, near Osborne, Isle of Wight. Seated round the table, from left to right, are George, Prince of Wales, Princess Victoria, Tsar Nicholas II, Queen Alexandra, King Edward VII, and Victoria Mary, Princess of Wales. King Edward VII and Tsar Nicholas II on board the royal yacht Britannia, at Cowes. This was the last visit of the Russian royal family to Britain, and there were protests from Members of Parliament and the clergy about the condition of political prisoners and exiles in Russia.

9. Snettisham Beach, Norfolk, 1901. A whole page from Princess Victoria's photograph album. Reproduced by gracious permission of Her Majesty The Queen. Queen Alexandra had a beach house at Snettisham, near Sandringham. In the photographs the four children of the Duke and Duchess of Cornwall (later King George V and Queen Mary) – Princess Mary, Prince Henry (Duke of Gloucester), Prince Albert (later King George VI), and Prince Edward (Duke of Windsor) – are playing on the beach with their nurse.

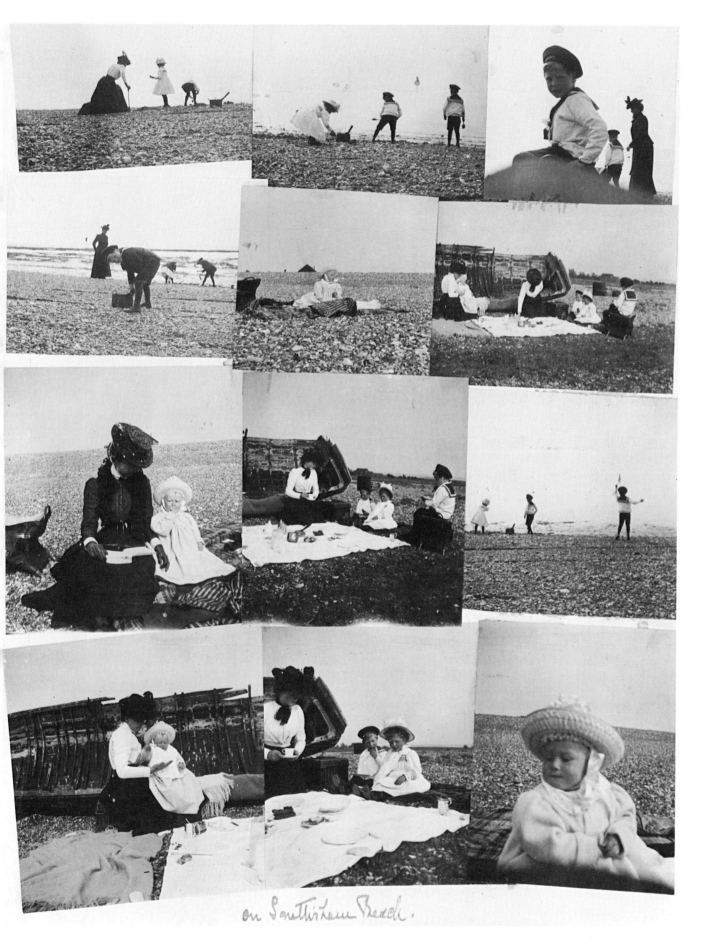

on Southdean Beach.

INTRODUCTION

Jane Beckett and Deborah Cherry

Visual images form a significant part of accounts of the past. They are structural to our view of a historical period, particularly that of the early twentieth century, when snapshots and newspaper photographs appear to depict the world 'as it really was'. What images are evoked by a phrase like 'The Edwardian Era'? Are they those of a last golden summer of garden parties, sunny days at the seaside surrounded by bathing machines, or raucous evenings at the music-hall? Even perhaps adventures in the new motor cars or early flying machines? These images dissolve in a historical haziness of a past conjured up by faded sepia photographs, called up in memories, old postcard albums sold in local markets, picture postcards bought in museums and libraries, and even recent television programmes and films.

But whose history is this? Whose struggles and achievements are obliterated, obscured by a white, imperialist and patriarchal visual mythology of tranquil upper-class leisure and working-class fun, a picture of an upstairs/downstairs harmonious and symbiotic world? Complex, fragmentary and discordant histories inform the whole range of visual images produced in the early twentieth century. All of them were made for specific purposes. They did particular ideological work in the representation of masculinity, femininity, class and race. Visual images marked out sharply different ideological positions; they informed the views which groups and individuals had of their society and they were a strong part of the political movements and social debates of the period.

Who had access to representation? Who had the power to represent themselves, their social group, to inscribe their gendered, class and racial position in the imagery of the time? What were the conditions in which these images were produced, bought and understood?

By the late nineteenth and early twentieth centuries, the economic and social forces which underpinned mid-Victorian stability were shattered. British economic retardation was faced on world markets by powerful manufacturing rivals – America, Germany and Japan – and in Britain by industrial unrest. The fundamental changes which were taking place in the social formation, particularly the growing feminist and socialist movements, and across a whole range of social issues characterize this period as one of general and protracted crisis (see *Crises in the British State, 1880–1930,* edited by Mary Langan and Bill Schwarz, London, 1985). The years 1901–1910 were a period of transformation , dislocation and confrontation with the old structures and the formation of the new, modern state and society.

A perceptive commentator observed in 1910 that Britain was 'a wealthy nation, but a poor state . . .' (L. G. Chiozza Money in 'British Budget Making', *Co-operative Wholesale Society Annual,* 1910. pp. 299–326.) Large portraits displayed in national museums and on the walls of country houses preserve a history of the few who enjoyed that wealth and privilege, where contrasts of wealth and poverty were sharp and bitter. Many of these images turn back to traditions of a British imperial past, drawing on the visual codes developed centuries earlier in the paintings of Van Dyck and Gainsborough to imply stability, order and authority at a moment when the ruling class was itself in crisis. Imperialism also found different visual forms in new sites for imagery in advertising, exhibitions, the 'science of eugenics', army reforms, the health policies of the State, the music-hall and 'moving pictures' at the bioscope. Photographs and snapshots, made possible by the development of roll film and a range of portable cameras, extended new forms of collective and individual representation, making the large, expensive portraits seem anachronistic. Photographs of strikes, demonstrations and union meetings presented collective representations of working-class solidarity and identity. But photography generally remained securely in the hands of the middle classes: high-street photographers posed their sitters beside columns and plinths or in front of painted landscape backgrounds, echoing the conventions of high

10. Photograph by Rita Martin of Gertie Millar, musical comedy star, 1909. Mander and Mitchenson Theatre Collection.

culture. And 'snapshots' and photographs of middle-class leisure were often points of production for views and beliefs about identity, domesticity, the family.

With the launch of the *Daily Mirror* in 1904 as a cheap illustrated daily, the popular press addressed newly literate publics, organizing news increasingly around photographs rather than drawings of people and events, categorizing what was newsworthy in visual terms, and interlocking texts and pictures. Newspaper photographs made visible many of the important political campaigns of the early twentieth century – the successful Black participation in national and local politics, the demonstrations of the women's suffrage movements and the hunger marches of the unemployed.

Picture postcards, like newspapers and advertisements, extended the visual imagery of popular culture. A range of conventions and practices developed: for towns, the high-street view; for rurality, the countryside as a place where the sun never sets and haymaking is an eternal rather than seasonal activity; and for people, the stern faces of male politicians to the ever-smiling women stars of the theatre and music-hall. Circulated across the country for a penny stamp, postcards were often avidly collected. Picture postcards of Gertie Millar were in such demand that photographs of her face were often superimposed on images of other women's bodies. She sued the publishers and lost (*Daily Mirror,* 29 January 1907, p.5). As this reveals, the industries of photography and postcard production, like the society in which they developed, were deeply patriarchal. The images on postcards were produced within contemporary debates on health, sexuality and morality. These debates were often conducted at visual level, as for example the campaigns against the appearance of variety artists and innuendo on stage in the music-hall turns, or those of feminists against venereal disease and prostitution. In other guises discourses on morality were the imperatives informing not only the society portraits but also the prevalent imagery of the healthy mother.

There were many whose portraits were never taken; many whose photography is a misrepresentation of their lives, identity, work and historical reality. There is much which has not survived, or is already thrown away; much, too, that is tucked away in attics and basements, or not yet recognized for what it is.

Moreover the photographs which survive on postcards, or in newspapers, in local libraries or in council records, may well have been taken by professional photographers, whose job was not simply to record, but to view from a specific position, informed by class, gender and race. Their technological knowledge gave them the power over who was represented, how and when. Photographers like Horace W. Nicholls could turn the camera on fashionable Ascot, poor children of London, or travellers on Epsom Downs. The rural working class was bathed in atmospheric haze for the aesthetic pleasures of the readers of *Country Life.* The urban poor were scrutinized by missionary societies and medical officers of health and their photographs were used in the strategies for improvement and reform of the working class and deployed as forms of social control.

The long traditions of the nineteenth-century women's suffrage movement were transformed during the early years of the twentieth century with spectacular marches, demonstrations and pageants, by the production of banners (770 were made for the procession of 13 June 1908), posters, postcards and souvenirs and through the work of feminist photographers working for the cause, as well as through the bravery of acts of militancy and resistance. The collective organization of women was also present in the demonstrations and strikes of working-class women and in the postcards they produced which countered images of them as feeble victims, unhealthy and isolated. Working-class solidarity, organized in the collective actions for better pay and conditions, was urgently necessary to counteract the exploitation of labour in the transformations to monopoly capitalism and the declining economic situation. It was visually orchestrated in the huge demonstrations and May Day rallies, in which were seen the magnificent banners of the trade unions, socialist societies, co-operative movement and friendly societies.

To call the years 1901 to 1910 the Edwardian era is misleading, mediating the complexity and discordancy of this decade through a single patriarchal figure. The whole field of political and social representation was in the process of transformations begun in the 1880s and not completed until the 1920s. The successful Black participation in politics; the feminist campaigns around suffrage, sexuality and work; the important Black anti-colonialist movements; and the labour movement of working-class and socialist organizations – all contributed to changing the structure and patterns of British society through collective identities and struggles.

Suffragists in Prince of ales Road, Norwich. Norfolk ounty Library.

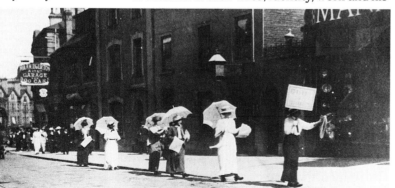

12. Suffragettes being welcomed on their release from Holloway prison. People's Palace, Glasgow.

13, 14. Joseph Chamberlain, 1902; John Burns and David Lloyd George, 1902. Photographs by Sir Benjamin Stone. National Portrait Gallery, London.

15, 16. Kier Hardie, 1908; J. Ramsay MacDonald, 1907. Photographs by Sir Benjamin Stone. National Portrait Gallery, London.

THE STATE

Bill Schwarz

In the inimitable words of A.J.P. Taylor: 'Until August 1914 a sensible, law-abiding Englishman could pass through life and hardly notice the existence of the state, beyond the post office and the policeman.' His view of the Edwardian period is perhaps a characteristic one, shaped above all by an understanding of the profound changes which subsequently occurred in British society during the First World War. But even noted historians can at times be misleading. A.J.P. Taylor writes from the perspective of the 'sensible, law-abiding Englishman'. But what about the female majority of the population, who had no say in the administration of their country and many of whom received cracked heads in demonstrating against this injustice – a rather painful way in which to notice the existence of the state? Or the Irish, whose sense of the state appears at this time to have been intense? Or those hundreds of thousands who found themselves forced out of the job market, pushed into the residuum, forced to rely on casual labour, poor-law handouts and perhaps petty crime in order to survive? It may be that women, the Irish and the impoverished do not qualify as being sensible in any case. For them, as for many others in the first decade of the century, the impact of state activity was extensive. And even the respectable Englishman, although he might not have perceived it, was coming increasingly to be governed by the deeds of the politicians and the bureaucrats.

It is possible to isolate four fundamental transformations in British society which help explain the increase in state activity at this time. First, there arose competition from new industrial powers abroad – most of all from the USA, Germany, Russia and Japan. Britain's huge overseas economic interests could no longer rely, as they had in the previous century, on the fact that Britain was the single nation which possessed an industrial economy. Thus Britain not only had now to compete with more efficient nations abroad, but also with foreign investment, particularly from the USA, in the British domestic market itself. Many businesses (especially those in iron and steel) began to look to the state for an element of protection.

Secondly, different groups or classes in society be-

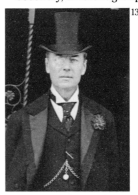

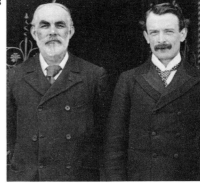

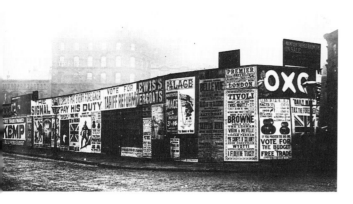

came more organized and sought representation within the state as unified corporate interests. The largest enterprises were cartelized in this decade, emerging as huge modern combines. The older divisions between those who gained their incomes from agriculture (and gravitated to Toryism) and those who gained them from manufacturing (predominantly Liberals) drastically lessened, with the Conservatives now uniting all those who were, broadly, capitalists and plutocrats. At the same time the concentration of the working class in the great industrial cities, the growth of trade unionism and the emergence, in the early years of the century, of the Labour Party ensured that a distinct interest and voice of labour cohered, matching that of business. Each, in its distinctive way, began in this period to lobby politicians on behalf of its respective collective membership.

Thirdly, the administrative system which had developed in the early years of industrial Britain in the 1830s and 1840s effectively fell to pieces, unable to meet the new demands upon it. Nowhere was this clearer than with the Poor Law, with the famous Royal Commission of 1905 calling for the destruction of the old system and an extensive overhaul of the nation's welfare administration.

18

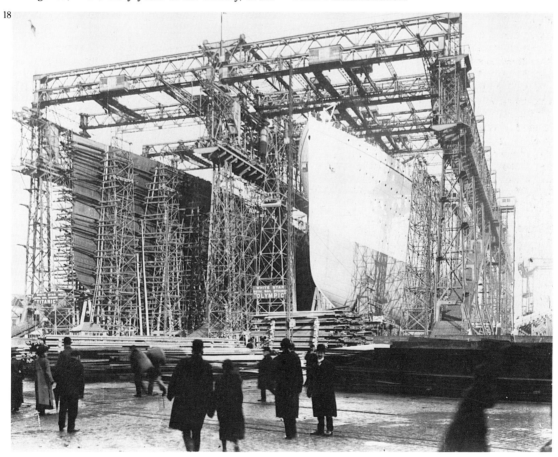

19. *An Englishman's Home.* 1909. Conservative and Unionist Party poster. Conservative Party Archives, Bodleian Library, Oxford.

20. *'Learn to Think Imperially'. The Great Election Puzzle.* 1906. Liberal Party poster. John Johnson Collection, Bodleian Library, Oxford. This lampoons Joseph Chamberlain's proposals for protective tariffs for Empire goods, against the advocacy of Free Trade.

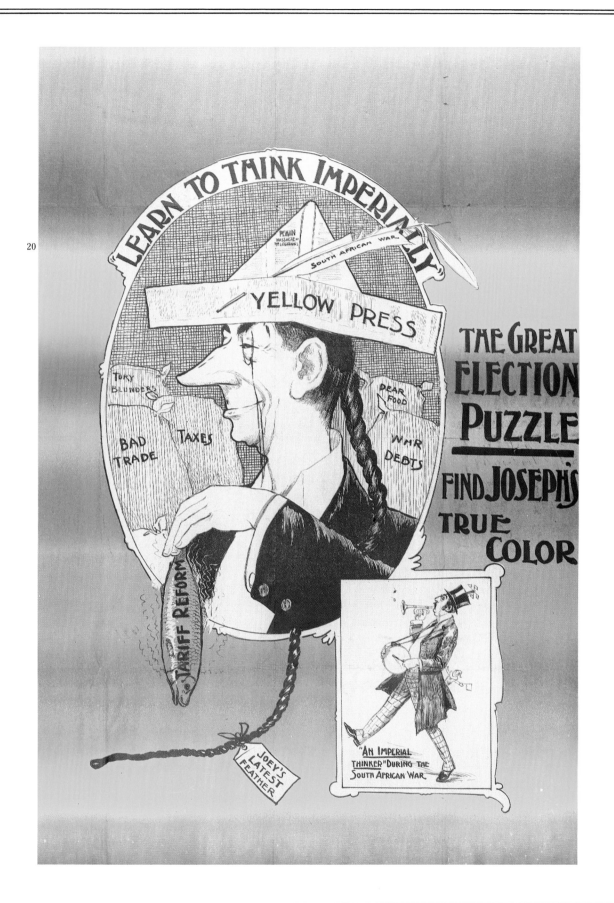

21. Cartwright Hall, Bradford, c. 1904. Bradford Public Library. The opening of Cartwright Hall, an art gallery to commemorate Dr Edmund Cartwright, credited as the inventor of the power loom and woolcombing machine, was celebrated with an exhibition of the textile industries of Bradford and the West Riding of Yorkshire. Through the textile industries Bradford had strong trading links with Germany.

22. The display of the British navy before Edward VII at Spithead for the Coronation in August 1902. *Illustrated London News*, 1902. Norfolk County Library. Battleships and merchant ships were assembled to show the British fleet at Edward VII's accession; the illustration impressed upon the readers of this middle-class magazine the importance of the navy for the defence and economic power of the Empire. 'Thirty-five per cent of the national budget was devoted to armaments', the Dreadnought being introduced in 1906 and 'the whole of the British navy being rebuilt virtually within the decade'.

21

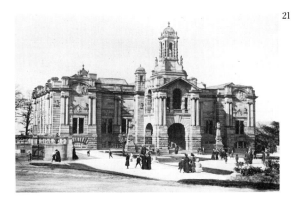

22

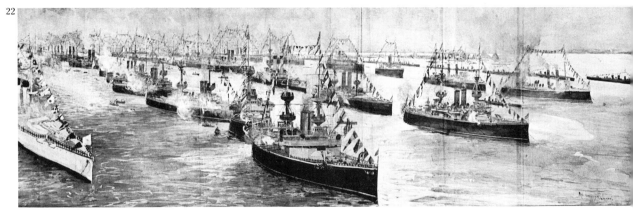

23

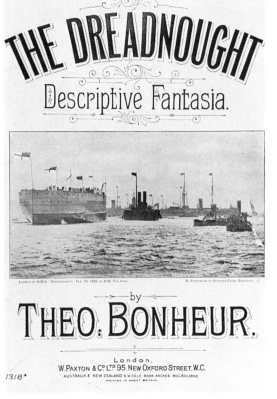

THE DREADNOUGHT
Descriptive Fantasia.

LAUNCH OF H.M.S. "DREADNOUGHT," FEB. 10, 1906, BY H.M. THE KING. BY PERMISSION OF STEPHEN CRIBB BONTHIER. J.)

by
THEO. BONHEUR.

London,
W. PAXTON & Co LTD 95, NEW OXFORD STREET, W.C.
AUSTRALIA & NEW ZEALAND, E.W. COLE, BOOK ARCADE, MELBOURNE.
PRINTED IN GREAT BRITAIN.
13/8*

24

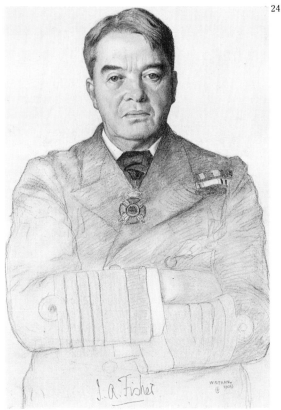

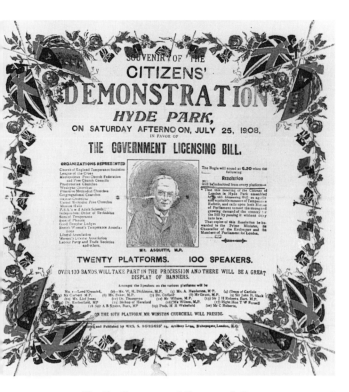

23. Sheet music: *The Dread-nought Fantasia*. 1906. Private collection.

24. William Strang. *Sir John Fisher, Admiral of the Fleet*. 1908. Reproduced by gracious permission of Her Majesty The Queen.

25. Souvenir of the citizens' demonstration, 1908, in favour of the Government Licensing Bill. National Portrait Gallery, London.

26. Mary Durham. *Newgate Prison*. 1901. Museum of London.

The old Newgate Prison was demolished in 1902 for the new Central Criminal Courts. During the period much of eighteenth-century London was pulled down to make way for a new, magnificent and pompous 'Edwardian' architecture to carry the power of the State and the Law.

Finally, the mass of the population – women and the majority of working men – sought political representation: the right to vote as full subjects of the nation. The history of the struggle for universal suffrage is a long one, stretching back well before the Edwardian period. However, from the turn of the century the call for *political* rights was distinctive in that it combined with struggles for *social* rights – for a form of state which would provide every member of the nation, irrespective of the workings of the market, with at least the bare subsistence to ensure they stayed alive. In a culture shift of great significance, the idea that the state should guarantee social rights, and that the population should not have to rely on the market, gained a quite new legitimacy.

In response to these pressures a number of political groupings emerged dedicated to transforming and modernizing the British state along these 'collective' lines. Within the Conservative Party there were Joseph Chamberlain's tariff reformers; the Fabians orbited around the nascent Labour Party; and the influence of the New Liberal intellectuals like Leonard Hobhouse and John Hobson touched both the Labour and Liberal parties. All constructed their arguments, in different languages and to different degrees, in terms of the *crisis* of the old, nineteenth-century liberal state and the commensurate principles of laissez-faire. This was a moment when ideologies of National Efficiency took hold of reformers who hoped a drastic solution imposed from above would reorganize the state administration, modernize the economy and make it more competitive, and at the same time secure the allegiance of the working class by offering a systematic, national state welfare sys-

tem (on the Bismarckian model) and the fruits of high wages. Britain, with her Empire, would be transformed into the foremost of the great powers.

This, of course, never happened, and Britain's long economic decline can be dated from the closing years of the nineteenth century. But neither did the relations between state and economy continue as before. 1909 witnessed both the Trade Boards Act, which fixed a minimum wage in certain industries and attempted to destroy the sweated trades, and the Labour Exchange Act, which encouraged the mobility of labour under state direction. The Old Age Pensions Act of 1908 and the National Insurance Act of 1911 (pioneered by William Beveridge) represented the fruits of a new state welfare system based on the concept of universal provision as a social right.

At the same time, if only to a limited degree, intervention in industry was also extended. In the mines – which employed one in six of the adult male population – the length of the working day came under state control in 1906, followed by wages in 1912. Throughout this period Parliament attempted to force the railway companies to amalgamate. And it is highly revealing that thirty-five per cent of the national budget was devoted to armaments, the whole of the British Navy being rebuilt virtually within the decade.

Compared to the transformation which took place between state and society during and after the First World War, these changes may look relatively slight. Yet even so, it is time the myth of an Edwardian golden age free from state interference, in which the personnel of the state consisted only of Postman Pat and the local Bobby, died once and for all.

27. Electrical Trades Union banner, designed by Walter Crane, 1898. John Gorman Collection.

28. Gerald Spencer Pryse. *Workless.* Labour Party poster. First made for the 1910 election and reissued in the twenties, this poster drew attention to the political issue of the unemployed. The Labour Party Library.

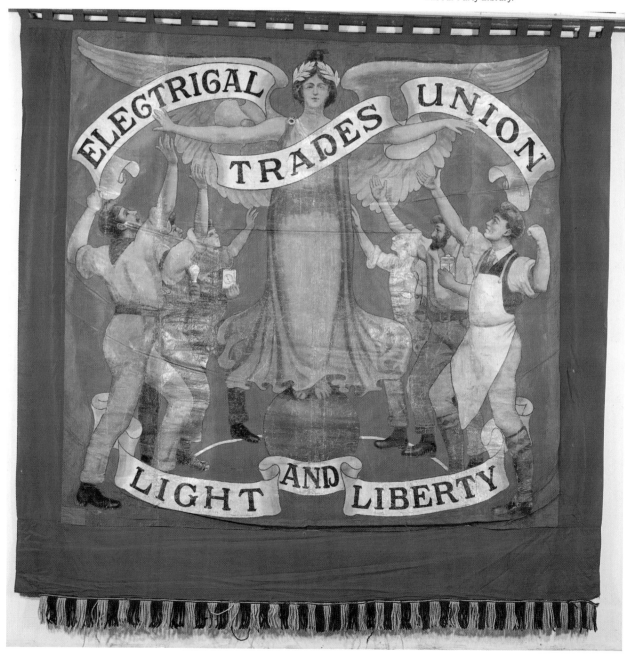

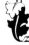

28

BLACK POLITICIANS

Ziggi Alexander and Audrey Dewjee

Sir Mancherjee Merwanjee Bhownagree (1851–1933)

Dadabhai Naoroji (1825–1917)

Shapurji Saklatvala (1874–1936)

Born in Bombay, the son of a Parsee merchant, Bhownagree came to Britain at the age of 30 and was called to the Bar in 1885. He was the second Asian to be elected to the House of Commons for a London constituency, being Conservative Member of Parliament for Bethnal Green North-East from 1895 to 1905.

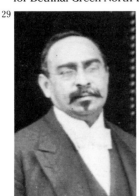 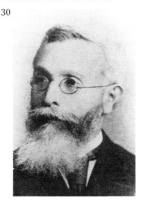

29 30

The first had been Dadabhai Naoroji, who was elected in 1892 as the Liberal Member for Finsbury Central. Although in his election address Naoroji promised that his first duty would be to his constituents, he made no secret of the fact that he would also be representing 250 million of their fellow subjects in India. He wanted to promote the cause of India in a parliament where the Indian budget was usually rushed through in an evening amidst empty benches, and where there was 'no-one to put forward the native Indian view on any subject'. During his three years in the House of Commons Naoroji proved himself a model constituency MP, at the same time working tirelessly to keep Indian issues in front of Parliament and to educate his fellow MPs about India's grievances, particularly the financial drain on the sub-continent caused by British trade and taxation.

It was as an antidote to Naoroji that the Conservatives decided to put up an Asian candidate of their own in the election of 1895. In Mancherjee Bhownagree they found an ardent supporter of British rule in India, as well as of Conservative policies in general.

Knighted in 1897, Bhownagree too was a conscientious constituency MP and he was returned in the election of 1900 with an increased majority. He gave generously to local charities and in memory of his sister donated a corridor to the Imperial Institute – now remembered as the Bhownagree Gallery in the Commonwealth Institute. After his defeat in 1906 he retired from parliamentary politics, but in the same year he joined with Naoroji and Mahatma Gandhi in a deputation to the Colonial Secretary complaining about the persecution of Indians in South Africa. He remained a pillar of Conservative London society until his death in 1933.

Dadabhai Naoroji, despite his advanced age, continued to be politically active throughout the Edwardian era. At 79 he stood as a candidate for North Lambeth in the election of 1906, losing in spite of a vigorous campaign. Later that year he departed for India, where, through the Indian National Congress, of which he was a founder member and several times President, he continued to work for justice. He died in 1917.

Although Naoroji and Bhownagree bowed out of British parliamentary politics in 1906, a fellow Parsee was preparing to follow in their footsteps. On his arrival in Britain in 1905, Shapurji Saklatvala immediately joined the National Liberal Club, but his views quickly became far more radical. He joined the Independent Labour Party in 1910 and went on to become the third Asian member of Parliament, winning his seat as a Labour candidate in 1922 and as a Communist in 1924.

Henry Sylvester Williams (1868–1911)

A Trinidadian-born barrister resident in London, Henry Sylvester Williams took a keen interest in international, Pan-African and British domestic politics.

His political awakening in Trinidad ultimately led him, whilst a student in England, to petition the government on behalf of colonial peoples. His period of residence in southern Africa also made him determined to fight injustice. By 1900, his political maturity was crystallized in the organization of the first Pan-African Conference, which brought together people of African descent from three continents to promote the interests of Africa and her people. As reported by *The Times* and other leading papers, among the Con-

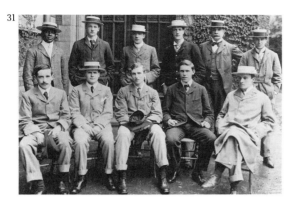

29. Sir Mancherjee Merwanjee Bhownagree, 1897. Photograph by Sir Benjamin Stone. National Portrait Gallery, London.

30. Dadabhai Naoroji. Popperfoto.

31. Edward Theophulus Nelson, Secretary, with the Oxford Union Society Standing Committee, Summer 1900. Oxford Union, Oxford.

32. Henry Sylvester Williams, 1910. British Library (Newspaper Library).

33. John Richard Archer. *Daily Express*, 11 November 1913. British Library (Newspaper Library).

34. Edward Theophulus Nelson. *Stalybridge Reporter*, 29 October 1910. British Library (Newspaper Library).

35. Edward Theophulus Nelson. *Altrincham, Bowden and Hale Guardian*, 28 March 1913. British Library (Newspaper Library).

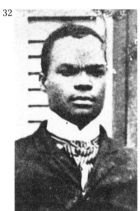

ference delegates were: Samuel Coleridge-Taylor; J.F. Loudin, the director of the Fisk Jubilee Singers; Dr John Alcindor of Paddington and Trinidad; English-born John R. Archer, later to become the first Black mayor of Battersea; and the renowned Afro-American sociologist Dr W.E.B. Du Bois. It was here at Westminster Town Hall that the sombre warning for which the Black American Du Bois was to be long remembered – 'The problem of the twentieth century is the problem of the colour line' – was first uttered, in the 'Appeal to the Nations of the World'.

Williams's political aspirations led him to seek Liberal party nomination, and when this failed he entered the 1906 local election as a Progressive. Standing in the unlikely ward of Marylebone, Williams enjoyed what one newspaper described as 'the distinction of being the only coloured citizen on any Council in England'. However, as a member of the minority party he found his three-year term of office extremely frustrating and thereafter channelled his energies and commitment in other directions.

John Richard Archer (1863–1932)

Born in Liverpool of a Barbadian father and Irish mother, Archer married a Black Canadian-born woman and settled in Battersea, south-west London, in 1890. At this time he was a medical student but he eventually gave up his studies and became a professional photographer. By 1900 he was involved in political activity. In that year he attended the first Pan-African Conference, held at Westminster Town Hall.

Whilst Archer maintained links with and strongly supported the Pan-African cause, he also became involved in local politics. He was elected to the Borough Council as a Labour member in 1906, polling 1,051 votes. Although he lost his seat in the 1909 elections, he regained his place on the council in 1912, and was elected Mayor of Battersea in 1913. During his political career he sat on the Wandsworth Union Board of Guardians, was secretary and agent of the North Battersea Divisional Labour Party and was Leader of the Labour Group.

Edward Theophulus Nelson (1874–1940)

E.T. Nelson came to Britain in 1898, from Georgetown, Guyana, to read law at Oxford. In 1900 he was elected secretary of the Oxford Union, when Raymond Asquith, who nominated Nelson, became President.

Nelson was called to the Bar in 1904 and settled in Manchester; his home was in Hale and his practice in the centre of the city. His most celebrated case came in 1909, when he acted as defence lawyer in a murder trial. George Harry Storrs, a businessman who lived at Gorse Hall, was stabbed to death at his home by an intruder. Nelson first acted for Cornelius Howard, a cousin of the deceased, who was tried and acquitted, and then defended Mark Wilde when he was subsequently arrested. He, too, was acquitted.

Nelson had a successful professional career and was well respected in the locality. He turned his attention to local politics and was elected to the Hale Urban District Council in 1913, on which he served as a Conservative for twenty-seven years.

1

HEALTH AND HYGIENE

The Edwardian State and Medico-Moral Politics

Frank Mort

In the autumn of 1913 scripture lessons for the pupils of Dronfield Elementary School, Derbyshire, took a radical turn. The girls from standard six were reading the Bible with their class teacher and headmistress, Miss Outram. One of the set texts for Advent dealt with the birth of John the Baptist. The verses prompted questions from the children about personal health and childbirth. At first Miss Outram told them to ask their mothers, but feeling that she might lose the girls' confidence if she blocked their curiosity she took a more direct approach. Telling them to close their Bibles, she read them a story about the beginnings of life on earth:

> Shall I tell you a story of how God made things in the beginning, a true story? Well, once upon a time there was no world at all. Doesn't it seem strange to think about it . . . And God said, 'Let there be light,' and there was light . . . Now, how do you suppose God planned always to have plants on the earth? God said, 'Let them have seed, each after its kind.' He knew that by-and-by, when they were ripe, they would drop down into the ground; there they would keep soft and warm for a while; then they would grow into more plants, with seeds, so there would always be plants on the earth . . . Then God wanted to have fish in the waters, so he made a mother fish to lay eggs . . . Shall I tell you about the very first little baby? God knew it would be the most precious of all. So He made a tiny egg, so small that it could not even be seen, and a little room on purpose for it to grow in, right inside the mother's body . . . Mother knew you were there and she loved you . . . The food she ate made you grow too, so she was very careful to eat only good food and take nothing that might harm her little baby. The fresh air she breathed made pure blood for you, and often during the day she wondered what you would be like . . . Then when you had grown enough . . . God opened a door . . . and brought you out into the world.[1]

Miss Outram claimed to have obtained her story from an American publisher, yet it was typical of early twentieth-century British health education teaching. Medics and educationalists used the language of evolutionary biology to target key groups within the population – especially children, mothers and the men of the armed forces – while the natural world, presided over by the image of the benevolent patriarch, was moralized to carry the significations of goodness, health, and social harmony. Inevitably, Outram stirred up trouble with her new-style scripture lesson. Angry parents and school managers joined forces, petitioning the Board of Education to remove their headmistress who, they claimed, was corrupting childhood innocence with her talk of biology and racial health.

Dronfield was not an isolated incident, nor was Outram merely an eccentric schoolmarm. She was a committed hygienist and a feminist – herself part of a much broader campaign to get 'race hygiene' on the school syllabus. For in the first decade of the new century health education took on great importance within public debate. A broad and often uneasy coalition – of medics, clerics, social purists, eugenists, and some feminists – campaigned to raise the question as a matter of national and even imperial concern. Books and pamphlets, conferences and public meetings, along with the formation of influential pressure groups, all testified to the seriousness with which the issue of health was being treated. More often than not campaigners looked to *the state* to enact their demands and the Edwardian period conjures up distinct images of state-backed hygienics: serried ranks of elementary schoolchildren engaged in physical drill or the white-coated male doctor lecturing to mother-and-baby clinics. Here we will be exploring the conditions which led to such developments. They point us to a number of key themes which need to be foregrounded in any account of this period – transformations in the role and functioning of the state, in the position of professional experts and their knowledge and in the political balance of forces which underwrote these changes.

In Corpore Sano

The contrast between state medicine's confident position in 1910 and its history over the previous forty years could not have been sharper. For in the closing decades of the nineteenth century state medicine had suffered partial eclipse; blocked both by a moral coalition opposed to the 'immorality' and ruthlessness of medical power and by a new breed of civil servant intent on curbing the medical expert.[2] Yet despite these setbacks *medical research* had continued to enlarge its sphere of influence. Medics might bemoan the lack of any new initiatives in public health policy, but they could point to rapid research into the aetiology of major infectious diseases as a mark of contemporary achievement. As the *British Medical Journal* trumpeted in its special commemorative number for the Queen's Diamond Jubilee in 1897, discovery of the micro-organic causes of disease had opened up a field which 'to the minds of our immediate ancestors seemed almost outside the knowable'.[3]

Major transformations within medical discourse provided the theoretical conditions for this perceived advance. The gradual acceptance of the germ theory of infection, following research of Pasteur and Koch into viruses and vaccines in the 1870s and 1880s, had resulted in the rapid isolation of the bacilli of all the major infectious diseases. At the heart of this research was an understanding of how the healthy body produced its own defences against invading bacteria. This medical model produced a new conception of *the body* as the site of health and disease. There was more and more focus on the internal biochemistry of the organism, as against the older notion that the healthy individual was directly shaped by the material environment, which had been dominant in the sanitary movement for much of the nineteenth century. Parallel investigations into cellular pathology gave this individual-centred discourse an even more resonant gloss: disease now had its origins at the level of the cell.[4]

Medicalized scrutiny of the individual and his/her role in health maintainance was a pivotal concept of preventive medicine in the early twentieth century. For Sir George Newman (first Medical Officer to the newly created Ministry of Health in 1919), contemporary medicine was now entering its 'biological setting'. The concept of the environment possessed a new meaning, more personal and intimate, concerned with the 'life history, heredity, family and domestic life, personal habits and customs' of individuals.[5]

There was of course no sudden abandoning of the principles of nineteenth-century public health policy. The broad programme of environmental medicine remained intact. Health measures enacted at the Local Government Board between 1900 and 1918 extended and deepened state intervention in familiar areas: sanitation, working-class housing, the industrial environment, nuisances, water-supply, and so on.[6] *In corpore sano* (Newman's phrase – the privileging of bodily health) was most visible in broad statements of medical ideology and in the growing debate over national health in Parliament and the press. But it was also present, as we shall see, in a different form in popular and commercial imagery, most notably in the dynamic advertising of the new popular press. In terms of legislation, though, its impact centred on the growing state-medical scrutiny of key individuals within the population – soldiers, mothers, and children. In isolating these groups for surveillance and regulation, the profession was not simply guided by its reformulated medical concepts. Doctors themselves were deeply implicated in broader political struggles in the years before the First World War.

National Efficiency and Imperial Health

State medicine's campaigns for improved military efficiency and health regeneration have usually been loosely attributed to the growing move towards 'collectivism' in the early twentieth century – that growing trend towards the state's involvement in so many areas of economic, political and social life. Medics have been cited as key examples of the modern breed of technical government expert.[7] What is absent here is an account of *why* the profession was able to reassert its position and demand increased representation within the state. This involves grasping the dynamic inter-relation between new scientific knowledge and the much broader public debates over national efficiency and imperial survival.

What were the conditions which made these issues central? In the late nineteenth and early twentieth century the fabric of the mid-Victorian social and political system was shattered by a series of contradictions, from Britain's loss of trade leadership and industrial unrest, to growing socialist and feminist militancy and intensification of anxiety over a whole range of 'social problems'. Each had their own particular history. But their coming together at the level of the state makes it possible to speak of a more general crisis.[8]

The swing over to scientific explanations and the re-entry of the expert into the state apparatus needs to be understood in the light of these larger economic and political events. Medics in particular capitalized on this state of affairs, mobilizing the results of their research as part of their push for increased recognition.

Campaigns to improve the health of the armed forces – thrown up by the military anxieties of the Boer War debacle – were a classic instance of the inter-relation between science and politics. Britain's poor military perfor-

mance sharpened the perceived economic, political and cultural threat to the Empire from other burgeoning nations – especially Germany. Recruitment was the major worry, following the high rate of rejects on the grounds of ill health. More disturbingly, military statistics seemed to confirm the existence of a degenerate underclass of the population which formed a residual pool of infection, locking into studies of the degeneracy of the urban working class by Charles Booth and Seebohm Rowntree.[9] Militarily, the demand was for major reforms in army training which took note of the new developments in hygiene, physiology and nutrition. Capitalizing on the alarm in official circles, the *BMJ* complained that military chiefs had still not learnt the terrible lessons of the South African war. Bacilli were far more deadly than bullets in the battle for imperial survival.[10]

Behind this medical pressure lay a thinly veiled threat – if the state refused to acknowledge its hygienic responsibilities towards the armies of the Empire, the result would be destruction. During the Russo-Japanese War of 1904–5, the *BMJ* noted ominously that the Japanese were capable of great feats of endurance on account of their strict attention to the laws of hygiene.[11] But anxieties were not restricted to official debate. Moments of panic, often orchestrated by the press, provided medics with a popular voice. Dramatic depictions of bacilli and cellular processes with their biochemical reactions generated a vocabulary which fitted well with the codes of popular reporting.

The vision projected by medics themselves was of a militarized conception of health, which could be extended to key civilian groups. Though critical of the aristrocratic amateurishness of senior army administrators, many medics were keenly attracted to the image of a militarily organized society. Their model was of functionally integrated systems and ordered hierarchies, transcending the atomized, petty divisions of party politics. It was a militarism which made good sense to the profession because of its connection with their own medical language where, as in Miss Outram's story, representations of organicism and physiological harmony were pre-eminent, and biology carried an overtly social message.

Beyond the army, it was the schoolchild and the mother who were singled out as targets for intervention. The school system of physical training put forward by the Board of Education in 1902, in close consultation with the War Office, took its impetus directly from military methods. Groups of exercises were designed to strengthen key areas of the body – limbs, trunk, bone-structure, nervous system – in order to promote greater physical efficiency in later life, at work or on the battlefield.[12] But PT was also

seen to deliver distinctive *moral* benefits. For the working-class child correct physical development could help eliminate the immoral effects of a dissolute culture or unhealthy environment, contributing to a gradual improvement of national physique. Disciplined bodies, responding instantly to words of command – this was the image of health and efficiency predominant in civil society as well as in military manuals.

The regime did address girls as well as boys. The board's medical department insisted that PT was a more effective way of improving national health than compulsory military service, because army training began too late and excluded women and girls.[13] The best way of inculcating the laws of health, medics and educationalists proclaimed, was not just through a didactic pedagogy, but by stressing the *pleasures* to be gained from PT. Pleasure was to be produced by the body's systematic conformity to physical norms. As Sir Robert Morant directed in his introduction to the 1909 syllabus:

> The Board desires that all lessons in physical exercise... should be *thoroughly enjoyed* by the children. Indeed, freedom of movement and a certain degree of exhilaration are essentials of all true physical education.[14]

In the debate over motherhood the new scientific concepts derived from physiology and biochemistry also influenced the direction of health campaigning. The declining birth rate was a significant feature of the Edwardian period.[15] And despite a decline in the general death rate for England and Wales between 1851 and 1901, infant mortality had actually increased. By 1900 it was almost as high as it had been fifty years before. Furthermore, as Arthur Newsholme, Medical Officer to the Local Government Board, noted, the birth rate was not declining uniformly; it was most marked among the upper classes, who had more than halved their fertility rate in fifty years.[16]

Medical campaigns around motherhood aimed to shift emphasis away from broad environmental reform and towards close scrutiny of the health of the mother and child. Scientists like Dr John Ballantyre, Assistant Physician to the Edinburgh Royal Maternity Hospital, together with progressive medical officers like Newman and Newsholme, argued that current research into pregnancy and the embryo delivered new methods of tackling the high infant death rate.[17] The demand was for a state-backed campaign to educate women and girls. They were to be prepared for their maternal duties and given assistance to maintain a higher standard of motherhood.

More often than not, the driving force behind this movement was a concern with population politics and racial superiority: a belief that a

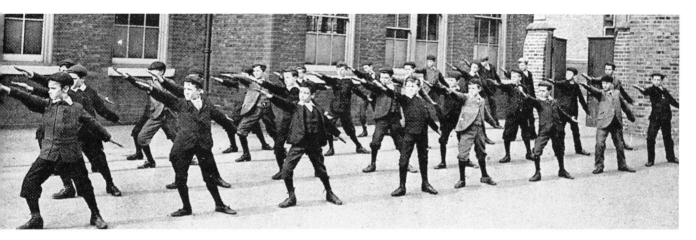

6. *The Board of Education's syllabus of Physical Exercises for use in Public Elementary School* (1909) was meticulous in plotting each stage of the physical regime. Based on army methods, the aim was to develop key target areas of the body – bones, trunk, nervous system. But, as always, they are highly gender-specific.

qualitative improvement in the racial 'stock' as well as a quantitative increase in the birth rate was the key to imperial progress and power. Even Newsholme, who usually avoided the emotive rhetoric of the social imperialists, felt that the choices facing the Empire were stark:

> It cannot be regarded as a matter of indifference whether the unfilled portions of the world shall be peopled by Eastern races, by negroes, by Sclavonic or other Eastern European peoples, by the Latin races, or by the races of Northern Europe.[18]

Racial Health

A further theme in health maintenance was an emphasis on the racial component of national character. From the 1870s theories of racial progress or decline had worked to transform the way physical and moral processes were understood. For social Darwinists like Herbert Spencer, evolutionary theory demonstrated scientifically what earlier social scientists had only grasped in moral terms. The individual and the nation needed to be seen as part of the evolutionary development of the race, through processes which obeyed observable and predictable laws. The rise of the eugenics movement in the early twentieth century crystallized the intellectual and political imperatives of evolutionary biology. Francis Galton had coined the concept of eugenic breeding as far back as the 1880s as the 'study of those agencies under social control, which may improve or impair the racial qualities of future generations'.[19] But eugenics only gained legitimacy and an institutional base in the period before the War. The Eugenics Laboratory, founded in 1907 under the psychologist and social imperialist Karl Pearson, and its rival, the Eugenics Education Society, begun in the same year with its journal *The Eugenics Review*, brought together a broad alliance of biologists, medics, clerics and prominent intellectuals and politicians. Such coalitions were to the fore in the handling of many social issues in the period – workplace conditions, education, sexuality, as well as health.

At the heart of the eugenist strategy lay a sustained attack on nineteenth-century environmentalism in all its forms – medical, charitable, and philanthropic. For early social reformers, human progress or decline had been seen to depend on the constant interplay of the individual's moral faculties and the social environment. Eugenists drew on recent research by the German biologist, August Weismann, to claim that the germ cells which controlled reproduction were distinct and independent of body cells. Hence inherited characteristics could not be modified by environmental factors. The way lay open for a sustained attack on environmentalism.

Environmentalism, eugenists pronounced, was at best a mere palliative. At worst it actively sustained the unfit in their reckless overbreeding. Medical science might mitigate suffering, but by preserving the degenerate it flew in the face of natural selection and the iron laws of heredity.[20] Eugenists concluded that it was crucial to redefine the terrain of social intervention. The site needed to be shifted back to the regulation of life itself; to the study of sound offspring and the elimination of all those 'race poisons' (alcoholism, venereal disease, feeble-mindedness) which were leading to national degeneration. Havelock Ellis, the sexologist, emphasized that henceforward the new aim of social reform was to purify conditions at source – i.e. in the womb.[21] While for Caleb Saleeby, a master of populist rhetoric, concern with race culture stood above politics, cutting across party divisions and pointing the way to national supremacy.[22]

How effective was the eugenic offensive? It is all too easy to get carried away by the rhetoric of race and degeneracy; to slip from looking at the way ideologies were produced to the way they were implemented. Despite a visible presence in policy and public debate, eugenics never achieved the overall hegemony that its advocates hoped for. Eugenists gave evidence to the Inter-Departmental Committee on Physical Deterioration, 1904, as well as to other govern-

ment inquiries into feeble-mindedness, alcoholism, marriage and divorce, and VD.[23] But their explanations of the deterioration of national physique in terms of the reckless breeding of the unfit, and their policies of forced segregation of degenerates and the issuing of eugenic marriage certificates authorizing racially fit unions, were never implemented.

If we look at the medical profession we find deep divisions over eugenics. Proposals by Dr Robert Rentoul for compulsory sterilization of the unfit were thrown out by the British Medical Association in 1904 on the grounds that they were contrary to medical ethics.[24] Yet a number of prominent medics continued to press the eugenic case. At the BMA's annual meeting in 1913 eugenists denounced medics' long-standing but misguided dependence on environmentalism. The *BMJ* intervened swiftly with a lengthy editorial, making the profession's position clear. While acknowledging the supreme importance of physical and moral regeneration for the nation's survival, the journal paraded the BMA's specific brand of social and physiological individualism.[25] The profession could not tolerate the challenge eugenics posed to this form of liberalism, with its stress on the value of each and every human life.

What occurred was not the dominance of eugenics, but the expansion and deepening of medical concepts to include racial and hereditary factors. Few statements on the future of the nation's health failed to reference the dimensions of race and evolution. Human biology was now to be studied as a series of stages in racial progress. The life history of each and every individual needed to be grasped not merely in the context of his/her immediate environment, but as part of a broader racial history.[26]

Such a conception was of course racist, patriarchal and anti-democratic. In practice, the philosophy of racial health involved laying down expert injunctions to the working class and to women on the importance of preserving imperial stamina and physique. This was projected both against other competing 'civilized' nations and against those black and brown races who threatened to 'swamp' the globe with their animal savagery. Britain would advance to a higher stage of civilization via a favourable environment *and* sound heredity, in other words by the harmonious integration of nature and nurture.

Social and Moral Hygiene

In 1917 the eugenist and social purist, the Revd James Marchant, confidently pronounced: 'It is now being fully recognized that all moral reforms for the regeneration of mankind must be brought about by the combination of religion and science.'[27] It was under the banner of social hygiene that medics and eugenists joined forces

with moralists and even some feminists to advance a grandiose and holistic vision of health. The new movement condensed a wide range of competing aims, but two linked concerns were paramount in the early twentieth century. On the one hand there was the new medical discourse, with its reconceptualization of the rules of health and hygiene. On the other, morality and religion claimed the right to be represented as vital components of the new hygiene. The resulting interchange of ideas and expertise forged a distinct alliance between medics and moralists, redefining moral problems and foregrounding a moral emphasis within social medicine.

The medico-moral dialogue was in sharp contrast to earlier antagonisms which had existed between the medical profession and moral reformers. Though the sanitary movement of the 1830s and 1840s had been underwritten by such a coalition, later events had shattered that alliance. Especially significant here was the legacy of the Contagious Diseases Acts. Passed in the 1860s with the aim of curbing venereal disease in the armed forces, the Acts had targeted female prostitutes as the source of infection and subjected them to forced medical inspection and detention.[28] The legislation had provoked a deep split between medics and moralists over how to tackle social problems. Was reform to be promoted primarily via state medicine or through moral solutions rooted in private voluntary initiatives? The rise of the social purity movement in the 1880s had spearheaded the attack on medical aggrandizement, heightened by a feminist critique of the profession. Purity advocated voluntary effort and pressure group tactics, backed by the coercive power of the criminal law to promote morality.

It was the shifting political and social conditions in the years immediately before the First World War which paved the way for a renewed dialogue between scientists and religious leaders, especially those within the established church. The metaphor of science and the sober figure of the state expert were used to attack older, voluntary and 'amateur' approaches to reform. National efficiency campaigners were particularly scathing in their critique of the 'provincial chapel-going radical', who was seen to deal in sectional and petty self-interest at a time when national survival was in question.[29] Along with this negative critique went the emergence of a reformulated moral discourse. Here evolutionary science was fully integrated with moral pronouncements about society's future progress or decline, while religion was rationalist and ethical, much stronger in defence of the established order and much less populist in tone. Old Testament morality, wreaking vengeance on the political establishment, was displaced by imagery of 'the perfect man',

as Dean Inge of St Paul's called him – the 'gentleman' whose overriding concern was with 'his' duties to the state.

Anglicanism provided the largest number of clerical recruits to social hygiene. Marchant, Dean Inge, and Mandell Creighton, Bishop of London, were all prominent hygienists. The Church of England may have found it easier to accommodate the cult of hygienics and efficiency. It had a long-standing concern with problems of authority and discipline and its stronger philosophical tradition made it compatible with the intellectual rigour of hygiene theories.

The reverse side of the coin was the prominence of moral concerns within the medical profession. Eugenically based metaphors lent themselves particularly well to this type of treatment. Hygienists spoke of the need to seize the actual moment when the nerve centres of life were poisoned through degenerate living. Newman's grandiose overview of the history of medical science, published in 1919, made out a powerful case for the totalizing conception of medicine. Although disease was now defined as an internal malfunctioning of the body, its causes included the whole of the social and moral history of the nation.[30]

The creation of the Ministry of Health in 1919 registered a self-conscious application of this language in policy. Under the banner of health education, the Ministry's aim was the creation of an enlightened public opinion. Sanitary legislation could only go so far in monitoring personal health. What was vital was a popular movement, stressing the individual's own ethical responsibility to observe the rules of hygiene.[31] Equally, voluntary initiatives like the People's League of Health, founded in 1917 under royal patronage, proclaimed: 'A Nation's Health is a Nation's Wealth.'[32] Popular pamphlets pointed to the inevitable *moral* consequences for those who broke the laws of health: 'nature knows nothing about "Forgive us our trespasses" . . . she demands payment for every one of her laws which is broken.'[33]

Feminist Responses

There was one further and perhaps surprising input into the social hygiene alliance – namely feminist and women's organizations. In the Edwardian period health sub-committees and working parties sprang up in many women's groups and suffrage societies, including the National Union of Women's Suffrage Societies and the Women's Freedom League, together with older philanthropic bodies like the National Union of Women Workers, an offshoot of the Ladies' Association for the Care of Friendless Girls formed in 1895. At one level, the interest in health was a testament to a burgeoning women's culture, which confidently asserted

the right to debate all social issues. But for some, especially the Ladies' National Association (LNA), veterans of the campaign to repeal the Contagious Diseases Acts, state medicine was still viewed with deep suspicion. The sticking point for feminists was the continuing legacy of the Contagious Diseases Acts. The fear was that the medical profession were still sunk in a 'blind materialism', promoting science without morality at women's expense.[34]

Yet gradually even the purity wing of the feminist movement began a tentative rapprochement with social hygiene. The changed medical stance on VD (its redefinition as a civilian rather than a military problem and the abandoning of enforced regulation of prostitutes as the central strategy) paved the way for a partial reconciliation between purity feminists and medics. As Blanche Leppington, a purity feminist, put it cautiously in 1902, provided doctors recognized the absolute centrality of moral self-control of the instincts then 'the microscope need not be despised'.[35] Over the next decade journals like the *Shield* of the LNA recorded an ongoing debate between old-style moralists and younger, often newly professionalized women, who held out the hope of a more rationalist approach to moral reform. Helen Wilson, the paper's editor, was herself a trained doctor. When in 1913 Alison Neilans of the LNA announced that 'we and our former antagonists can work cordially together', Wilson explained that the olive branch was the result of a change of heart among the medics.[36] The readership was offered a vision of the new Hygeia – a sanitized cosmopolis governed by health-giving purity and the sanctity of family life.[37]

Feminist responses to social hygiene were rarely unambiguous, partly because physiology and evolutionary biology were so powerful a mainstay of anti-feminist campaigns. But these concepts did provide women with categories of self-definition around which to mobilize, negotiate and occasionally disrupt and claim as their own. For many, like Miss Outram at Dronfield, the language of national health – like social purity before it – was used to advance women's influence in the social sphere. For others it enabled them to hold their own in the face of calls from male experts for a greater professionalization of the field. For the *Vote*, paper of the Women's Freedom League, the woman of the future would be far more than a nurse or a consoler, she would have a positive religion to realize as a high priestess of health.[38] Alice Ravenhill and Mary Scharlieb, themselves both doctors, insisted that biology conclusively proved that responsibility for safeguarding the nation's morals lay with women. For Scharlieb it was women's unique position as reproducers which made them so central to the physical and

moral training of future generations,[39] while Ravenhill saw the revelations of medicine and eugenics pointing to an enhanced position for women, not only as mothers, but as guardians of those aesthetic qualities which made for physical, intellectual and moral progress.[40]

The alliance of some purists and moderate feminists with the medical profession contrasts with the ongoing hostility displayed by many. The militant wing of the feminist movement did consciously draw on science, but to extend and deepen their attacks on men. As Lucy Bland shows, Christabel Pankhurst's *The Great Scourge* (1913) used medical authorities and statistics instrumentally to win specific arguments, while distancing itself from what was seen as the corrupt power of male professionals.

Frances Swiney's medical polemic was even more extensive, claiming women's innate biological and mental superiority over the rest of creation. Her own career was remarkable. President of the Cheltenham Branch of the National Union of Women Workers, she had been brought up in the colonial culture of India and was married to a senior military figure. In her fifties she began developing an elaborate theory about progress towards a matriarchal society. In a dazzling subversion of medical and eugenic theories she insisted that women, as the reproducers of life, were 'the centre of gravity of the whole biological system', while man was becoming more and more superfluous.[41] Darwin and Spencer had been wrong to argue that women were in a state of arrested development. Man was the immediate form. The shape of woman's face was far in advance of that of man; in the number of teeth they were leading evolution; they had more grace and more perfect physical beauty. Challenging the biologists Patrick Geddes and J.A. Thomson, Swiney pointed out that 'femaleness' was due to the presence of a chromosome *absent* in the male. Hence women displayed a more complex cellular composition, which was the positive force behind reproduction, whereas the katabolic or destructive male cells led to racial disintegration.[42] Current panics by eugenists and social reformers over national decline were misplaced in blaming the mother. It was *men* who were the cause of racial decay. In language which coupled moral outrage with a conceptual grasp of eugenics and the new biology, Swiney drew together the major problems – disease, feeble-mindedness, degeneracy, insanity – to expose male vice as the root of national decline.

Swiney's feminist hygienics and Pankhurst's medical polemic were part of a broader strategy aimed at curbing men's immorality. But the fact that these arch-opponents of male professionalism now referenced concepts of social hygiene, albeit in subverted form, was a measure of the changing language of feminism. It

testified to the growing power of the medical alliance and its ability to force a dialogue with competing political forces.

Popular Imagery

All of which is very much about the vision of health put forward by those inside the state, or by feminists who challenged these images through organized political and public debate. But what about the impact of the new hygeia on those who stood wholly outside this power-bloc? What was its impact on popular culture and on the working class? We cannot of course answer this question conclusively here, but by taking one area of popular culture, namely the images of health in commercial advertising, we can begin to gauge some of the effects of the new health politics.

More visible and dramatic advertising was itself part of major changes affecting the popular press from the 1880s onwards. Larger-scale capital investment, national distribution and technical development in the printing industry (making possible bolder layout and, in the Edwardian period, the use of photographs) were some of the other transformations. Commercial advertising drew on many of these new techniques, both culturally and economically. For it was in the newly formed monopoly companies – the result of mergers of smaller family businesses – that advertising and marketing figured prominently. The plethora of adverts in the Edwardian popular press for almost every domestic product from Bovril to corsets reflected the efforts of British manufacturers to deepen their appeal to the home market, and especially to the working-class consumer.

In a period when medical treatment was private and expensive, adverts for patent medicines, potions and invigorating tonics loomed large in the advertisers' brief. A survey of their vocabulary gives something of the flavour of their 'campaigns':

38. Eugene Sandow, Swedish exponent of 'physical culture'. His exercises were designed to promote physical health and beauty, and carried a popular message of self-help and medicine. They were serialized in the *Daily Mirror* in 1909.

39. Advertisements from
ynolds News. British
rary (Newspaper Library).
e illustrations accompany-
g advertisements for patent
edicines drew on two
stinct visual techniques.
ne was to use a popularized
ientific language, as in the
eno's' drawing of the nasal
ssages, which carried an
timistic comment on
entific progress. The other
s to employ the conven-
ns of popular melodrama
th lurid depictions of the
set of the disease or the
raculous cure.

'The Gymnasium at Miss
echase's Academy', a scene
m The Dairymaids, Apollo
eatre, London, 1907. Man-
r and Mitchenson Theatre
llection. Discourses on
alth crossed into the West
d theatre. The Sandow Girls
ercising in the gymnasium
ng:
For improvement of the
ure and deportment
For conducing to the cult of
ce and vim
There's nothing like an
-to-date assortment
Of exercises practised in
 gym.
We are bent upon the study
the graces
And pursuing them with
ergy and zest,
For tho' fortunes have been
d to lie in faces,
Tis in figures they are apt
be expressed.

VITALOIDS
The World's Best Nerve Tonic.
Are you Weak and Nervous?
Are you Melancholy and Depressed?
Are you Lacking in Vim, Vigour, and Vitality?
Try one box of VITALOIDS and you will be as-
tonished how quickly your troubles will vanish;
how your digestion will improve; your spirits
grow brighter; your strength increase; your
Nerves be soothed; how your whole System will
be braced up and invigorated.
(*Reynold's Newspaper*, 6 January 1907)

Ladies, Try the INVIGRO Body Brace FREE
Improve Your Figures
The INVIGRO Body Brace is a marvellous new
invention for perfecting the figure and relieving
Internal Pains, Lassitude, Backache, Headache,
Indigestion, Melancholy, Lung Disease, Consti-
pation, and many other ailments with which
your sex is afflicted
(The *Daily Mirror*, 5 January 1909)

Don't Look Old! Preserve Your Appearance
Keep your situations
Lockyers Sulphur Hair Restorer
Darkens in a Few Days
(*Reynold's Newspaper*, 13 January 1909)

What is so significant about these captions is
the way they took up, negotiated and at times
contested the official images of health circu-
lated by medics and moralists. There was no
simple process of osmosis, where dominant im-
ages filtered down to popular culture. Rather,
official languages were continually transformed
and reworked by the popular media.

Take the metaphor of science so dominant in
state medicine. Commercial advertising cer-
tainly celebrated its own romance of science.
Consumers were invited to sample 'Veno's Light-
ning Cough Cures' or 'Coleman's Nerve Pills' via
a snap lecture on the lungs or the nervous sys-
tem. Readers were told about the wonders of the
human body by way of comparisons with other
scientific dramas like electricity or the tele-
phone: 'the brain is the central nerve exchange
and to and fro are flashed the thousands of mes-

sages of wants and requirements of every organ
of the human body'.[43] Visual illustrations graphi-
cally displayed sections of the human anatomy
as in medical textbooks, while the guarantee
that remedies were 'medically approved ' was
stamped on almost every cure.

Yet this optimistic commitment to scientific
progress jostled for space with other, more con-
tradictory, messages. Notions of self-help
medicine along with a strong suspicion of medi-
cal power also ran through the advertising brief.
'Away with harmful drugs', proclaimed the man-
ufacturers of Peps, 'the nasal breathing cure for
Coughs, and Colds and Chest Ailments'. An
angry letter to the *Daily Mirror* in 1909 put the
case for greater frankness on the doctor's part
when dealing with patients, including the scrap-
ping of medical Latin: 'Why am I to be treated as
a Child when I consult a doctor?'.[44] Readers of
the popular press were at times encouraged to
put their faith in the commercial marketplace
rather than in medical experts as far as health
was concerned, because at least patent
medicines were free from those mystifying
power relations involved in a consultation at the
doctor's surgery. In 1907 *Reynold's Newspaper*
reported on 'The Disappearing Doctor', who,
they claimed, was being replaced by popular
medical handbooks in the treatment of ordinary
ailments.[45] Eugene Sandow, the Swedish expo-
nent of physical culture and exercise, was the
most prominent advocate of self-help cures in
the Edwardian period. Sandow's course 'Health
without Medicine', advertised in The *Daily Mir-
ror* throughout 1909, set out a regime of muscle
training and physical development which re-
quired no drugs and no medical treatment.[46] His
immediate aim was 'the curing of definite bodily
ailments and maladies'. But Sandow projected a
long-term vision of a graceful physical culture
which was billed as 'a social necessity' to
women and 'an advantage in social and busi-
ness life' for men.

We have come a long way from Dronfield
school and Miss Outram's health education
teaching. But now we can see how her project
was part of a wider national scheme. In the early
years of the twentieth century the metaphor of
health figured prominently in public debate,
crossing many areas of social policy. It was sup-
ported by a broad series of alliances and espe-
cially by the voice of medical knowledge and au-
thority. Campaigners looked increasingly to-
wards the state to enact their demands, and the
period sees the foundation of many features of
modern state medical provision. But we should
beware of reading this as a smooth story of med-
ical progress and social enlightenment. Despite
real gains, the new hygeia was shot through with
many of the power relations which marked Ed-
wardian society. In the ongoing romance of sci-
ence those inequalities have not gone away.

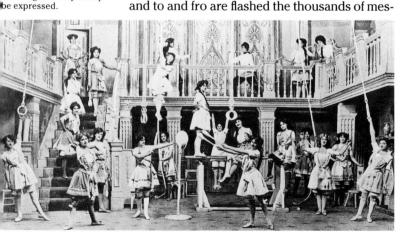

IRELAND

W. A. Maguire

Ireland was politically quieter, socially more progressive and economically no less prosperous during the reign of Edward VII than in the decades before or after. In politics the Home Rule party, reunited under the leadership of John Redmond, was faced first with five years of Conservative rule (when there was no hope of home rule), then with five years of a Liberal government so strong in the House of Commons that it had no need to rush to keep its Irish promises. In any case, until 1911 the House of Lords had the power – and the will – to veto any such attempt. So Redmond and his Nationalists, unchallenged as representatives of Catholic Ireland and committed to parliamentary politics, bided their time.

This state of political calm was more apparent than real. While the Home Rulers controlled most of the seats in Ireland as a whole, the opposite force – Unionism – was firmly entrenched in the north and had powerful allies in Britain. So long as home rule remained only a promise (or a threat), the Unionists also bided their time, but they were already well prepared to mobilize opposition to it. At the other end of the political spectrum, too, the position of the Nationalists was challenged by groups which in varying degrees favoured separation from Britain, if necessary by physical force. The common background to these groups, whose appeal at this stage was limited to intellectuals and activists, was the combined influence of three things: the Anglo-Irish literary movement (W.B. Yeats and others) which revived and romanticized the ancient legends and history of Ireland; the Gaelic League (Douglas Hyde), which sought to preserve and revive the use of the Irish language; and the popular Gaelic Athletic Association. All three contributed powerfully to the 'de-Anglicization of Ireland' that Hyde had proclaimed as the aim of the League in 1893. To this cultural movement Sinn Fein (Ourselves Alone) added a political element, though Sinn Fein was as yet – like its founder Arthur Griffith – small, enigmatic and only potentially dangerous. More actively extreme was the revived Irish Republican Brotherhood. Though none of these movements made much impression on the country at large so long as the moderate Redmond seemed likely to achieve his moderate aim, the Boer War revealed (or confirmed) the existence of a considerable reservoir of popular feeling hostile to the British Empire (again, it was quite otherwise in Ulster).

The land question, for so long a major cause of unrest, was actually solved during these years by George Wyndham's Land Act of 1903, which provided funds to enable tenants to buy their farms and made it worth while for landowners to sell by giving them a substantial bonus on top of the agreed price. Already, the Ascendancy class had lost its hold over local politics as a result of an Act of 1898, which took power from the county grand juries and gave it to councils elected by the ratepayers. These democratic bodies, with their majorities of Catholic farmers and shopkeepers, soon became as much bywords for corruption as their predecessors, but they did much to alleviate another old social problem by building large numbers of labourers' cottages in the countryside.

The establishment of University College, Dublin, in 1908 largely satisfied the Catholic desire for an alternative to Trinity College, while the growth of farmers' co-operatives was a sign of rural progress. Other advances, such as old-age pensions and improvements in the treatment of children, were the result of Westminster legislation for the whole kingdom, just as agitation in Dublin and Belfast for women's suffrage was the local manifestation of a national movement.

The two great Irish conurbations also shared with other British cities social problems such as poverty, overcrowding, homelessness, crime and prostitution – and fierce conflict between employers and unskilled workers. Dublin especially, its traditional craft industries largely destroyed by competition and the effects

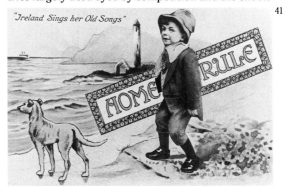

"Ireland Sings her Old Songs"

HOME RULE

41

41. A Home Rule postcard, c.1908. Ulster Museum, Belfast. The old Ireland is symbolized by the round tower, wolfhound and emigrant ship, the hopes of a new Ireland under Home Rule by the boy and the rising sun.

42. Poor children, Belfast, c.1902. Ulster Museum, Belfast.

43. The mould room, Belleek Pottery, County Fermanagh, c.1902. Ulster Museum, Belfast. A rare example of successful rural industry.

44. The Irish delegation, women's suffrage march, June 1908. Photographed by Christina Broom. Museum of London.

45. Street market, Patrick Street, Dublin, 1914. Ulster Museum, Belfast. Some of the worst slums in the city were in this area.

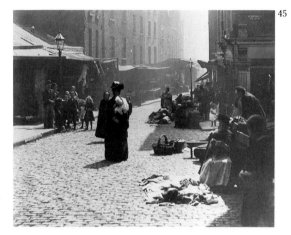

of a stagnant economy, suffered from dreadful poverty cheek by jowl with affluence, and had the worst housing and the highest death rate of any city in the British Isles. Nearly a quarter of its population lived in rotten one-room tenements, an average of six to a room. If all unfit housing had been condemned and closed, 60,000 people would have been homeless. This state of affairs was partly due to the power of some members of the corporation who were slum landlords, but the basic problem was the poverty of a large population of unskilled workers who were frequently unemployed. Unlike Belfast, Dublin had few firms employing large numbers. Guinness's brewery, an exceptional success, had a capital value of £5 million but employed only 2,000 workers. In contrast, the York Street Spinning Co., capital value half a million, had 4-5,000. Furthermore, wage levels in Belfast for skilled workers compared favourably with those across the water, whereas they were generally low in Dublin.

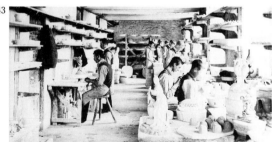

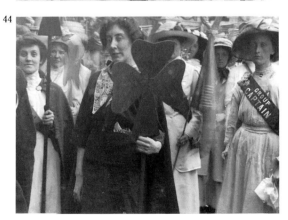

The contrast between wealth and poverty was therefore less extreme in Belfast, where, in addition, the many skilled workers shared the attitudes and beliefs of their middle-class employers. Their pride in the city's industrial and commercial success found expression in the building of a splendid new City Hall. Public health improved to the point where a man could live three years longer in Belfast than in Dublin (Dubliners doubted that any sane man would wish to). The dark side of the picture – apart from the literal pall of smoke that hung over the place and begrimed its buildings and its inhabitants – was most obvious in the wretchedness of unskilled workers, among whom were many of the city's Catholic minority (just under a quarter of its population). For them, hours were long (carters worked a 68-hour week), wages low, employment irregular. The great strike of dockers and carters in 1907, led by James Larkin, was a bitter affair; large numbers of troops had to be drafted in to keep order. For a time Protestants and Catholics made common cause, despite the efforts of some employers to separate them, but it was not long before the sectarian suspicion and hatred that caused someone to describe the population as consisting of 'well-to-do bigots and bigoted rowdies' resumed their sway. The papal decree of 1908 concerning 'mixed' marriages did not help matters. Competition for jobs and – as Edward's reign ended – the approaching climax of the home rule struggle raised the temperature to boiling-point.

LONDON

Jane Beckett and Deborah Cherry

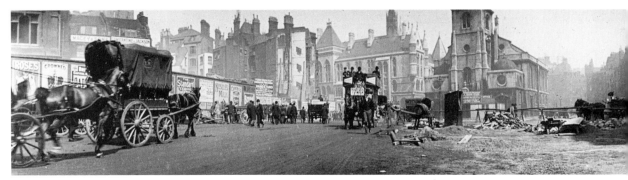

The claim in 1908 that London was 'not only the largest but one of the finest cities in the world' (*Baedecker's Guide to London*, 1908) was affirmed in the rebuilding programme during the Edwardian period: the massive Strand improvement scheme and reconstruction of the West End; the building of new Government offices in Whitehall, linked to the approach to Buckingham Palace via Admiralty Arch; and the completion of Westminster Cathedral. In 1911 over 6½ million people lived in 'Greater London'. The severe poverty and overcrowding in the inner city areas contrasted during Edward's reign with the growth of the 'outer ring' of the city to the east, north and south-west, where the population increased by 45.5 per cent.

Central to this development was the rapid growth of a cheap public-transport system. The electric underground was extended to the north, and the inner systems electrified, served by Lots Road power station, Chelsea (1902–5). These were linked to a tram and bus network. The new systems gradually replaced the horse-drawn cabs and buses, and their related jobs in grooming, stabling and handling. To the east, the Great Eastern Railway was expanded, providing work and homes for employees and rapid communication for clerks commuting to the City of London. Middle-class owner-occupied houses in the suburbs were purchased by families on an income of £150-£200 per annum, who frequently employed a maid of all work on an annual salary of £16. Roller-skating rinks and cinemas were built there, rather than the music-halls and pubs of inner London. Although the development of the suburbs was welcomed as a solution to inner city congestion, the

problems associated with their unplanned sprawl were fiercely debated within the Progressive and Moderate administrations of London's governing body – the London County Council (LCC). The popular press, and liberal social reformers who worked in inner city settlements and in men's and women's clubs among the urban poor, constructed an image of a divided London. A dark, often fog-bound centre – rife with the dangers of 'hooliganism' (crime), disease and poverty – was set against the image of a bright, healthy, suburban life. The inhabitants of the inner city were often politically active, with strong traditions of working-class organization and unionism,

47

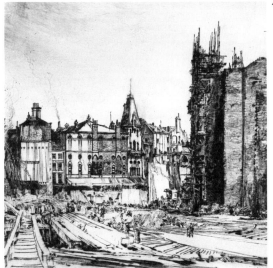

46. Aldwych and Kingsway, c.1903. Kodak Archive, National Museum of Photography, Film and Television, Bradford.

47. Muirhead Bone. *The Old and New Gaiety Theatres*. c. 1902-3. Hunterian Art Gallery, University of Glasgow. The picture shows demolition for the Strand-Aldwych redevelopment scheme.

48. Map of Holborn, c.1900, showing the area to be cleared for the building of Kingsway.

49. Tenants evicted from overcrowded inner city areas as they were cleared for rebuilding, 1902.

50. Muirhead Bone. *The Great Gantry, Charing Cross Station*. 1906-7.

visible in mass demonstrations on London's streets and in the formation of the Independent Labour Party, the Social Democratic Federation and the Clarion movement. There was a strong Socialist presence on the LCC.

But the suburbs were not solely inhabited by the middle classes. From 1900, the Progressive administration of the LCC began to build cottage estates in north and south London. In the private sector, many new villas were built for two-household occupation, one family on each floor. The 'Workmen's Ticket' on public transport increased the mobility of the working class.

For many, however, mobility was not an option. Low wages, casual, sweated or unskilled labour and the need for market porters, costers, flower sellers, dockers and home workers to be near their work, meant that they had to go on living in the overcrowded, high-rent inner areas. 'Those who can afford it move out and those who cannot escape crowd in,' Charles Booth noted in the *Survey of Life and Labour in London* (1887-1903). Here was a population of many races and creeds, maintaining their own cultures and institutions, and often claiming their 'own' areas of London – the Chinese community in Limehouse; the long-established Jewish com-

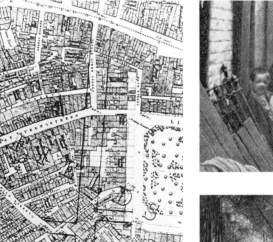

49

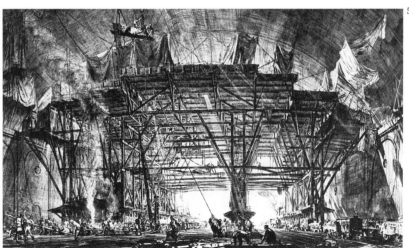

50

51

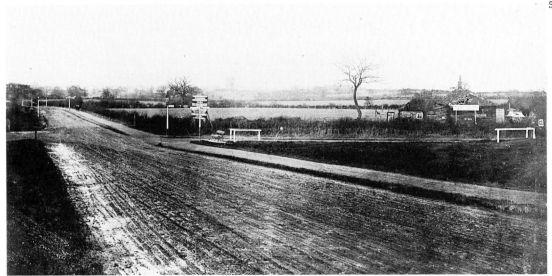

52

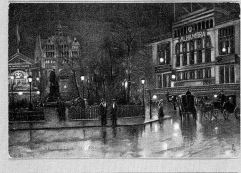

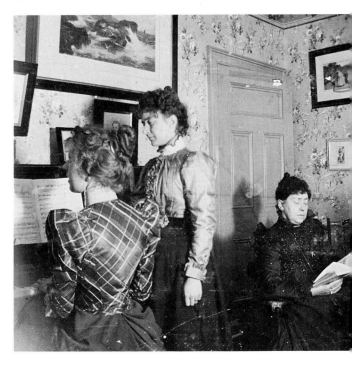

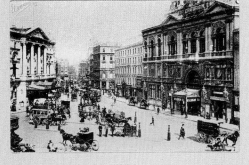

51. The junction of North End Road and Finchley Road at Golders Green in 1904. London Transport Executive.

52. Picture postcards of Battersea Park; Leicester Square showing the Alhambra Music Hall; and Piccadilly Circus. Private collection.

53. Women in a drawing room, c.1900. Kodak Archive, National Museum of Photography, Film and Televison, Bradford. Evening entertainment in the new suburbs, gathered round the upright piano. The Musical Home Journal published scores for home entertainment and a range of sheet music was available from the many musical publishers.

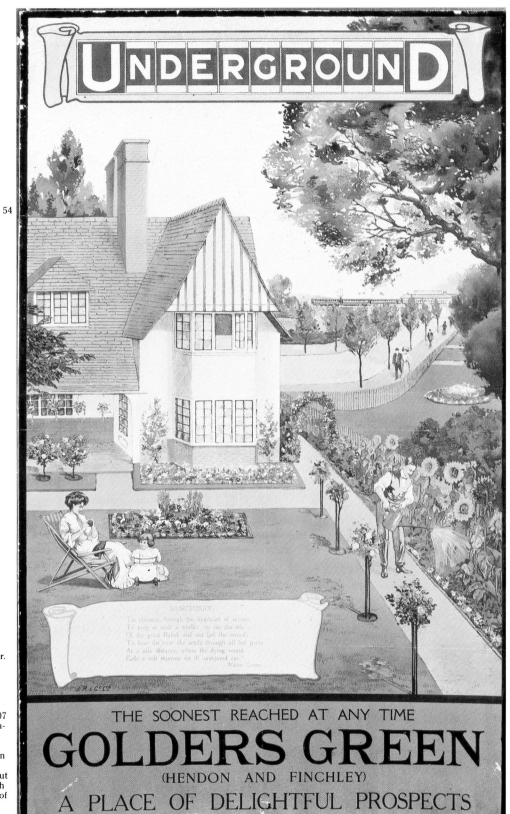

54

UNDERGROUND

SANCTUARY

'Tis pleasant, through the loopholes of retreat,
To peep at such a world; to see the stir
Of the great Babel, and not feel the crowd;
To hear the roar she sends through all her gates
At a safe distance, where the dying sound
Falls a soft murmur on th' uninjured ear.'
William Cowper.

THE SOONEST REACHED AT ANY TIME

GOLDERS GREEN

(HENDON AND FINCHLEY)

A PLACE OF DELIGHTFUL PROSPECTS

4. *Golders Green*. 1908.
London Underground poster.
London Transport Museum.
American investment
financed the Underground
Electric Railways between
Charing Cross and Golders
Green between 1902 and 1907
into what had been an exten-
sive tract of open country
north of Hampstead Heath.
The suburb of Golders Green
was rapidly developed by
speculative builders, who put
up a cottage house type with
tiled roof, irregular patterns of
windows and gables, and
casement rather than sash
windows.

55. William Rothenstein. *Jews Mourning in a Synagogue*. 1906. Courtesy of the Trustees of the Tate Gallery, London. From 1904 Rothenstein made a series of drawings and paintings of the Machzike Hadaas Synagogue in Spitalfields. This painting was presented to the Tate Gallery in 1907 by Jacob Moser, JP, in the name of the Jewish community and in commemoration of the Jewish exhibition at the Whitechapel Art Gallery in 1906.

56. Nellie Joshua. *Heatherley's Art School*. c.1902. Private collection. Heatherley's, in London, was one of the most popular private art schools of the mid-nineteenth and early twentieth centuries. Art training was available to women here.

57. Aerated Bread Company's Depot, Ludgate Hill, 1902. ABC, Lyons and Express Dairy tea rooms provided essential light refreshments for city employees and West End shoppers.

munities in the East End, now increased by the recent pogroms against Jews in Russia and Poland; French, German and North African settlers in Soho; and Italians in 'little Italy' in Holborn. Many households lived in one room in four-storey houses, with shared water and drainage. A massive road-building scheme had been initiated in the 1880s, with the reconstruction of the Thames Embankment, Charing Cross Road and Shaftesbury Avenue and the realignment of Piccadilly Circus. These schemes, and the twenty-eight acres cleared for the Strand and Kingsway routes, destroyed old working-class communities and dispersed the inhabitants, either into other already overcrowded areas or into the LCC model dwellings which were built to replace old housing. One of the effects of the clearance was to contain the areas in central London used for prostitution, so that they became centred near the music-halls and theatres of Leicester Square. Right beside these dense, overcrowded working-class communities was London's West End, formed by new buildings organized around middle-class pleasures and business – The Piccadilly Hotel (1909); the Ritz (1903); the Cavendish Hotel, which was run by Rosa Lewis and patronized by King

55

 58

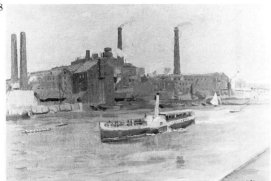

58. Harold Gilman. *The Thames at Battersea*. 1908. Kirkcaldy Museums and Art Gallery. Gilman's painting of the Thames shows the changing function of the river during the Edwardian period. On the south bank of the river are the chimneys of Nine Elms Pumping Station, but on the river there are pleasure craft and a paddle-steamer rather than the working barges and lighters of the London docks.

59. The Embankment. 1900, Kodak Archive, National Museum of Photography, Film and Television, Bradford.

60. Shipyard workers arriving at the Thames Ironworks, Blackwall, c.1908. Museum of London. The Thames Ironworks at Newham continued to build ships until 1912.

Edward; the Royal Automobile Club (1903); and the Grand Canadian Trunk Railways building (1906). There were also new department stores and shops, restaurants and cafés, and theatres and music halls. These developments provided employment for men, as skilled and casual labour in the building programme, in the construction of the new transport system and in road cleaning and sweeping. There was also work as waiters, cooks and servants in hotels and in the furniture trade. Women worked as waitresses, maids and servants, as shop assistants and in the manufacture of clothes. London's West End signified consumer pleasures, by day and by night.

The port of London was of central importance to Britain in the handling of goods necessary to international and colonial trade. In the Edwardian period the main shipbuilding industries were lost to the Clyde and the Mersey, but skills from shipbuilding were diversified into two new industries central to the formation of London as a modern capital – electricity and mechanical engineering. Cranes and mechanical unloading equipment were built and operated by men employed in the docks. As the Thames waterway was too shallow and its docks too narrow for the new large vessels, skilled lightermen and barge handlers unloaded cargo for storage in the new warehouses. Those at Shad Thames and Wapping distributed grain; cold stores at Millwall handled meat and butter. Women worked in the growing food industries in the dock areas. To facilitate travel for men and women to work in the dock areas the LCC constructed tunnel links under the river at Blackwall (1897), Greenwich (1902) and Rotherhithe (1905).

The LCC, unlike other municipal authorities, did not run London's services – gas, water, electricity – or have control of London's docks. From 1904, however, the LCC became the local education authority for London's schools, polytechnics and art schools. It administered London's parks and open spaces and its sewage and drainage, and it ran the fire-brigade and tramway system.

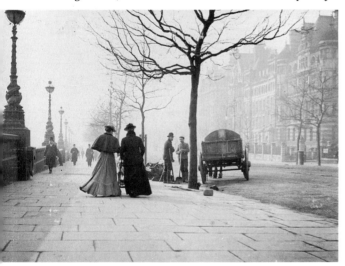

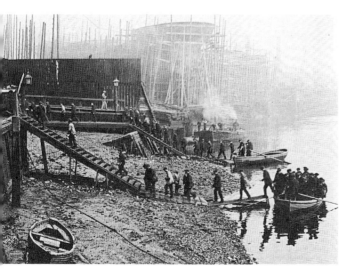

THE MUSIC-HALL

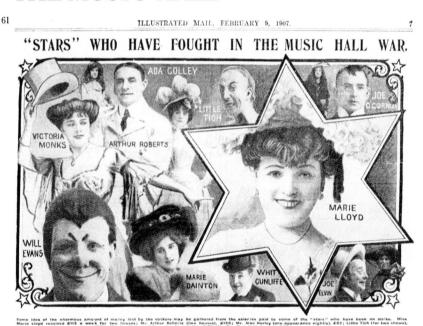

61 ILLUSTRATED MAIL, FEBRUARY 9, 1907. 7

"STARS" WHO HAVE FOUGHT IN THE MUSIC HALL WAR.

ADA COLLEY

VICTORIA MONKS

ARTHUR ROBERTS

LITTLE TICH

JOE O'GORMAN

MARIE LLOYD

WILL EVANS

MARIE DAINTON

WHIT CUNLIFFE

JOE ELVIN

Some idea of the enormous amount of money lost by the strikers may be gathered from the salaries paid to some of the "stars" who have been on strike. Miss Marie Lloyd received £115 a week for two houses; Mr. Arthur Roberts (two houses), £150; Mr. Alec Hurley (one appearance nightly), £85; Little Tich (for two shows), £150; Mr. Joe Elvin and Company (two halls), £175; Mr. Gus Elen (one house), £40.

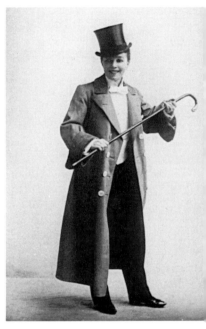

63

61. 'Stars who have fought in the Music Hall War'. *Illustrated Mail*, 9 February 1907. The Variety Artists' Federation was formed in 1906 and the following year, in conjunction with the National Association of Theatrical Employees and the Amalgamated Musicians Union, it entered a fierce struggle with the music-hall managers over pay and conditions.

62. An Edwardian postcard of Vesta Tilley, the music-hall artist who specialized in male impersonations.

63. Cartoon. *The Performer*, 27 December 1906. The syndicates of Moss and Stoll established large chains of music-halls throughout the country, standardizing the entertainment and controlling the artists' contracts and work.

64. A music-hall gallery, 1902. Music halls throughout Britain had huge nightly audiences. The entertainment was made up of differing 'turns' and, increasingly, featured the bioscope or early cinema. The architecture of the halls, combined with the variety of ticket prices, segregated the audience into different areas, providing separate bars, walkways and staircases.

65. Spencer Gore. *Stage Sunrise, The Alhambra*. 1909-10. Private collection (courtesy Anthony d'Offay Gallery).

43

BLACK ENTERTAINERS

Ziggi Alexander

The cultural impact of the Black presence in Britain has received very little attention from historians, although contemporary sociologists and the media have given some coverage to post-war Black artistic expression.

Long before the Black performer was a truly established phenomenon in Europe and North America, entertainers of African descent were in evidence in European courts, pageants, travelling shows, on stage and as part of army and street bands. The African's early association in the European mind with the exotic and evil sometimes had the advantage of allowing the more skilful and talented to develop their art with much less hindrance than ambitious Black women and men usually had to suffer.

In *Handel's Kettledrums and Other Papers on Military Music*, Henry George Farmer cautions that:

> It should not be forgotten that negro drummers not only gave a tremendous fillip to regimental music . . . but it was their contribution in this so-called 'Turkish music' that opened the eyes of the great composers, beginning with Mozart and Beethoven, to the possibilities of a new tone colour and fresh rhythmic devices in the wider realm of orchestral music.

Farmer's lack of cultural chauvinism allows us out of the traditional realm of the 'dark continent' motif into the rich province of transcultural exchange. Another example, taken from legitimate theatre, highlights individual rather than group accomplishment. Marshall and Stock, in their biography of the Black Shakespearean actor, Ira Aldridge, confirm, with more than one illustration of the process, this transcultural activity. One chain begins with the Victorian Aldridge's work with the Meininger Drama Company and ends with Stanislaus Stanislavsky:

> In 1878 the Meininger Company, which had already become famous, came to London and earned great acclaim, then to Moscow, where it influenced the young Stanislavsky, and so the ripples of reform spread – the initiation of some of which may be attributable to the Chevalier Ira Aldridge, Knight of Saxony.

These links were rarely acknowledged, and with few exceptions, most notably the composer/musician Samuel Coleridge-Taylor (see pp. 48-9), the Black artistic community was segregated and restricted by the designation 'ethnic art'. Commenting on an act playing at the Palace Theatre, London, in 1905, the *Era* reflected the prevalent view:

> Grotesque comedy is more effective when accompanied by a black face, as it is in the doing of Ford and Wilson, one of whom presents a capital sketch of a negro dame given to vanity and lace petticoats, and each ever ready with amusing quips. The coon is as inevitable as rag-time.

The 'coon' was an invention of the Euro-American. Supposedly based on the antics of the 'plantation negro' and credited with the dubious accolade of being the USA's first independent theatrical form, black-face minstrelsy was popular with British audiences even into the second half of the twentieth century. For Black performers and music-hall goers, entertainment and amusement were not without cost. Paradoxically so, since for the artist it provided a source of scarce work, and seeing fellow Africans on stage gave Black audiences a sense of race pride. Yet both groups were also aware that harmful racial stereotypes were continuously reinforced. Although White professionals dominated minstrelsy, there was interest in seeing Black performers on stage. The *Era* records at least five acts in 1901, four in 1905, and one in both 1906 and 1907. The 'idol of the Music Halls', James Bland, was reputed to have earned £10,000 in 1900 alone.

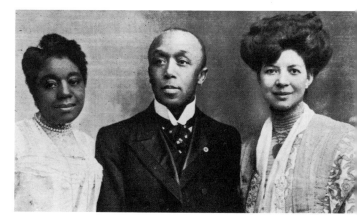

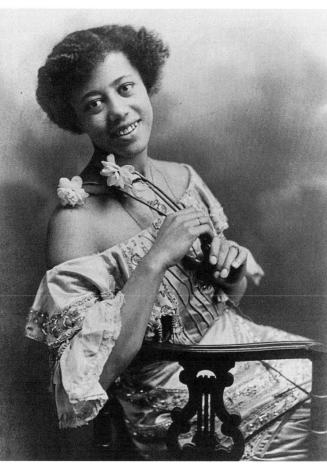

66. The Fisk Jubilee Singers.
Private collection.

67. Miss Rossiter Billie.
Private collection.

68. Bert Williams and George
Walker.

the show drew the following ecstatic response from
one critic:

> Negro entertainments in this country have been
> associated almost invariably with coon songs,
> cakewalks and plantation walkrounds. It is . . . a
> really fresh and novel experience to introduce to
> the jaded experience a . . . musical comedy that is
> not only played throughout by real coloured
> people, but written and composed by clever and
> able representatives of the negro race . . . We have
> had coon comedians both of the real and burnt cork
> variety on this side before, but funmakers of the Wil-
> liams and Walker type are rare indeed . . . 'In
> Dahomey' with its wonderful vitality, its quaint
> comedians, its catchy music, and its unique envi-
> ronment, should be one of the dramatic sensations
> of the London season.

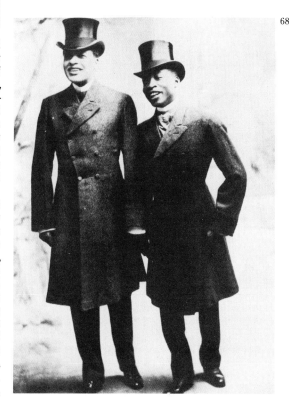

68

The 'novelty' act at the turn of the century included
Black children or 'piccaninnies'. In 1906 the singer
Eva Taylor faced her first audience, aged 2½, as part of
the Black child chorus backing the White American,
Miss Josephine. Meanwhile at the Empire Palace, Eal-
ing Broadway, *Virginia and Piccaninnies* were billed
as 'genuine coloured boys and girls' (as opposed to
'Tray and Rich the Black and White faced' comedy
team appearing on the same night). Another child
star, better known for her contribution to jazz, was
Arabella Fields, who in 1909 appeared as 'Belle Field
and Piccaninny' at the Shepherds Bush Empire.

Whilst music-hall provided work for the vast
majority of Black performers, others succeeded by
different means. In 1903, the Black American show *In
Dahomey* was staged at the Shaftesbury Theatre. The
company comprised over one hundred members,
with Bert Williams and George Walker in the principal
parts. So successful was this break from the minstrel
convention that on 23 June 1903 members of the cast
were invited to perform at Buckingham Palace during
the garden party held for the ninth birthday of the
King's eldest grandson, Edward (later Prince of
Wales), and in 1904 the No.2 Company came to Britain
to tour the provinces, with male leads Avery and Hart,
and Stella Hart as the female star. Composed by Will
Marion Cook, with lyrics by Paul Lawrence Dunbar,

Members of the cast of
In Dahomey. 1903.
69. Miss Aida Overton Walker,
70. Miss Rhoda King,
71. Miss Birdie Williams,
72. Miss Ida Gigas. Mander
and Mitchenson Collection.

The *Weekly Despatch* described the impact *In Dahomey* as follows:

> The talk of the theatrical town is undoubtedly of the novel entertainment now being offered at the Shaftesbury Theatre, in the shape of the negro musical comedy. Its success has been instantaneous, and night after night not a stall or box can be secured.

Yet *In Dahomey* was 'a satire on the American Colonization Society's "back to Africa" propaganda'. In pure entertainment terms, its most memorable legacy was the cakewalk, a dance which had post-Victorian society leaping to its feet. As with the response to early rock and roll in North America, some of the old guard viewed the introduction of Black culture into polite society with horror:

> With the passing of the old healthy sensual (but never sensuous) English dances came the rushing in of alien elements. Chiefest and most deadly, the cakewalk tells us why the negro and white can never lie down together. It is a grotesque, savage, and lustful heathen dance, quite proper in Ashanti, but shocking on the boards of a London Hall.

Attention from a different quarter provided further unwelcome publicity. Research by J. P. Green has described how members of London's Black community, happy with the success of the show, had shown support and congregated in the vicinity of the theatre. Publicans complained of bad behaviour from certain elements and some refused to serve Black people as a result. Consequently, on 9 September 1903 the *Westminster Gazette* was one of many newspapers forced to ask if there was 'A Colour Line in London'. Attempts, including legal action, were made to reverse the ban, and the matter was made public by a 'black gentleman of culture and refinement . . . at present in this country studying our sociological conditions, a subject on which he is an authority'. The sociologist may have been W. E. B. Du Bois. In the event, the episode demonstrates Black community interest and solidarity, as well as the determination of Black people to exercise their civil rights.

Other Black entertainers worked without the glare of publicity and earned a steady income touring the country. For example, appearing at the Wyndham Theatre in *Madame Delphine* in 1900 was Amy Height, 'a real negro'. According to the *Era*,

> Miss Height is a provincial actress who is quite in demand for coloured parts. She is a good artist, and plays with restraint, sympathy, and much refinement of feeling. In appearance she is tall and slender with a chocolate complexion, large mouth and typical negro features.

The same actress appeared in *Uncle Tom's Cabin* at the King's, Hammersmith, in the year that *In Dahomey* took London by storm. At this time there were at least two touring companies presenting adaptations of the Stowe novel. John Tilly's Company pulled in audiences by casting 'real negroes', trained dogs and an 'American midget donkey', and Charles Harrington's No. 1 Company, which relied on the spectacular festival scene to draw in the crowds, boasted 'a number of real Negroes and freed slaves' (including Lizzie Allen, 'the coloured ballad vocalist') among the cast.

Among all those who so excited the Edwardian public, the only one whose fame has endured is the composer, Samuel Coleridge-Taylor. His children, like those of Ira Aldridge, also chose the entertainment field in which to pursue a career. Unlike Avril Coleridge-Taylor, who became a conductor, Amanda Ira Aldridge did not follow directly in her famous father's footsteps. Ira Aldridge's daughter attended the Royal College of Music in 1883 after winning a Foundation Scholarship. She was a pupil of Jenny Lind and of Dame Madge Kendal, who once played Desdemona opposite her father's Othello. For many years she enjoyed success as a contralto. According to *The Times'* Review of 1905:

> Miss Ira Aldridge held the attention of a large audience on Saturday afternoon . . . So good an effect as that achieved by Miss Aldridge in Dvořák's 'Gypsy Songs' calls for the exercise of a great deal of art . . . Miss Aldridge's style is excellent, her voice warm and mellow, and her intelligence far beyond dispute; the combination may well serve to explain the measure of her success.

Unfortunately, her public career ended after she suffered severe laryngitis, and she became a music teacher. When she also began composing, she adopted the name of 'Montague Ring' and some of her work was later recorded and broadcast.

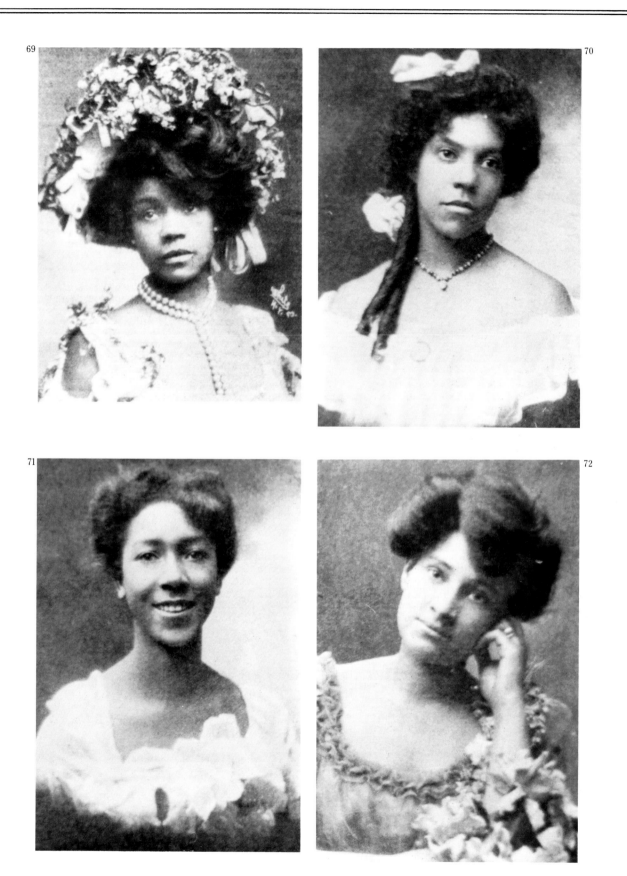

SAMUEL COLERIDGE-TAYLOR

Audrey Dewjee and Ziggi Alexander

The first performance of *Hiawatha's Wedding Feast* in 1898 launched the twenty-three-year-old composer Samuel Coleridge-Taylor's international career. From then until his untimely death in 1912 he was one of the most popular English composers of the Edwardian era.

It is difficult now to appreciate the importance and impact of Coleridge-Taylor's music. It is seldom performed today, being currently out of fashion. But in addition to its vast popularity with the contemporary concert-going public, it was held in high esteem by fellow composers. After the debut of *Hiawatha's Wedding Feast,* Sir Arthur Sullivan noted in his diary, 'Much impressed by the lad's genius. He is a composer – not a music maker. The music is fresh and original. He has melody and harmony in abundance, and his scoring is brilliant and full of colour, at times, luscious, rich and sensual.' Sir Edward Elgar described Coleridge-Taylor as 'far and away the cleverest fellow amongst the young men' when recommending him to the organizers of the Three Choirs Festival at Gloucester.

Samuel Coleridge-Taylor's origins are not widely known. He was born in Theobald's Road, London, on 15 August 1875, the son of an African doctor, Daniel Peter Hughes Taylor, who had come to Britain in the late 1860s, had studied medicine and had qualified as a Member of the Royal College of Surgeons. His mother was an Englishwoman, named on the birth certificate as Alice Taylor. Soon after the baby's birth Dr Taylor returned to Sierra Leone, for reasons which have not yet been established. The young Coleridge-Taylor grew up in Croydon, where at the age of six he started regular violin lessons. A Colonel Walters, impressed by his talent, financed the young man's studies at the Royal College of Music, which he entered, aged 15, in 1890. At first studying the violin, he switched to composition two years later, after some promising anthems were brought to the notice of the principal, Sir George Grove.

While at college his works started to attract attention, even across the Atlantic, so that when the Black American poet Paul Lawrence Dunbar visited Britain he sought out the young composer. Coleridge-Taylor was inspired by Dunbar's poetry and soon the two held joint public recitals of their work. In early 1897

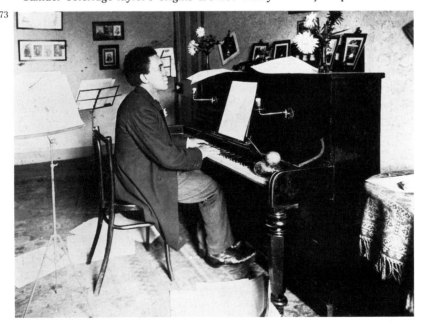

73

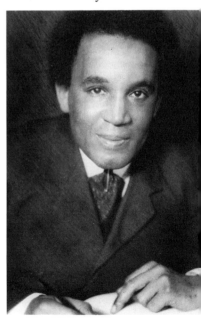

Coleridge-Taylor set some of Dunbar's poems to music, with the title *African Romances*. Ten years later, Coleridge-Taylor toured Britain with another Afro-American, an ex-student of his named Clarence Cameron. Nor was this link with Afro-America the only one Coleridge-Taylor sustained. He visited America several times, conducting concerts in four major cities and gaining high praise for a rhapsodic dance, *The Bamboula*, a calypso-style piece, based on a West Indian melody which was composed especially for the Norfolk Music Festival held in Connecticut in 1910. He was invited to the White House to meet President Roosevelt, a gesture which pleased many of his Black American followers, and his reputation was kept alive by the members of the Choral Society which bore his name.

On this side of the Atlantic he continued to receive acclaim. The Festival of British Music held at Crystal Palace in 1905 was subtitled 'From Sullivan to Coleridge-Taylor' and his *Ballade in A Minor* was well received, as was his *Symphonic Variations on an African Air*, first played at a Philharmonic concert in London in 1906. But this success was not accompanied by financial reward. The rights to *Hiawatha*, his most popular work, had been sold to the music publisher Novello for just 15 guineas prior to its first performance, and Coleridge-Taylor found it a constant struggle to make ends meet.

In 1899 he married Jessie Walmisley, a White Englishwoman who had been a fellow student at the Royal College of Music. They had two children, Hiawatha Bryan, born in 1900, and Gwendolen (later known as Avril), born in 1903. To provide for his family Samuel Coleridge-Taylor was obliged to take on many teaching posts, as well as conducting and adjudicating engagements in different parts of the country. Although a brilliant teacher, he warned a friend, 'Never teach. It will kill you physically and artistically. Everything you give to your pupil is something taken from yourself.' As a conductor he worked with the Rochester Choral Society, the Handel Society and the Stock Exchange Orchestral and Choral Society as well as with many provincial orchestras. *The Times*, in June 1905, commented on his influence: 'Another amateur organization, the Handel Society, showed . . . that under its new conductor, Mr S. Coleridge-Taylor, it has improved out of all knowledge.'

Despite this heavy workload he was a prolific composer, producing much of the commercial choral and incidental music which the public demanded, perhaps at the expense of the ensemble music for which he showed so much promise as a young man. In 1911, he completed his last and favourite choral work, *A Tale of Old Japan*, which quickly proved second only to *Hiawatha* in popularity.

Although his youth was clouded by shyness, exacerbated by racism, he overcame this in adulthood. His professor of composition, Charles Villiers Stanford, was very supportive of his young pupil. Overhearing another student call him 'nigger', Stanford assured Coleridge-Taylor that he had more music in his little finger than his tormentor had in his whole

75

body. This support, and Coleridge-Taylor's meetings and discussions with other Black artists and political thinkers, and particularly his involvement in the Pan-African Conference in 1900, boosted his self-confidence and gave him a pride in his race which enabled his genius to flourish. In much the same way that Brahms and Grieg had used Hungarian and Norwegian themes, Coleridge-Taylor deliberately sought out and reinterpreted African rhythms and motifs in his music, with such works as *Toussaint L'Ouverture*, the *African Suite, Songs of Slavery, Quadroon Girl*, and the 24 *Negro Melodies*.

His pride in being African was not limited to his musical activities. He challenged racism whenever the opportunity arose. For example, in response to one local newspaper's report of a barrister's racist address to a Purley debating society, he wrote:

It is amazing that grown-up, and presumably educated, people can listen to such primitive and ignorant nonsense-mongers . . . Personally, I consider myself the equal of any white man who ever lived, and no one could ever change me in that respect; on the other hand, no man reverences worth more than I, irrespective of colour and creed . . . An arrogant white man . . . dared to say to the great Dumas: 'And I hear you actually have negro blood in you!' 'Yes,' said the witty writer; 'my father was a mulatto, his father a negro, and his father a monkey. My ancestry began where yours ends!' Somehow I always manage to remember that wonderful answer when I meet a certain type of white man . . . and the remembrance makes me feel . . . wickedly happy.

Overwork helped to bring on an attack of double pneumonia at the end of August 1912, and on 1 September Samuel Coleridge-Taylor died. The musical tradition in the family was continued, both Hiawatha and Avril Coleridge-Taylor becoming conductors.

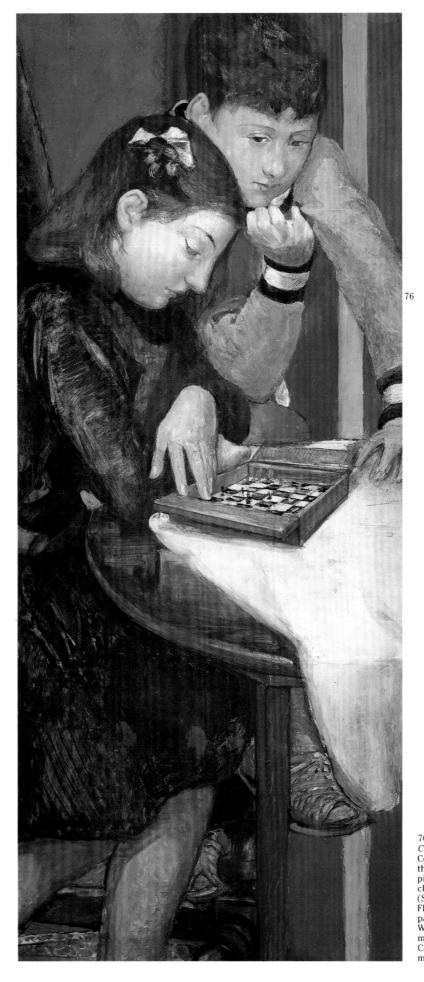

76

76. Mary Sargant Florence.
Children at Chess. 1910.
Courtesy of the Trustees of
the Tate Gallery, London. The
picture depicts the artist's
children, Philip and Alix
(Strachey). Mary Sargant
Florence was a peace cam-
paigner during the First World
War. She painted a series of
murals at Bourneville for
Cadbury, the Quaker cocoa
manufacturer, in 1912–14.

2

EDWARDIAN CHILDHOODS

Childhood and Children: Image and Diversity

Anna Davin

When we draw upon our bank of visual memories for images of Victorian childhood we probably picture first a series of dirty, ragged, underfed children – brutally treated little sweeps like Tom in *The Water Babies*, overworked piecers in cotton factories, drawers hauling their heavy tubs of coal, and perhaps street urchins. These images come largely from the efforts to protect and rescue such children which we associate with names like Shaftesbury, Kingsley, Dickens, Mayhew, Mary Carpenter or Hans Andersen. Their power lies in the contrast with the 'proper' children's activities and appearance which we visualize for Victorian times in the rosy-cheeked, well-dressed girls and boys of paintings and Christmas cards, skating and sledging in fur muffs and warm coats, or playing in warm, cheerful rooms with their new toys.

Images of Edwardian children come less readily to mind and are less sharp, perhaps because they are less polarized between rich and poor. Gender difference is important in them, but the emphasis is most of all on the identity as child. The children portrayed in old photographs or the illustrations to children's books (or in their filmed versions, like *The Railway Children*) are likely to be predominantly middle-class, but any poor children will not at first strike us as very different. They, too, will be shown at play or at school, rather than at work; and they will probably be wearing clothes which to us look much the same as those worn by the young of more prosperous families, instead of the rags and adapted hand-me-downs of earlier portrayals. Of course closer inspection reveals differences: the poor girl's pinafore was less elaborately frilled and perhaps less clean and starched, her black stockings did not fit too well, her floppy hat had tattier trimmings and was past its best; while her brother's Norfolk jacket, knickerbockers and cap or his sailor suit had seen better days and were anyway never of the best quality or cut. But overall, in our generalized image of the Edwardian boy or girl, similarities in appearance and activity prevail over differences.

77

This suggests two interlocked questions. The first is whether the impression is a valid one – how far children's lives corresponded with the image of 'the child'. And the second is why representations of Edwardian children give us the impression that they were homogeneously 'children' by comparison with their predecessors, that their identity as children overrode class (though not gender) difference. Both require us to look at the direct and indirect effects of longer shifts in the perception of childhood and at material changes in the second half of the nineteenth century.

The Content of Childhood

Middle- and upper-class Edwardians shared a fairly clear understanding of the category 'child' and of what was appropriate to childhood. This was bound up with middle-class ideas concerning family and gender, and had developed during the previous century, at first in relation to the

Jessica Hayllar. *There me to my window a robin.* 10. Rochdale Art Gallery. e title is taken from a ildren's song.

51

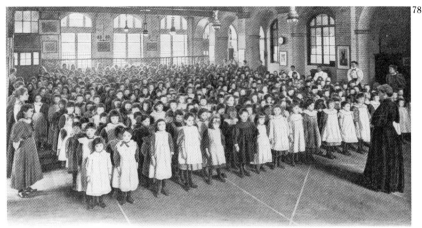

78. Afternoon assembly, 1902. Children in elementary schools were expected to be orderly and neat. Clothes were bought second-hand; sometimes there were no spares, so pinnies and other garments had to be dried overnight. Mothers and sisters worked wonders remaking, mending and patching.

79. 'King Baby'. 1902. Babyhood was given great importance among the well-to-do, with all kinds of special paraphernalia and intensive adult attention.

children of the well-to-do rather than as a universal ideal. In this perspective, the child was someone whose capacities and responsibilities were limited by age and immaturity; who was therefore economically and legally dependent on adults; who should not be burdened with 'adult' knowledge (especially about money or sex); and whose time ought to be divided between play and lessons, according to age. Children were to be sheltered both from the outside world and from adult life. They were to inhabit a different world, visible in the organization of time and space in the middle-class family. They were to eat, sleep and pass their time apart: the houses of those who could afford it now had day and night nurseries and schoolrooms, and the care and education of the young was handed over where possible to specialized servants – nurses, nursery maids, governesses and tutors.

In the course of the nineteenth century these assumptions were generalized into a universal definition of the child, so that practices which gave children too much responsibility or independence or knowledge, or stretched their capacities unduly, or allowed them to share in adult activities and concerns, were seen as misguided and wrong. The child prodigy fell out of fashion in the middle and upper classes, while the child who earned a living became the object of their pity rather than their admiration. Education was separated from work and defined more narrowly. Instead of learning through experience by watching and helping adults, children – except those from families whose income and culture allowed suitable teaching – were to be taught in schools, by teachers and from books.

The developing consensus on the universal nature of childhood was reinforced, in the middle class especially, by a growing emphasis around the end of the century on the innocence and gaiety of children. This came in part from nineteenth-century educationalists like Froebel and Montessori, and it permeated the influential writings of the new child study movement, whose members included teachers, doctors and other professionals who worked with children,

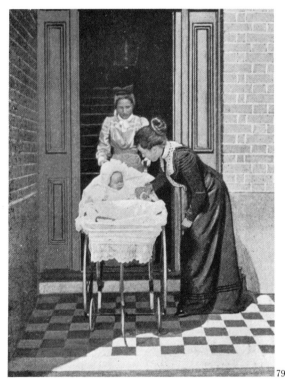

researchers who were studying their health and behaviour, middle-class parents, and various enthusiasts for kindergarten methods and educational reform. Their belief that childhood was naturally a time of joyous play and discovery led easily into the argument that children needed space and time for play as much as they needed food and shelter – that play was their right. (Margaret McMillan, the socialist educationalist, was a particularly eloquent and forceful exponent of this argument, supporting it with her experience of work with children in Bradford and London.) At the same time, their researches showed that many children were not carefree and joyous, but underfed, overworked, small and unhealthy.

State and Childhood

As the definition of what children needed for healthy development was being extended, so

was the understanding of who should provide the conditions for it. Ever since the Elizabethan Poor Law, foundlings, orphans and paupers – children without parents or whose parents were unable to support them – had been the charge of parish authorities (sometimes backed up by philanthropic institutions); while the passage of Peel's Health and Morals of Apprentices Act (1802) had reaffirmed the ultimate responsibility of the state for parish apprentices. In the course of the nineteenth century this responsibility was gradually extended. After hesitant beginnings, wider and stronger legislative restrictions were brought to bear on how and where employers could use, not just parish apprentices, but any children. From the 1830s education also became a state concern. Schooling was seen as a necessary counter to bad influences, and a system of subsidies was set up for existing and projected schools which met official standards. Then, with the Education Act of 1870 (and subsequent supplementary legislation), school boards were set up all over the country to build and run enough schools to allow the introduction of compulsory education. At the same time, official and unofficial rescue work reduced the population of street urchins, gathering them into orphanages and poor law schools, or sending them to start a new life (and to supply cheap labour) in the colonies. Even the home was not inviolable: from the 1880s cruelty, neglect and 'immorality' were increasingly accepted as legal grounds for removing children from their families.

In the years around the turn of the century concern with the lives of children focused on their health. It was fuelled by anxiety about the nation's imperial and economic prospects. The birth rate was declining while infant mortality was not, which alarmed those who equated population with power; while the low level of health in the urban working class (made visible through the problems of volunteers for the Boer War) alarmed those who saw 'a fit and virile race' as essential if Britain's imperial supremacy was to be maintained against challenges from

Germany and the United States. Public interest in child health was therefore invoked, with arguments like these:

– Because such a wastage of human life is a loss of the nation's best capital . . .
– Because the conditions which make for the death of infants, make also for disease, which . . . renders unfit at the outset those who should become able and healthful members of the community . . .
– Because this question appeals to us on humanitarian grounds . . .
Margaret Alden, *Child Life and Labour*, 1908.

Campaigns by groups like the Women's Industrial Council and the Committee on Wage-Earning Children, and official enquiries into the 'physical deterioration' of city dwellers and into the employment of children, led to a range of reforms and provisions intended to promote children's welfare. School authorities were encouraged to introduce kindergarten methods for the infants; to overhaul buildings along new hygienic lines; to improve physical training; to regard play as an essential part of the curriculum; and to make provision for children with special problems. Local authorities were empowered to provide free school meals (1906), and were required to follow the lead of Bradford and London and provide medical inspection of school children (1907). The Employment of Children Act (1904) banned the employment of children between nine at night and six in the morning, limited it to children over eleven, forbade the use of half-timers in any extra employment, and insisted that children should not be set to do work which could be injurious to their life, limb, health or education. It also gave local authorities the right to regulate street trading and to set various further restrictions. The treatment of juvenile offenders was modified (1901 and 1907); and improvements in the care of Poor Law children were attempted. Then the Children Act of 1908 (which some called the 'Children's Charter') codified and revised existing law in such areas as infant life protection, prevention

of cruelty, juvenile smoking, treatment of offenders, and exclusion from pubs. Voluntary efforts were expanded alongside official provision for children's well-being, with a special emphasis on clubs, outings and healthy amusements.

From the principle of public responsibility for orphans and paupers, then, evolved the justification for wider public concern with, and provision for, children in general, with regard to their employment, their schooling, their domestic circumstances and beyond. This was hard to accept for those who held to the prevailing middle-class doctrines of laissez-faire and individual rights. The helplessness of children therefore had to be stressed, and their identity as not adults, so as to affirm both their right to protection and the duty of the state to intervene on their collective or individual behalf. They were not adults 'free' to negotiate wages and conditions of work, so they needed legal support. They were dependent on parents (or surrogates) for their support and education, so if parental provision failed it should be suplemented or replaced. In the 1900s this line of argument was reinforced by the assertion of the value of children to the community and therefore to the state. The notion of 'State parenthood' was introduced, with the justification that it would complement and strengthen the feeling of parental responsibility, and improve the training of the future good citizen.

Class, Childhood and Gender

Of course the nature of intervention on children's behalf was determined by the assumptions of the authorities about what was or was not right for children. Such ideas were rooted in the middle-class consensus about the special character of childhood as a time of dependence and innocence and the need for children to be cut off as far as possible from adult life and concerns. They did not always fit with working-class notions of childhood and education, or with the economic needs of the poor family. Nor, usually, were they brought to bear with much sympathy or understanding. One kind of childhood was

right, the other wrong.

The introduction of compulsory school resulted in a conflict between the two views of childhood. Its advocates held that if parents did not understand that the place for children was school, rather than work or the street, they must be forced to send their children there anyway. If they resisted they were irresponsible; they were seen as letting their children run wild, which was a threat to present and future social order, or as lazy and avaricious, exploiting their children by driving them out to work. Both street arabs (children led astray who might yet be reformed) and child workers (victims of parental greed and irresponsibility) had to be rescued and given a more appropriate experience of childhood, so that they would grow up to be better parents to the next generation. The child was presented as helpless and passive, victim or raw material more than an agent. The parents were presented as ignorant and irresponsible at best. The authorities had the right, and the duty, to impose their version of childhood and their version of education.

Although such arguments prevailed, they were not universally accepted, even in the middle and upper classes. Some (especially those who could use child labour) saw early employment as a good training for the children of the poor and thought school a waste of time for them. Others did not approve of children's being forced to school against their parents' wishes, and regarded compulsion as unjustifiable interference with individual rights. Others again were rightly concerned at the economic results of compulsion for poor families.

In working-class families in the second half of the nineteenth century it was usual for children to contribute to the family economy from an early age, in labour, cash or kind. From ages five and six they would run errands and help with smaller children and domestic chores. From as young as eight they might bring in casual or even regular earnings, and their employers might also feed them or pay them partly in kind. If members of the family worked in a workshop

80. William Rothenstein. *In the Morning Room.* c.1905. Manchester City Art Gallerie

54

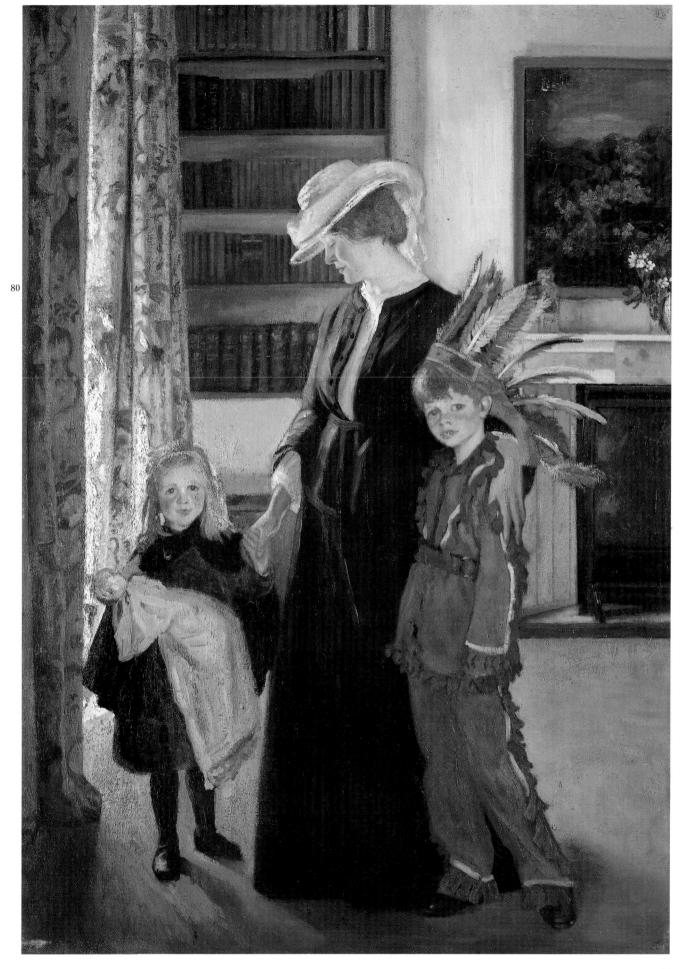

81

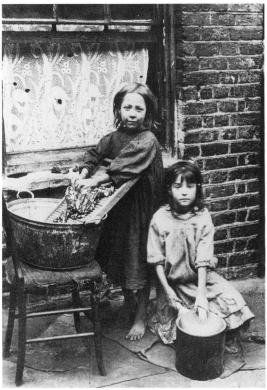

82

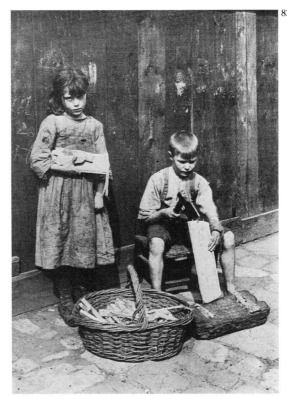

81, 82. Spitalfields Nippers. Photographs by Horace Warner. Bedford Institute Association. Children contributed both labour and earnings to the family economy. These very posed photographs were taken to arouse interest in the work of a philanthropic institution.

83. Match and tin-tack box makers. *Sweated Industries Exhibition Handbook.* 1906. Mary Evans/Fawcett Library. Such work was irregular and badly paid, but enabled house-bound women to earn and school children could join in when they got home. It was always piecework, so every little counted. Match box makers might earn 3d a gross and 1s.3d a week.

or at any joint enterprise (a stall or a shop, or a woodchopping yard, or making matchboxes, brushes, artificial flowers, or paper bags, or making and selling toys), children joined in. For poor families the time and labour of children was indispensable. But whatever the family's economic situation their help would be valued and encouraged: it was good training for children to learn to be useful. The children themselves took for granted that they did what they could. They were also proud of what they put into the family purse, like a girl in 1913 who knew that the family's Sunday joint was bought with her weekly earnings. (Every day in her dinner-hour she went to a nearby factory to take orders for lunch from her mother's workmates, and fetched their orders of pease pudding, pie and mash, saveloys or fish and chips, then when afternoon school finished she came back to wash up for them.)

When schooling first became compulsory, children were required to attend a recognized school for five hours every weekday (except during designated holidays) from the age of five until they were at least ten. (Leaving age varied across the country and over the period: in London it quickly rose to 14.) This conflicted both with traditional views about teaching children the skills they would need as they grew older, and with children's customary role in the domestic economy. Even parents whose need for help from their children was not acute were often impatient at the demands of school, especially as the years passed and the basic skills of 'booklearning' and 'summing' had been

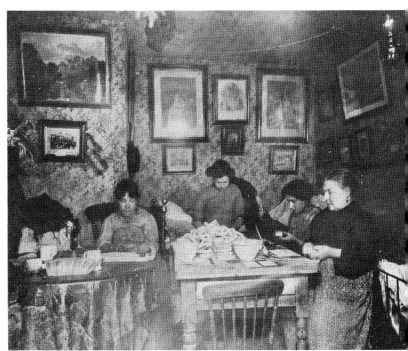

acquired. As a North London costermonger put it, when summoned for not sending his children to school (they had presumably been helping on his barrow or stall):

My children are middling educated; but I say labour before scholarship. There are plenty of scholars in this country starving at the present time. And what I want to do is to teach my children to get an honest living in the streets.

The Times, 23 Sept. 1891, p.8.

In the poorest households real hardship could result from sending older children to school. It was worst for households whose only breadwinner was the mother and where there was a toddler or a baby normally cared for by an older child. (The youngest age of admission to board schools was three, so children over that age could be sent to school.) If there was no grandmother to be called on, and no chance of a reciprocal arrangement with a neighbour, she had few options. One was paid childcare, whether by a neighbour or in one of the inadequate number of crèches, but this could take a third or a half of a woman's low wages. Another was to find work which could be combined with childcare – most often domestic outwork, which was appallingly paid and which put extra strain on living space, but with which children could help after school. The parish might help with out-relief – a weekly dole of bread and perhaps some money – but to get it a women with more than two or three children would have to hand over some of them. She could also give up and take the family into the workhouse, but then she would be separated from the children, and brothers and sisters from each other.

With the improvement in living standards which had taken place in the last decades of the nineteenth century, the numbers of families in desperate poverty had declined. But there was still little cushioning against such disasters as illness, death or unemployment, and the children in all families were the reserve to be called on in domestic crisis, brief or long term. In emergency, it was expected that a daughter should take her mother's place, or a son add his energies to the family's effort to survive. Occasionally school authorities would accept this and allow an older child to leave school early. The degree of flexibility on this varied according to the local Board. In London, the age and standard which had first to be reached rose steadily, and, by the 1900s, poverty and special circumstances had to be extreme before exemption was granted. (Between 1895 and 1900 the number of exemptions in London dropped from 1,205 to 313.) 'Half-time' arrangements, which allowed older children to spend half the day at work and half at school, also varied from place to place. Most of the country's 37,000 half-timers in 1907 were in northern mill-towns, where mill-owners insisted that without children's labour the industry would collapse, and where the practice survived till 1918. In London half-time was initially allowed if a child was 'beneficially and necessarily at work'; but it was phased out in the 1880s and 1890s: numbers dropped from 2,417 in 1879 to 88 in 1899, and it was then abolished. Oral evidence suggests that it survived unofficially: Mrs M, born the eldest of 17 in Hoxton in 1896, recalled being allowed to go half-time at the age of 12, because her mother had new twins, six babies needing bottles, and a broken arm.

By the 1900s most working-class parents of school-age children had themselves done their stint in the classroom, and were likely to accept that their children would have to do the same. They no longer had the option of patronizing a local private school, more flexible about hours and attendance, such as had flourished in poor neighbourhoods till the Education Act of 1875 effectively disqualified them. Among the many families in London and other cities for whom the conflicting demands of school and the domestic economy were still a problem, two common and overlapping patterns had developed. The first was for a schoolchild to be kept home now and then as a childminder. This would be a girl if there was one the right age, partly because enforcement of girls' attendance was less strict. It happened when the mother had the chance of a day's work, usually at charring; or when help was needed to finish and deliver a batch of outwork; or on washing day. Similarly, if the infants' school was closed for any reason (most often because the building was used as a polling station) attendance of older sisters and some brothers suffered. The second pattern was for children to work outside school hours, which might affect their punctuality or their ability to keep awake, but did not

84. Doll's house, given to Diana Gurney in 1904. Norfolk Museums Service, King's Lynn Museums.

85. Stanhope Forbes. *Gala Day at Newlyn*. 1907. Gray Art Gallery and Museum, Hartlepool. Every Whit Monday Newlyners processed through the town to the grounds of the local land-owner. The Gala Day was organized by two groupings important in Edwardian Britain, the Temperance movement and the Sunday School of the Primitive Methodist Church. From the 1880s artists settled in Newlyn (also a popular holiday resort) and they made their living purveying images of the fishing community to the urban middle classes.

incur the same risks as staying away. They did early morning jobs, dinner-hour jobs, after-school jobs and Saturday jobs; or they took over domestic responsibilities (especially cleaning, shopping and childcare) for their mothers or for neighbours.

During the 1900s, then, the real life of many children was a little closer to what in the middle-class consensus was a proper childhood, but it still did not match up to the newest ideas about their needs and rights. They were clearly demarcated as 'children'. They lived under adult supervision at home or in Homes. They spent five hours each day in school, where the adult authority over large classes reaffirmed the subordination and dependence of the young. Their employment was restricted and regulated. They wore clothes which designated them children; and read periodicals (especially comics) and cheap books written specially for children. They had playgrounds and parks in which to play and Happy Evening clubs to tempt them out of the streets; while the Country Holidays Fund gave some a chance to sample the healthy pleasures of the country or the seaside.

But on the other hand they were still closely involved with adult cares and concerns, and, as a social worker wrote of South London in the 1900s, 'the difference between a child and an adult was everywhere regarded as one of degree rather than of kind.' (Alexander Paterson, *Across the Bridges*, 1911, p.58.) Although they played, their games – 'Poor Jenny Lies a-Weeping' and the like – had adult subjects like courtship and death, which offended some middle-class adults' requirement for childish innocence. They still ate much the same food as adults, and stayed up late, and were often to be found joining in adult activities. Poverty in the 1900s, though not as desperate or as widespread as in the mid-nineteenth century, was still serious and extensive, and restrictions on children's employment did not reduce the need for their help. So they worked a double shift, combining school with early morning jobs, and worked late into the night at matchboxes or other homework. The schools also expected the children to come neat and clean, while domestic space and property was increasing and standards of housekeeping and of child care were rising, all of which meant more domestic labour. The growing currency of new ideals also set up new problems. Those who carried heavy responsibilities now knew that children were supposed to be carefree, which might increase the burden. The ragged, verminous, ill-shod urchins, because they were fewer and less ubiquitous than 50 years before, knew themselves to be deprived and neglected. But those who were unhappy and brutally treated at home no longer had the option of attempting early independence: the alternative was life in a Home, which meant losing all freedom. Again, those whose mothers took seriously the injunctions to keep their children from playing in the street might be no healthier for being cooped up at home. The greater incidence of anaemia amongst girls was sometimes attributed to their being kept more at home.

The lives of poor and of middle- and upper-class children were very different, however similar the general image. One observer contrasted the sufferings of 'the little people of the West End', who had to wear gloves and keep clean and tidy, and must not be rough or rude, with the 'free spontaneous existence of the back street'. (Henry Iselin, 'The Children of the Poor', *Macmillan's Magazine*, 1907.) The children of the well-to-do did not go hungry, though they might have to be satisfied with 'nursery food'. They were generally more supervised, whether by servants or by mother (and perhaps father), or both. They had more clothes and more toys, mostly gender-specific, and they went on holidays, to

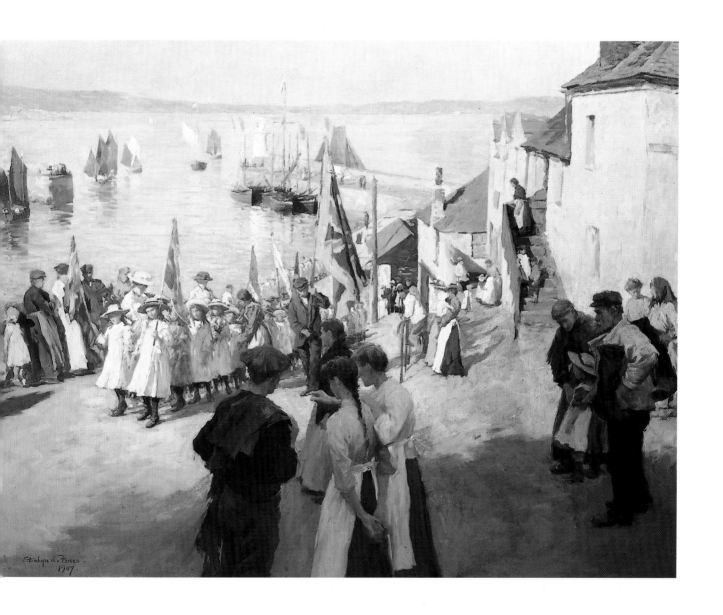

farm or seaside. Older children would help look after and entertain younger ones, but always with a responsible adult in the wings. Boys would have no real domestic responsibilities, and girls only minor ones like arranging flowers or sewing, knitting and mending. Younger boys and girls would either share some form of home tuition or be sent to small, select local schools; boys usually received more formal schooling, though use of boarding schools for girls was on the increase.

Edwardian boys and girls were dressed alike (which of course does not mean that their treatment was identical) till the age, usually between three and five, when boys were taken out of petticoat and dress and into some form of trousers, and probably also had their first haircut. This practice ('breeching') was general across class, and was often accompanied by a degree of ritual and celebration. After that the appearance and the experience of boys and girls was distinct, though the difference was likely to be greater

higher in the social scale and wherever ruling-class views on gender separation prevailed, in schools for instance.

The classic London Board school, still to be seen today, had three floors, each housing an autonomous department, for infants (up to seven or eight years old), girls and boys. Separation began as the children arrived: there were usually two entrances (sometimes three), with 'Girls and Infants' over one arched doorway, and 'Boys' over the other. These can still be seen. Playgrounds were also separate, divided not only by a wall, but by rules against approaching the frontier, or talking or even looking across it. Each of the three groups had its own cloakroom and in the playground its own range of water closets. (At home, segregated toilet facilities would, of course, have been unknown.) Even in the infants school there were differences of syllabus: the boys did more drawing and handwork, and the girls more sewing and knitting. In the upper standards the girls' range of subjects

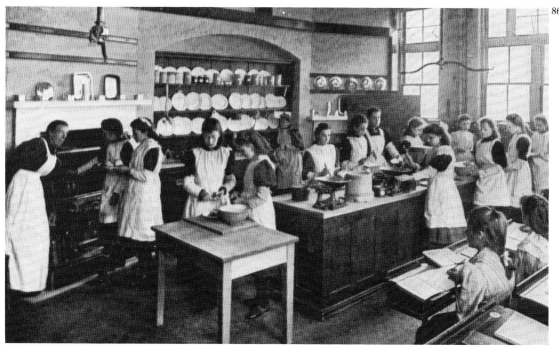

86. Learning to cook, 1902. Great emphasis was placed on domestic instruction for girls, especially in elementary schools, though methods and equipment were more relevant to domestic service than to facilities in their own homes.

86

87

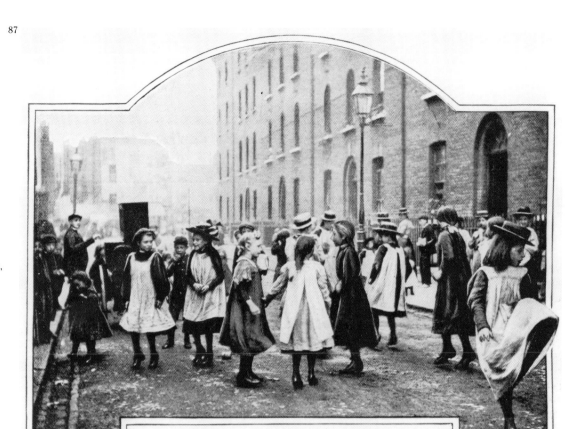

DANCING TO A STREET ORGAN.

87. Dancing to a street organ, 1902. Organ grinders and other musicians who earned their living in poor streets were always surrounded by children, especially girls, dancing to whatever music was played with solemn and graceful enthusiasm or wild abandon.

was narrower, and dominated by domestic instruction. Their punctuality was worse and their attendance was more irregular than the boys', but the school attendance officers and the authorities generally were often more lax in chasing them up or pursuing cases of absence, unless they were prolonged.

In general, younger working-class girls and boys shared a common experience of daily life at home. As they grew older, differentiation increased. They would cease to wash and dress in front of each other; and would sleep in different rooms, or in a room split by an improvised curtain. More domestic help would be expected of girls than of boys in most families, and more freedom, and perhaps more food, be given to boys. In their street games they played together a good deal, at least until the age of eight or nine. Then they began to diverge. The girls, usually with younger children of both sexes in tow or joining in, played hopscotch, skipping, ball and singing games; while boys, though often with tomboys among them, tended to play or roam together in groups. Boys could swim naked in the canals and rivers; girls could not.

Middle- and upper-class girls were usually even more restricted, both by convention and by clothes. They would be more closely supervised than their brothers. Often they were not permitted to go out alone even in the day, or to use public transport even with the protection of brothers. On holiday they might ride astride or

roam as freely as their brothers. Their education and independence were limited. They would be expected to acquire a different set of skills, including those necessary for social and domestic organization. They were bound more closely to the family by ties of emotion and obligation, knitted in childhood but likely to hold, supporting and restraining them, for the rest of their lives.

Edwardian Childhoods

Major differences of childhood experience in the 1900s can be identified within and across class, in relation to work, health, independence, education and even duration. (A fourteen-year-old servant was not a child; but the sixteen-year-old whose needs she served was.) All of these were in turn affected by other factors. Location was one: a child growing up in a town had different opportunities and responsibilities from one in the country; but this was further complicated by class. (Eileen Baillie, as the little daughter of a well-connected clergyman in an East End living, spent many hours at her nursery window enviously watching the street children with whom she was not allowed to play: see her memoir, *Shabby Paradise*.) The child's position in the family mattered, too, along with numbers of siblings and the balance of boys and girls: an eldest or an only girl in a large family would always have more to do. Religion and other cultural heritage in a given family was also signifi-

88. Summer fete, Methwold, Norfolk, 1913. The postcard is inscribed 'John is holding the Donkey'.

89. St Mary's Infant School, Group IX. c.1908-10. Private collection.

90. *Let Glasgow Flourish*, a banner made by Ann Macbeth and Jessie Newbury for the British Association for the Advancement of Science, which still owns it. Embroidery was transformed by the many women of the Glasgow school into an art form, but it retained its traditional association with femininity and was identified as an area of art practice suitable for women.

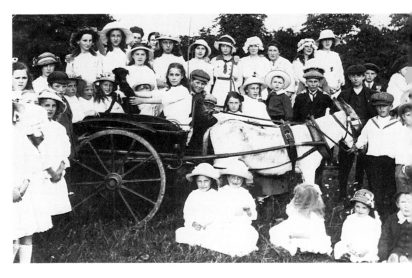

cant, especially in relation to gender difference and attitudes to different kinds of work or to education. And the origins of a family and its relationship to the neighbourhood could be important, too: children of a newly arrived family, especially from a group against which there was any prejudice, if not accepted by their peers, might be isolated and perhaps bullied.

This social diversity of children's experience was not well represented in visual form, or even in the children's literature which was an important feature of the period and which does effectively portray diversity of *character* in a narrow social band of children. The imagery most easily available serves to reinforce the abstract ideal of 'the child', not to reveal the many childhoods experienced by Edwardian children. Children are shown at play in appropriate settings – the home, or garden, park or playground. They are shown massed at school, or perhaps on outings. They are shown on holiday, playing on the sand with daringly bare legs and floppy hats. Alternative representations – the working child, the street child, the child in adult territory – are to be found most often as part of the presentation of a problem: the homeworking families photographed for the Sweated Industries Exhibition, for instance, or the tastefully posed

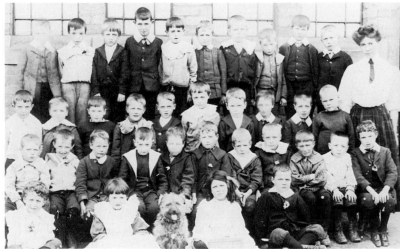

'Spitalfields Nippers' used to raise funds for the Bedford Institute. It is a useful reminder of the dangers of taking what we see at face value. The homogeneous image of the Edwardian child reflects the contemporary preoccupation with universalizing a middle-class ideal, and obscures the existence of multiple Edwardian childhoods. It is about the child, not children.

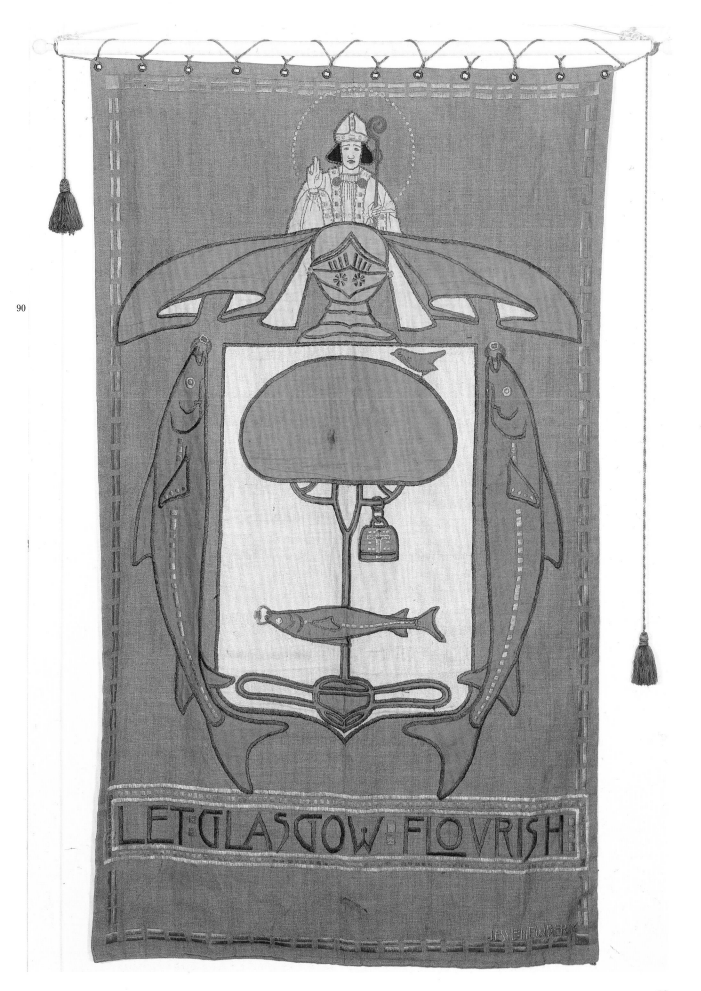

LET·GLASGOW·FLOVRISH

JESSIE·NEWBERY

GLASGOW

Jane Beckett and Deborah Cherry

By 1911, Glasgow, the second largest city in Britain, had a population of 784,496 inhabitants. In the Edwardian period men were chiefly employed in the shipyards and docks, in the metal, mining, engineering and building industries and as carriers. Men and women worked in the printing, stationery, textile, clothing, and furniture trades; and women also worked in domestic service. The Scottish Co-operative Wholesale Society, established during the 1880s, expanded considerably in the 1890s, and centralized manufacture at Shieldhall. In common with many larger cities of the period, Glasgow's industrial and commercial structures developed with its multicultural nature: communities of Irish, Highlanders, Russian and Polish Jews, Italians, and black peoples were settled in the city.

Glasgow was a city with strong labour traditions and working-class organization. The Social Democratic Federation, Scottish Labour Party and Independent Labour Party all had highly articulate and theorized activists and educators. Large May Day rallies on Glasgow Green – 30,000 marched in 1909 – celebrated the strength of the socialist movements. Glasgow's political movements incorporated strong anti-landlord feeling and support for Irish and Scottish home rule. Glasgow women were active in the women's suffrage movements and in the campaigns for better conditions for women workers – organizing unions, strikes, and investigations. Women were prominent leaders of the Glasgow rent strike of 1915.

Political struggles and class conflict, however, were not among the themes of the Glasgow International Exhibitions. That of 1901 was a massive spectacle, of civic prosperity, industrial pride and Empire. Eleven and a half million visitors went to the Exhibition,

which took over £400,000 in gate money and in tickets for entertainments. The 1901 Exhibition had three major components: the new Kelvingrove Art Gallery, built with the proceeds of the first International Exhibition of 1888; the Machinery Hall; and the Industrial Hall, which displayed the heavy engineering and shipbuilding on which Glasgow's wealth was based.

By 1901 Glasgow was firmly established as a major port and commercial and industrial centre. Massive investments of capital in the second half of the nineteenth century and early twentieth century enlarged the docks and deepened the sea channel to make possible the building of luxury liners and naval warships. Alongside shipbuilding there developed heavy engineering and the manufacture of industrial machinery, benefiting from nearby coal mines, iron and steel foundries and the extensive railway network. Industrial success, increasingly through large family firms or public companies, depended on low taxation, few restrictions on development or pollution, and the exploitation of labour outside the regulation of the Factory Acts. Industry prospered on the whole, despite a slump in the years 1906 to 1908, which affected every aspect of the city's life.

In the city centre were the shipping offices, insurance companies and banks which supported and

91

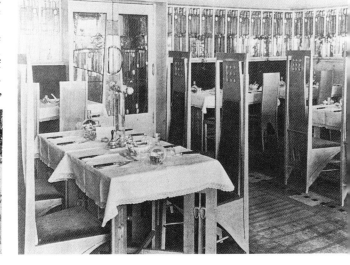

91. Muirhead Bone. *Glasgow International Exhibition from the west*. 1901. Hunterian Art Gallery, University of Glasgow.

92. Charles Rennie Mackintosh and Margaret Macdonald Mackintosh. Room de Luxe, Catherine Cranston's Willow Tea Rooms, Sauchihall Street, Glasgow, 1903. Hunterian Art Gallery, Mackintosh Collection, University of Glasgow.

93. Charles Rennie Mackintosh. Hill House, Helensburgh. 1902-4.

94. Tenements in Calton, Glasgow. People's Palace, Glasgow. When Peter Fyfe was Medical Officer of Health in Glasgow, he made photographs of Calton, using them as illustrations in lectures which he gave. He was involved in campaigns for improving working-class living and working conditions, speaking at the Glasgow conference on Sweating in 1907.

financed Glasgow's industries. Tea rooms, linked to Glasgow's temperance movement and its huge tea trade, catered for the commercial, retail and shopping centre. Many of the tea rooms were owned or managed by women. The city's business men and women supported numerous architects, artists and designers, commissioning magnificent offices and premises, decorative schemes and artefacts for their tea rooms and houses. The Arts and Crafts movement thrived in the city, in close relationship with Glas-

gow's metal trades, furniture trades and textile industries.

But alongside this conspicuous display of wealth was terrible poverty, suffering and hardship. While the rich moved to spacious mansions and tenements in the west of the city, to villas in the south, and outwards to Helensburgh, the working classes lived in the old houses of the city centre, in the 'made-down' or converted middle-class blocks, or in industrial tenements. They were at the mercy of building

94

95

95. Embroidered panel by Ann Macbeth and Marie Currie. Mrs J.A.M. Inglis.

96. Woman winding bobbins Mitchell Library, Glasgow.

97. The Barrows, Glasgow. Photograph by Peter Fyfe. People's Palace, Glasgow.

98. Coronation souvenir tin mustard penny ovals, starch box, mustard tin, advertising stamps, and booklets for children. 1901-10. Colman's Norwich.

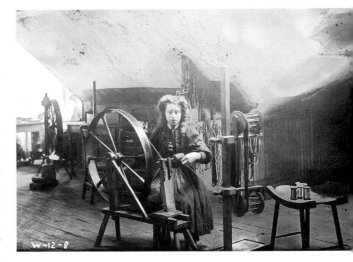

speculators and landlords, who obtained multiple rents from overcrowded tenements on small plots in a city where land values were high. Between 1901 and 1910 well over half the population of Glasgow lived in households of one or two rooms, with two or three people per room. Often a single tap was the only water supply for a six-storey tenement containing sixty to seventy households. Infectious and fatal diseases spread rapidly, and in this heavily polluted environment respiratory illnesses were common. Houses were 'ticketed' by the Corporation in an attempt to regulate the chronic overcrowding; by 1902 there were about 20,000 ticketed houses. Furnished accommodation in 'farmed' or sublet houses was profitable for the entrepreneurs, but the reality of the poor, usually unskilled or unemployed, who lived in ticketed or farmed houses was, according to the Glasgow Herald of 1903, 'the lowest depths of wretchedness and poverty'.

Municipal supplies of water, gas and electricity and a telephone system had all been provided by 1900, along with trams. There was public health provision for public baths, wash-houses, refuse removal and street-cleaning. Major sewage-works were built in 1904 and 1910. To deal with housing conditions, the City Improvement Trust, started in 1866, began a programme of building and acquisition. But by 1902 only 257 houses had been completed for some 700 to 800 people. By 1914 only a further 245 houses had been built. Such policies also indicated some of the problems in dealing with urban development. Demolition increased overcrowding in nearby neighbourhoods; the 'ticketing' system, with its nightly inspections, made continuous sleep impossible for the inhabitants; and the city's model lodging-houses, which ran at a profit, regulated the conduct of their inmates. But Glasgow did much in its 'municipal socialism' and few cities could do more.

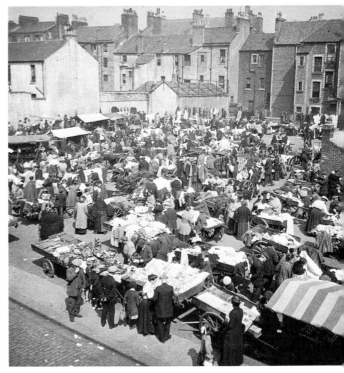

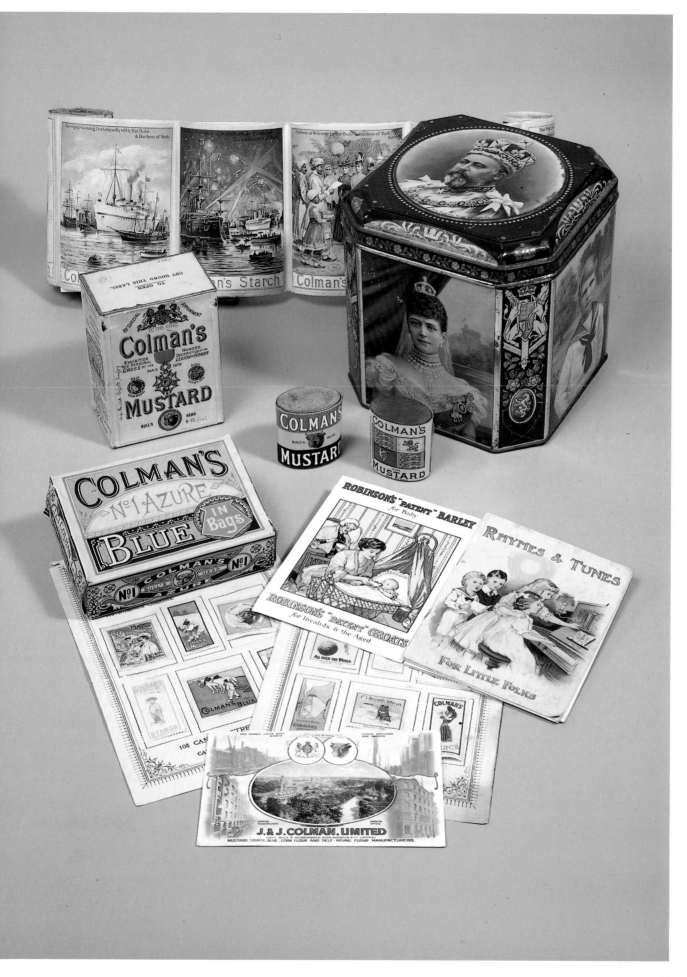

NORWICH

Jane Beckett and Deborah Cherry

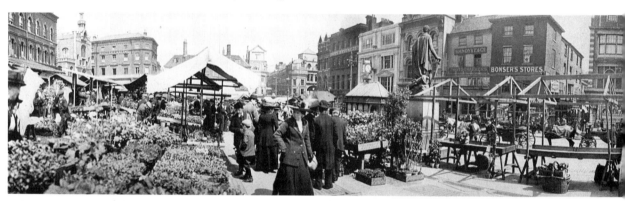

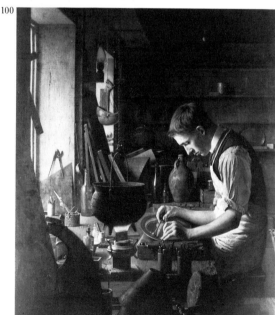

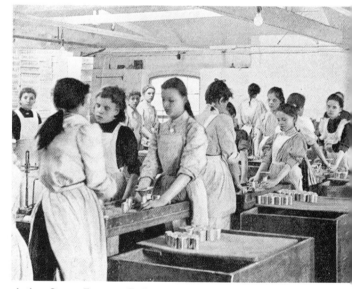

100

By 1900 the structure of East Anglia had changed from an industrial and highly populated area to an agricultural community with a stagnating rural population and industry concentrated in Norwich, Yarmouth and a few market towns. Norwich's economy was dependent on its position as a port, as the centre of an agricultural area – primarily grain-growing and cattle – and as a centre of the tourist trade. The expansion of the Great Eastern Railway at the end of the nineteenth century opened up seaside resorts like Cromer and Sheringham, popularized through Clement Scott's guide to 'Poppyland', and many second holiday homes were built along Norfolk riverways and the Broads. Norwich corn market was second only to London's but it employed no labour and its money was made not for the city but for the landowners of large Norfolk estates. By contrast the cattle market, also one of the largest in Britain, was vital to the economic life of the city and provided unskilled

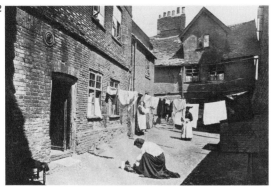

102

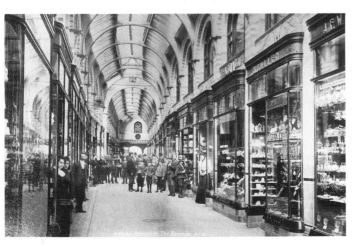

99. The Saturday flower market, Norwich, c.1913. Norwich City Library.

100. Walter Dexter. *The Workshop.* 1900. Castle Museum, Norwich.

101. Women packing penny oval mustard, Carrow Works, Norwich. 1905, Colman's of Norwich.

102. An unimproved court, Norwich, 1909-10. Photograph from W. Hawkins, *Norwich: A Social Study* (1910).

103. George Skipper. Interior of the Royal Arcade, Norwich, c.1900. Norfolk County Library. The Royal Arcade cut through small streets linking the fruit, vegetable and flower markets to Castle Meadow, creating a comfortable indoor shopping mall for the middle class.

employment for men as drovers and porters. As work on the land declined, or was reorganized around a growing technology, men came to Norwich in search of employment. Some were corralled into the army, as Norwich was a garrison town; others found work in large breweries, on the railways, in the building and joinery trades, in printing, and in the manufacture of motor engines. The average wage of 16 shillings a week compared favourably to farm wages at ten shillings a week. But the 1904 march of the unemployed marked the chronic shortage of work and the many unskilled and casual workers, too poor to move, were forced to work for rock-bottom wages.

The boot and shoe industry developed from the production of cattle hides and skins, and from a diversification of skills from the old textile industries bringing dexterity in light-weight, turned shoe work. Men and women worked for large firms, such as James Southall and Co. (Startrite) and Howlett and White (Norvic), and in the smaller, cramped workrooms of the 'garret-masters'. Homeworkers were exploited as reserve labour for seasonal employment at the lowest levels of pay, as little as 3 shillings a week. The Norwich boot and shoe workers had no agreed minimum wage until 1908, when the threatened union strike won a fixed scale of work, minimum wage and revisions for piece-work.

Norwich had a large, cheap labour force of women and children; more women lived in the city than men.

Sixty-three per cent of the workers in the food, drink and confectionary trades in Norwich were women, girls and boys. J. J. Colman's Carrow works employed 2,600 workers. Carrow had a works canteen and provided medical care, a clothing club, school, pension scheme and sport and leisure facilities. But as the sociologist C. B. Hawkins noted in his *Norwich, A Social Study* (1910), as the employees were given little responsibility in running the facilities, 'in this matter, the firm plays the part of the benevolent despot.' Colman's and the Council, which controlled the markets, public baths, cemeteries, and electricity, paid some of the highest wages in the city, just over a pound a week.

The Trade Union movement was relatively weak in the food, drink and clothing industries in comparison to the activism of the boot and shoe workers, but tailoresses and women-weavers successfully struck for better wages and conditions in 1908. Norwich was a city with a long labour tradition, returning W. G. Roberts as a Labour MP in a dramatic election result in 1906. There was a strong Labour church, socialist Sunday school and a branch of the Independent Labour Party; the Labour Institute was the largest working-men's club in the city. The co-operative society's membership and sales were buoyant.

The poorer working classes lived in overcrowded alleys and courts of the old city centre. From the 1880s the Council had a policy to compel owners to drain, level and pave these courts, but progress was slow, and by 1906 it was reported that several courts were 'still unlighted and unpaved, whilst a great many are damp and sunless'. Living conditions were terrible, infectious diseases common and the death rate higher than average. Factory employees in regular work lived in suburban terraces built outside the walls of the old city in the late nineteenth century.

Traditionally known for banking, from the 1880s Norwich had become a centre for insurance. Magnificent new buildings and offices, designed by George Skipper, were now added to the city centre, for companies such as the Norwich Union Life Insurance (1901–6) which were central to Norwich's prosperity. Norwich industries supported artists such as A. J. Munnings and Walter Dexter, who designed advertising, illustrated tourist books and painted local views of the countryside for their urban patrons.

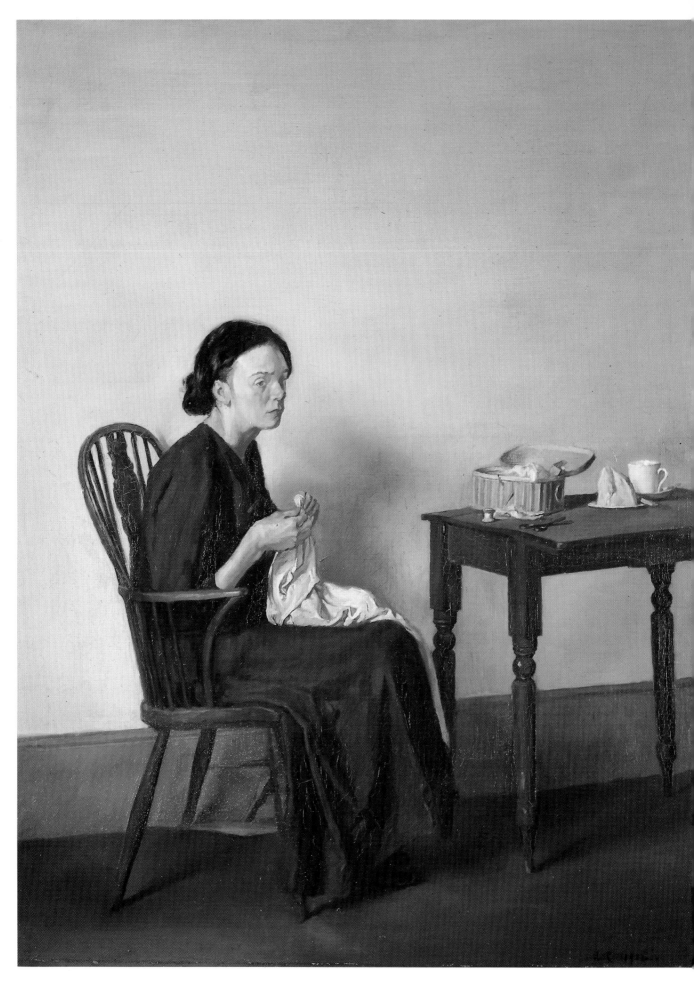

3

WORKING WOMEN

Overdressed/Underpaid: Women Workers and the Production of Femininity

Jane Beckett and Deborah Cherry

On May Day 1906 the *Daily News* Sweated Industries Exhibition opened at the Queen's Hall, Langham Place, London. 'Sweating' had been a political issue since the mid-nineteenth century, its terms of definition shifting as successive pieces of legislation failed to attend to it. The Royal Commission of 1890 defined it as low pay, excessive hours of work and insanitary conditions: a life of unremitting toil for a pittance. The Commission recognized that these characteristics applied not only to 'sweat-shops' and home workers, but 'in the main, to unskilled or partially skilled workers', definitions which therefore applied to many women workers.[1] The *Daily News* Sweated Industries Exhibition sought to draw public attention to the conditions of working-class women throughout Britain, and to increase demands for State legislation to govern their working conditions, and, by implication, their home conditions.

The exhibition contained a range of goods produced through the sweating system and it also put on display workers engaged in their production. Grouped at twenty-three stalls, all

but two of these workers were women, mostly home workers in the clothing trades, making shirts, trousers, waistcoats, underclothing, pinafores, baby clothes, boots and shoes. Some of them made trimmings for clothes – fur, lace, vamp-beading, artificial flowers, accoutrements for military uniforms; and others worked in the secondary trades of button carding, hook and eye carding, glove stitching, shawl fringeing, and steel bending for corsets. But there were also basket makers; box makers of all kinds, including match-box makers; paper bag makers; and sack makers. Leisure products, such as tennis and racquet balls, and their makers were included, alongside makers of chains, dolls, brushes, and coffin tassels.[2]

The Exhibition provided information on rates of pay, hours of work, the overheads of each trade, and, where this could be given, the retail price of each article. The number of rooms in which the workers lived and worked, and what they paid in rent, were also listed.[3]

Deliberately held in London's fashionable West End, the exhibition was opened by Princess Henry of Battenberg, the King's youngest sister. Sensationalist accounts in the popular press and books had presented sweating and working-class culture in terms of tourism to a dangerous place. To counter middle-class fears of a residuum of idle, degenerate poor, the Handbook of the exhibition stressed the skills, diligence and patience of the workers:

Description of work	Artificial Flower Making
Rates paid	Violets, 7d gross; geraniums 7d gross; buttercups 3d gross; roses 1/3 to 3/6 gross[4]

Remarks : A clever woman and magnificent worker. Cannot read or write. For fifty years she has made artificial flowers, and for skill and indomitable perserverance she has no superior... To support herself and her husband without parish relief or philanthropic aid, she has often worked fourteen, and even sixteen hours daily.

105

To generate middle-class concern, the degradation and poverty of sweating were also emphasized, as for example in this account of a shirt maker:

> Mrs D is the wife of a labourer who is irregularly employed and who earns 17/- or 18/- a week at work. Mrs D has three children all of whom are under six years of age... She makes men's shirts throughout at 1/3 and boys at 1/- a dozen. These shirts take fourteen and twelve hours respectively to sew ... the shirts on which the mother was engaged would, it is absolutely certain, be used as bedding for the family at night, and thus lend themselves as a medium for the dissemination of dirt, disease and vermin among the puchasing public.[5]

By isolating the workers and putting them on display, confrontation with their actual conditions of poverty could be avoided. The reviewer of the socialist paper, the *Clarion*, had expected:

> Sweaters dens, and all the sickening, disgusting, angering sights and sounds and smells . . . Plenty of slums, and rookeries, and smells, and sores, and squalling brats, and gin palaces, and weary, worn women and cadaverous men.[6]

But when he entered the hall his 'foot fell silently on a soft-carpeted floor. Around the walls were neat, varnished stalls, displaying goods, as it might have been a fancy fair or bazaar.' Working-class women and their work had been transformed into the pleasurable spectacle of middle-class exhibitions. 'As a social function', the *Labour Leader* acidly commented, the exhibition 'was a huge success; indeed after leaving the Sweated Industries exhibition, Princess Ena was so happy that she went off to a waxwork exhibition.'[7] And even the editor of the *Daily News* regretted that for many visitors the exhibition was merely 'a painful interlude between a visit to the shops in the morning and a visit to the theatre in the evening'.[8]

The middle-class Edwardian public was familiar with exhibitions as sites of information, education, pleasure and entertainment. Middle-class women frequently organized and visited charity bazaars and exhibitions at which their handicrafts and trifles were displayed and bought. Women's work and women workers were included in the international exhibitions in Glasgow (1901), Bradford (1904) and the Palace of Women's Work at the Franco-British Exhibition in London (1908). Unlike the Glasgow International Exhibition however, where working-class women were present to demonstrate manufacturers' machinery, the revival of highland crafts, or middle-class women's philanthropic activities,[9] the *Daily News* exhibition included women homeworkers in an attempt to show their conditions, and so raise public opinion.

> Those into whose hands this catalogue will fall, will realise that these forty workers, at one penny or two pence an hour, are typical of hundreds of thousands of their fellow citizens, and that under circumstances of squalor and privation impossible to depict in such an exhibition, they are creating things necessary for our convenience or amusement.[10]

The neat, ordered interiors shown in the photographs in the Handbook conflicted with the reports from several investigators of 'dirty comfortless houses' and 'indescribably filthy' rooms, and the struggles women had to keep them clean and tidy given their long exhausting hours of work. The reviewer in the *Clarion* com-

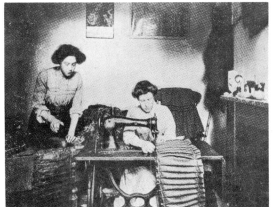

106

106. Skirt workers. *Sweated Industries Exhibition Handbook*, 1906. Mary Evans/Fawcett Library. The photograph in the Sweated Industries Exhibition handbook pursue strategies by this date common in surveillance procedures: the isolation of an individual or small group in prescribed space, accompanied by a text designating what were perceived as characteristic features, in this case occupation, hours of work, rates of pay, numbers of rooms and rent.

mented that none of the images connected with the exhibition – the poster, catalogue cover, or photographs – 'make the ignorant feel what such conditions really mean. You can buy a handbook giving you reams of similar facts about the sweated industries with plenty of photographs – realistic, lying photographs.'[11] As in many other social investigations of the period, photographs were included to provide visual evidence, and readers were assured that they 'have not been in any way altered, or with two exceptions, touched up'.

But far from simply documenting or recording working-class women, such photographs were also part of the broader movement to survey and control the working class, and they were used in this way by the state, education, medicine, the police, philanthropy, and the illustrated press. Working-class women were subjected to a technology firmly secured in the hands of the dominant classes, who, because they were rich enough to buy photographic equipment, were in control of their own representation, and photographed themselves in

moments of leisure and pleasure.[12] In contrast the photographs which they took of working-class women marked these women as perceptibly different and visibly subordinated.[13]

Working-class women were also visible in high culture. Paintings of servants, costerwomen, laundresses, agricultural workers, and needlewomen were displayed at art exhibitions or studio showings for the pleasurable entertainment of middle- and upper-class visitors. For them art exhibitions were part of the social calendar. Moreover, the making of art was predominantly a middle-class occupation. Like photographs, paintings of working-class women were invested with social and economic relations of power. Working-class women were the subject of paintings, but they themselves had no access to the means of representation, no power to determine how, why and by whom they were imaged in high culture.

The Sweating Debate

The sweating debate united a broad political spectrum: philanthropists, clergymen, paternalist manufacturers such as Rowntree and Cadbury,[14] Liberal and Labour MPs, the charitable and settlement institutions, and different groupings in the women's movement. These were all woven together into a hegemonic alliance to campaign for state legislation, and hopes resided in the landslide victory of the Liberal government of 1906. The immediate outcome of the Sweated Industries Exhibition was the formation of the Anti-Sweating League. The political momentum was maintained with conferences, publications, reports, and coverage in the Liberal press.[15] A parliamentary commission was set up in 1907, and in 1909 the Liberal government passed the Trades Boards Act, which established a minimum wage for chain-making, box-making, lace-making and finishing, and the making of ready-made clothes. Despite this and subsequent legislation, the issue of sweated labour, though rarely on the political agenda, remains an issue today.[16]

Sweating intensified as the range of consumer

7. Interior of a middle-class home. Kodak Archive, National Museum of Photography, Film and Television, Bradford.

108

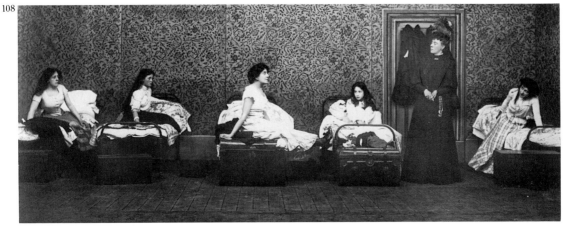

108. Act I from Cicely Hamilton's *Diana of Dobsons*, produced at Lena Ashwell's co-operatively run Kingsway Theatre, London, 1908. Mander and Mitchenson Theatre Collection. The life of the woman shop assistant was often presented to theatre audiences as happy and carefree. But in line with the campaigns of the shop assistants' union, Cicely Hamilton focused on the 'grind and squalor and tyranny and overwork' in Dobson's drapery firm. Shop assistants worked long hours for low pay. Their work was physically exhausting and demanded considerable concentration as well as the effort of maintaining an air of politeness. 'Living-in' provided at best a place to sleep and monotonous and hurried meals; at worst, the rooms were dirty, overcrowded and vermin-ridden, and the food contaminated.

109. Mary Macarthur, 1909.

110. The box makers' strike at the Corruganza Works, London, 1908. Postcard issued by NFWW and reproduced in *The Woman Worker*. Mary Evans/Fawcett Library.

111. Emily Ford. 'They *have* a cheek I've neven been asked'. Published by the Artists' Suffrage League. 1908. The Labour Party Library.

goods, particularly for middle-class markets, expanded dramatically over the period 1880–1914. The new, large department stores, where many of these consumer goods were sold, often employed women shop assistants to work long hours for low pay. The big businesses and public companies, so characteristic of the Edwardian period, were fearful of competition from Germany and America, and manufacturers as well as social investigators voiced concern over issues of 'national efficiency' and the fitness and productivity of the workforce. These anxieties were part of the prevalent racism of the period; anti-semitism was rife in attacks on 'alien' and Jewish 'sweaters'. The Aliens Immigration Act, which limited immigration, was passed in July 1905 and became law five months before the Sweated Industries Exhibition opened.

Women's Trade Unions

Outside these structures of state power and commercial capitalism women took political action, and by working through networks and associations established in the late nineteenth century they consolidated and extended their political voice.[17] The Women's Trade Union League (WTUL), formed in 1874, sustained small unions of women workers and acted as a federation for all unions containing women members.[18] By 1900 the strength of the women's trade union movement lay in the textile and cotton industries in the North and in the boot and shoe industries of the Midlands. After 1903, following the appointment of Mary Macarthur as Secretary, the WTUL concentrated its activities among the increasing numbers of women employed in the garment, food processing, box-making, and metal industries in London, and in the newer areas of women's employment as shop assistants, clerks and telephone operators. Some of these women were to be among the most active in the women's trade union movement. For unskilled women and those too poor or isolated to join or form a union, Mary Macarthur founded the National Federation of Women Workers (NFWW) in 1906.[19] The NFWW was rooted in the

ideas and militancy of the general labour unions, with low subscriptions and a strike fund. The record of the NFWW from 1906 to 1914 was one of increasing membership and strikes.[20]

The period from 1880 to 1914 was characterized by women's active resistance to their exploitation as women in the developing structures of capitalist production. After the famous Match Girls Strike of 1888, the Allied Laundresses carried out a magnificent campaign, following their exclusion from the 1891 Factories and Workshops Act. They held a mass demonstration in London to bring public attention to their cause, and their continued activity brought changes in legislation in 1895. But the women who took washing home, and who worked in laundry companies, continued to do heavy and exhausting work for long hours a day.

During the Edwardian period unionized and non-unionized women were actively militant against long hours and low pay. Their strikes, pickets and demonstrations were reported in the pages of the *Woman Worker*, the paper of the NFWW, and the *Women's Trade Union Review*. Women also joined the many unemployed marches, their presence signalling women's right to work.

One strategy for action was educational work: in the words of Mary Macarthur, 'knowledge is power'.[21] The WTUL, NFWW, and the Women's In-

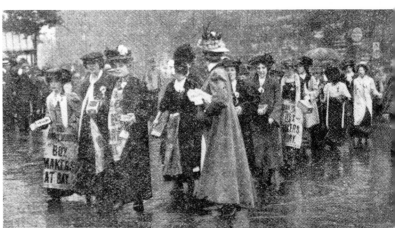

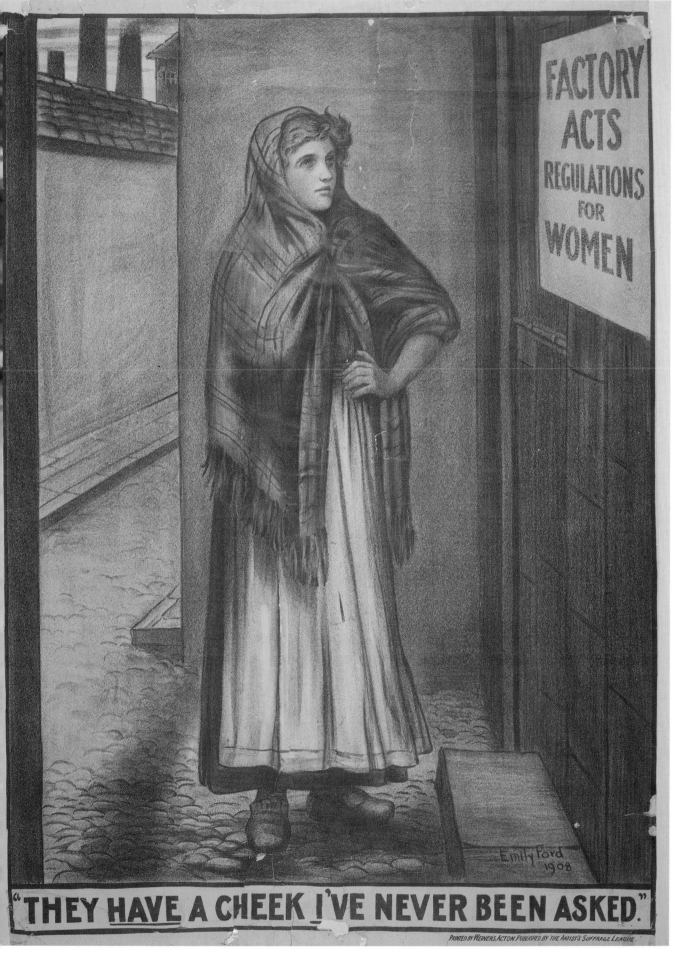

FACTORY
ACTS
REGULATIONS
FOR
WOMEN

Emily Ford
1908

"THEY HAVE A CHEEK I'VE NEVER BEEN ASKED."

PRINTED BY WEINERS, ACTON. PUBLISHED BY THE ARTIST'S SUFFRAGE LEAGUE.

dustrial Council (WIC), formed in 1889,[22] set up social and educational organizations for working women which ranged from women's and girls' clubs to drill instruction. The WTUL and the WIC also published pamphlets and books dealing with the legislation covering women's work.

The main problem in addressing the issue of sweated women workers was, as Gertrude Tuckwell, President of the WTUL, indicated, that 'the larger class of sweated industry was found among the home workers, too scattered to act together for their corporate interest'.[23] Unionization was therefore ruled out. The women's trade union movement worked to educate the public through exhibitions of sweated women workers,[24] and the WIC produced campaigning reports of its investigations. Like the WTUL and the NFWW, the WIC was involved in the campaigns to secure a minimum wage. Between 1897 and 1906 the WIC carried out a series of investigations into the home industries of London. The second report of 1906 described the unremitting toil of the home workers and their 'conditions of dirt, disease and overcrowding'. A forceful attack on the lack of legislation, it was published just before the Daily News Sweated Industries Exhibition opened. In common with other publications on sweating and with Gertrude Tuckwell's preface to the Sweated Industries Handbook, the report identified middle-class responsibility and involvement:

Nor can we comfort ourselves with a belief that the products thus wrung out of suffering are not in our own houses. To whom are not shoes sent home in boxes? Who does not buy matches, or tin tacks, or tooth brushes? . . . There is no person in this kingdom . . . who does not partake the proceeds of underpaid labour.[25]

The WIC, the WTUL and the NFWW all campaigned to improve the conditions of sweated workers. They identified sweating not simply among home workers, but also in the newer areas of women's employment as shop assistants and clerks, and in a whole range of women's work where pay and conditions were at a minimum.

The WIC also campaigned on the issue of married women's work. Edwardian investigations into women's work were framed by debates around feminine sexuality, and discussions of sweating were held in the context of fears that sweated women workers would turn to prostitution.[26] Family life – caring for children at home – was seen as the proper sphere for all women. There was, in the period, considerable debate as to whether women should work at all, and as the ideology of motherhood strengthened,[27] whether married women should work. Married Women's Work,[28] a detailed investigation carried out by the WIC, the Women's Labour League (WLL) and the Fabian Women's Group in the industrial north and in Glasgow between 1908 and 1914, argued that married women's work was socially and economically necessary. This viewpoint was put forward in letters to the Woman Worker, and was firmly held by the 'radical suffragists' of the Lancashire textile towns. WIC investigators drew attention to the double burden of married working-class women:

Marriage which looked at in anticipation presents itself as a way out, proves often but a second underpaid employment added to the first.[29]

Cicely Hamilton provided an explanation for this, arguing that the issue of women's low pay should not be seen in terms of the 'family wage' paid to a man, but was rather related to the subordination of women and the subsistence wages paid to the wife:

A good many causes have combined to bring about the sweating of women customary in most if not all departments of the labour market, but it seems to me that not the least of those causes is the long established usage of regarding the work of a wife in the home as valueless from the economic point of view.[30]

Her book, Marriage as a Trade (1909), argued that marriage was a 'compulsory' institution involving the sexual, social and economic subju-

"No Better Food."

Dr. ANDREW WILSON, F.R.S.E., &c.

112

Fry's

"Have none but FRYS The name implies STRENGTH · PURITY & FLAVOUR."

PURE CONCENTRATED

Cocoa

DO NOT BE DECEIVED by misleading statements, but rely upon the experience of nearly **TWO CENTURIES.**

gation of women. The book was one of many published in these years which not only presented a critical analysis of masculine power and sexuality, but powerfully advocated celibacy and spinsterhood as political positions for women.[31]

Women investigators from the WIC, the Charity Organization Society (COS) and other philanthropic and medical groups negotiated the difficult ground of Edwardian domestic ideology when they crossed the threshold of working-class houses to find very differently organized families and households.[32] Framed by imperialist ideas of 'racial degeneration' and national efficiency, the COS activities and reports laid emphasis on regulating and reforming the structures of working-class life at home. Their methods of investigation were rooted in middle-class beliefs about the family. Such principles informed the ways in which they gathered and assessed evidence and the conclusions they drew from it. The centrality in COS investigations of the eye-witness account formed the basis for the professionalization of social science during the Edwardian period. Photographic representations, too, were presented and accepted as eye-witness accounts of the 'real' conditions of working-class women's lives.

The ideology of home, family and service affected all women and girls, but it had a different meaning according to their social class. Between 1891 and 1911 two out of every five employed women were in domestic service. Helen Bosanquet, who was Secretary of the COS and a firm advocate of the family, recommended that working-class girls be employed in domestic service in 'a well-managed family'. This, she considered, would be the best preparation for family life, providing training in domestic skills and acting as an antidote to what she perceived as the mismanagement of working-class households.[33] The COS, like other charitable institutions, ran registries and employment bureaux for servants. While they undoubtedly provided job opportunities they also bound these women into the structures of the middle-class home.

They benefited the employers who constantly complained about 'the domestic servant problem'. For those middle-class women who were unfamiliar with organizing large households, pamphlets, manuals, and books, such as the multiple reprints of Mrs Beeton's *Household Management*, were published, setting out the appropriate work skills of domestic servants, who had to be fitted into 'the arrangements of the household in which service is taken'.[34]

The long hours of housework, kitchen work, and general domestic drudgery common in these households were not apparent in the images of women servants which appeared in middle-class magazines advertising food, tea, cocoa and domestic products. Whereas middle-class women appeared elegantly dressed in photographs, paintings and fashion plates, so signifying wealth and social standing, domestic servants in their neat uniforms and pristine white aprons represented not only social subordination but also the domestic order and cleanliness of the middle-class home. In advertisements for cleaning products and soap, this whiteness did not just signify cleanness against dirt. White and black were also set against one another as categories marking racial difference. Companies producing goods such as tea, cocoa, and tobacco through colonial exploitation used images of black people in their advertising to address predominantly white audiences. These advertisements not only created markets for the products, but also disseminated the ideologies

of imperialism and Empire.[35] There were complex levels of exploitation; products from the colonies were reprocessed and packed by sweated labour in Britain:

> The most worn out girl whom I remember ever to have seen was engaged upon no harder task than the packing of cocoa . . . she sat day after day pouring powdered cocoa into ready-made square paper packets, of which she then folded down the tops and pasted on the wrappers. She received a half penny for every gross . . . Each shilling represented twenty four gross of packets; she had therefore filled, folded and pasted, in the week (to earn 7s), 168 gross or 24,192 packets.[36]

Both in actuality and imagery, white middle-class domestic pleasures were premised on the exploitation of race and class.

The clothing trades

The investigations of sweating and women's employment all paid particular attention to the large number of women in the clothing trades. Women workers specialized in particular aspects of making, trimming or finishing. In consequence these isolated women were set up in competition with one another for work and wages. Sewing machines speeded up production for the ready-made and made-to-measure markets; women worked longer hours, under greater pressure, and their work was increasingly deskilled.[37] Women worked as home workers; as indoor workers in factories and workshops; in the workrooms of the larger department stores; and in individual dress-making and tailoring houses. In the clothing factories of the Co-operative Wholesale Society levels of pay and hours of work were regulated and no home work or outwork was used.

The long hours of work and cut-throat competition for orders were not infrequently blamed on middle- and upper-class women ordering new clothes at short notice. But in reality the oppression of working-class women in the clothing trades was partly a function of the

SOME MODISH MORNING BLOUSES.

changing relationship between patriarchal power and capitalism over the period from 1880 to 1914. Men's ownership of capital, stock and the machinery in factories and workshops, their position in management and their organization of systems of work and payment were all consolidated by the formation of large firms, public companies and department stores. These areas of patriarchal power were linked to men's control over legislation for factories and workshops. Professional identities and managerial skills were secured for middle-class men *against* the overworked and underpaid clothing makers and shop assistants, and the women employed at intermediate levels – as designers, as cutters and as fitters in charge of workrooms, or as 'middle-women' distributing homework.

The elaborate clothes of fashionable women in Edwardian Britain were extremely labour-intensive, the product of hours of skilled needlework, machining, cutting, fitting, and trimming by working-class women. The power, therefore, of middle- and upper-class women to signify by their dress their social position, wealth and class and their construction in femininity was based on the labour and expertise of working-class women. Women investigators were sharply aware of the class differences between the production and consumption of 'really good and expensive clothing'.[38] In *Makers of Our Clothes*, an extensive enquiry into the conditions and pay in the clothing trades, Clementina Black and Mrs Carl Meyer reported on the skilled sewing done for low pay and the enormous gulf between the retail price and the worker's

113. 'Some Modish Morning Blouses', *Woman*, 21 Februar 1906. British Library

114. Sylvia Pankhurst. *In a Leicester Boot Factory.* 1907. Professor Richard Pankhurst These women are probably workers in a small producers co-operative factory. The workroom is well lit and ventilated by contemporary standards.

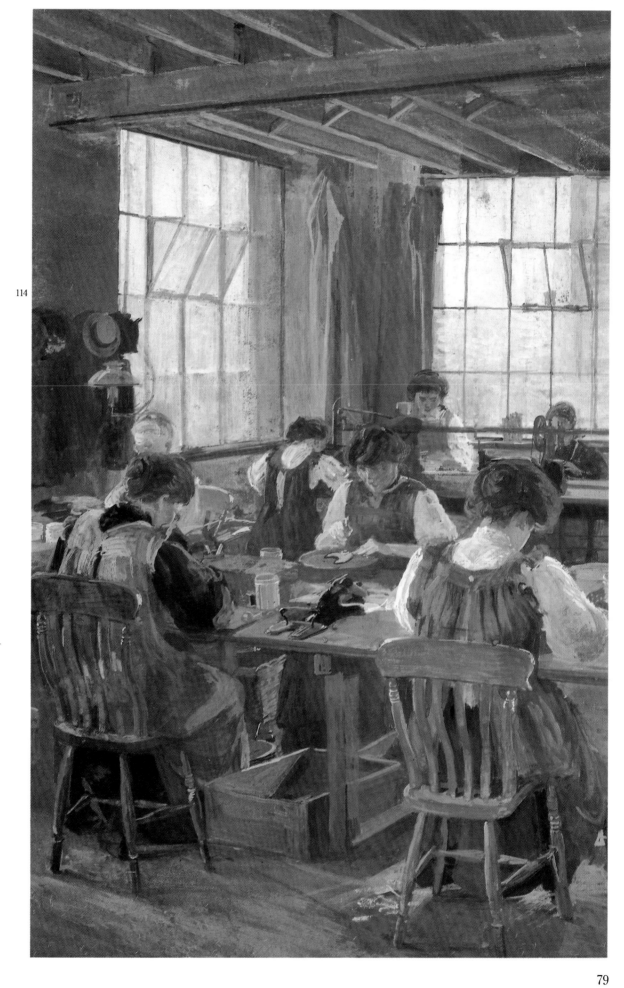

Cicely Hamilton.

115. Cicely Hamilton, c.1910. Photograph by Lena Connell. Private collection. Cicely Hamilton was a feminist, actress, writer and member of the Women's Writers' Suffrage League. Many radical feminists wore severe suits, often with shirts and ties. Lena Connell was one of the many feminist photographers who worked for the women's movement recording events, demonstrations and portraits.

116. 'Domestic Servants' cotton washing dresses'. Daughters of the Deep Sea, Gorleston. John Johnson Collection, Bodleian Library, Oxford.

middle- and upper-class women's resistance to patriarchy was strong and publicly visible. For many feminists, dress marked a political choice, and frivolous frills, those signifiers of feminine subordination, were refused.

Working-class women's dress was just as complex in its codes, meanings and regional variations. There were work-day clothes and 'Sunday best'. For working-class women a tucked blouse or pleated bodice permitted movement, and tucks above the hemline adjusted the skirt length. Clothes of plain or lightly patterned fabrics with little or no decoration did not draw specific attention to the body. Deliberately sexualized images of working-class women relied upon breaking the conventions by lifting the skirt to show the ankles or lower legs.

payment. For example, for a silk blouse retailing at between 17s and 25s with 'back and front composed entirely of small tucks and of insertions of lace' the woman factory worker was paid 10d; 'this skilled young woman could not make two such blouses in a day.'[39] In the Edwardian period the blouse was transformed from the severe shirt of the 1890s by intricate tucks, lattice work, insertions of lace and ribbon and embroidered decoration. This distinctive item of fashionable women's dress was bought and worn only at the expense of the working-class women who made them, sold them, and laundered them.

For middle- and upper-class women, to be feminine was to be tightly corseted and to wear highly decorative and restrictive clothes. The female body was subordinated as 'feminine' by two main strategies. The decorative detailing of lace, beading, embroidery, the overlaying of different fabrics, and the insertion of pleats drew attention to the feminine body as a site of pleasure. Corseting bound the body into a distinctively 'feminine' shape, reinforced as desirable through fashion illustrations. From 1900 the 'S' shape was fashionable, with a large overhanging bosom, narrow waist, and protruding hips and bottom. By 1908 this shape was redefined – with a raised bosom, a less constricted waist, narrow hips (with corseting down to mid-thigh), and a slender skirt; pleating near the hemline served to accentuate the ankles, now made visible by the slightly shorter skirt. This tightly bound and restrictive form of dress, related to a new emphasis on slimness, emerged historically when

116

DOMESTIC SERVANTS' COTTON WASHING DRESSES. For HOUSEMAIDS, NURSES, Etc.

Are the speciality of THE DAUGHTERS OF THE DEEP SEA, GORLESTON, SUFFOLK.

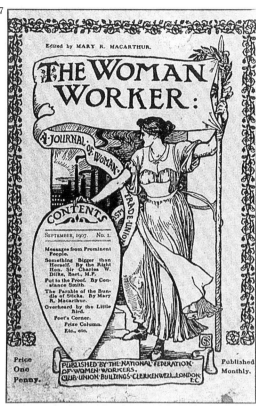

117. Cover of the *Woman Worker*, 1907-8. Mary Evans/ Fawcett Library.

Popular Imagery

During the period from 1880 to 1914, women's magazines became an area of capital investment. From the 1890s special companies were set up by the male press barons such as Harmsworth or Pearson to publish 'women's magazines'.[40] The forms of femininity were therefore largely controlled and to a certain extent created by men – through their investment in magazines, in department stores, and in the clothing industries, where they worked as designers or fashion illustrators, and ran several leading tailoring and couture houses.[41]

For the women readers of 'women's magazines' and of the daily and weekly papers with 'women's' pages or columns, femininity and feminine pleasures were constructed around appearance and domesticity. Articles on changing fashions, hints on beauty and advice on household matters and childcare formed the staple fare of this literature. Although occasionally disrupted by information on employment, much attention was given to women's appearance at work. This predominant emphasis was reinforced by illustrated advertisements for hair and beauty products, ready-made clothes, corsets, and jewellery. Advertisements were essential revenue for the capitalist press and were therefore increasingly present in women's magazines from the later nineteenth century.

One of the most noticeable features of the imagery and appearance of fashionable women in the Edwardian period was the emphasis on whiteness: pale-coloured dresses, white dresses for presentation at Court, pearl necklaces, white skin achieved with cosmetics. The visual representation of white women became a crucial issue in British imperialism in the later nineteenth and early twentieth centuries. Images of white upper-class women, white middle-class mothers, white working-class women were part of the endemic racism of these years. Paintings at art exhibitions celebrated a distinctively white history; classical Greece and Rome provided historical examples of cultures founded on colonialism and slavery; and the medieval past gave precedents for Christian imperialism. A regime of representations, spread across paintings, newspapers, shopping catalogues and popular culture, provided whites of all classes with self-images which allowed them to justify their colonialism, with its oppression and ruthless economic exploitation of black peoples. These images were understood against the *misrepresentation* of Black peoples, discussed by Ziggi Alexander and Annie E. Coombes elsewhere in this volume.

One of the most fundamental changes taking place at the turn of the century was the improvement in print technology. Illustrated papers and magazines, picture postcards, street posters, and illustrated advertisements were made possible by cheap printing processes and the new technology for reproducing photographic images. With the post office permitting the printing of postcards by private companies by 1894, and the introduction of the penny post four years later, an increasingly wide range of images of music hall and theatre 'stars', politicians, city scenes, and seaside and countryside views were available for sale and circulation. With this technology came an increasingly wide range of images of women on street hoardings and in magazines.

These postcards, posters and advertisements set out competing and conflicting definitions of femininity and working women. Domestic respectability was pictured, for example, in the postcards showing actress Marie Tempest 'at

81

118

118. Picture postcards of Camille Clifford, Phyliss Dare, Mrs Patrick Campbell, Nina Sevening and Marie Tempest. Private collections. The star system was created by the programming and publicity of the entertainment industries and by the circulation of postcards such as these which carried the image of the artist, sometimes in a famous character role, across the country.

119. An interior decorated with images of stars, mostly Gertie Millar. Mander and Mitchenson Theatre Collection.

120. National Federation of Women Workers banner, 1914. John Gorman / National Museum of Labour History.

home' in surroundings comparable to those in paintings and in amateur snapshots of middle-class interiors; actresses posed in the manner of society portraits. Set against these images was the sexualized availablity of the music hall artist Marie Lloyd, shown with a bunch of cherries in her mouth, or Kitty Lloyd in a short, knee-length skirt.

These images were powerful influences on the formation of Edwardian femininity. Women were encouraged to model themselves on the 'stars' of the theatre and music-hall, to emulate a particular 'look'. Camille Clifford's distinctive shape and face, circulated on postcards and posters, sold corsets and magazines. The images of Marie Lloyd and other famous artists sold toothpaste and hair products.

Contesting definitions and images of working-class women and femininity were produced within the women's movement. In 1907 Sylvia Pankhurst travelled throughout Britain speaking on suffrage and living with, writing about and painting watercolours of working-class women at work, a project which was formed by her commitment to working-class women's visual and political representation.[42]

The *Woman Worker* not only provided news of disputes, strikes, branches and the WLL, but in its early issues worked against the dominant definitions of femininity as appearance produced by the 'women's magazines'. It counselled against wearing corsets, using hair tongs, curlers, or restoratives, advising instead warm

vests, hair brushing and eating fresh vegetables and salad. At this date the *Woman Worker* used many visual images to mark out its definitions of femininity. Photographs of women trade unionists and activists accompanied the articles about them, the editorial page included a drawing of a woman writing at a desk, and the cover depicted a woman worker carrying a banner and leaning on a shield. This image was reworked for the NFWW banner, unfurled in 1914.

Equally powerful were the images that working-class women created for and of themselves by marching on public demonstrations, organizing picket lines and speaking outside factory gates. In sharp difference to the spectacle of the well-dressed fashionable society woman, these public spectacles of working-class women embodied a politics which campaigned and militated for change.

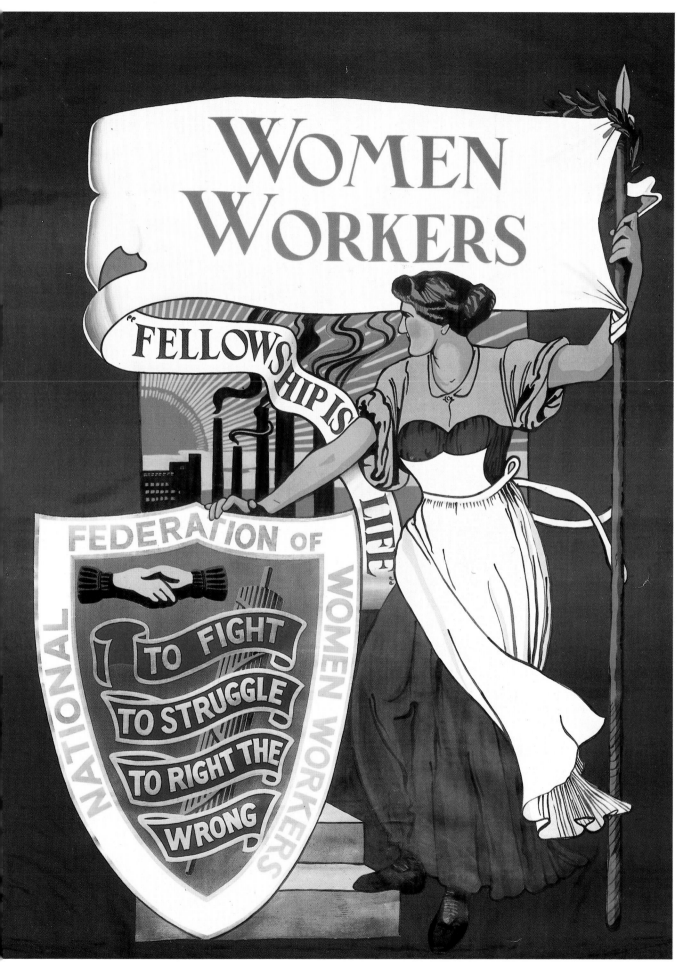

SHOPPING

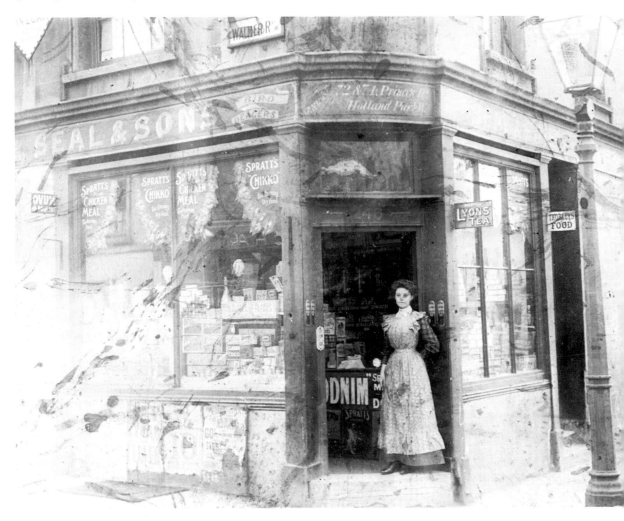

122

AT OXFORD CIRCUS.

123

121. Corner Shop, Walmer Road, West London. Kodak Archive, National Museum of Photography, Film and Television, Bradford. Working-class households with few cooking facilities could buy small quantities of food at the markets or at corner shops, which, like some co-operative stores, gave credit, essential for survival when one third or more of the weekly wage was spent on rent. Small shops like this were staffed by women workers who could not have a break all day, even for meals.

122. Flower sellers at Oxford Circus, 1902. Working-class women made a living selling flowers from the London markets. The opening of the department stores in the West End extended the social spaces of middle-class women, giving them access to the public streets.

123. London and Glasgow Tea Company, Kay Street, Glasgow. Mitchell Library, Glasgow.

124. Sunday morning, Middlesex Street, Whitechapel, 1902. 'Petticoat Lane' was (and still is) a famous street market in the heart of the Jewish neighbourhood of East London, selling meat, fish, fruit, clothes, boots and crockery, alive with the bustle and cries of street hawkers and the sound of gramophones playing music-hall songs.

125. Mrs Codland, Ashreigney, North Devon. Beaford Archive. In rural areas, the village shops – department stores in miniature – tended to be run by women.

124

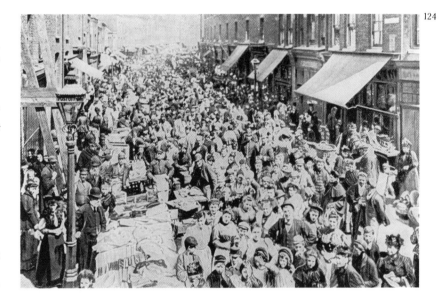

125

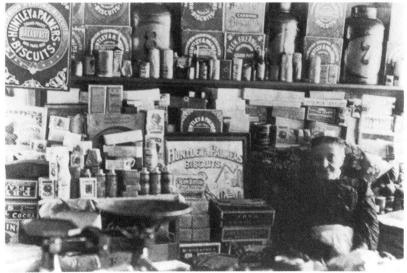

126. Commemorative china and tin, catalogue and handbook from the Co-operative Union and Co-operative Wholesale Society Libraries, Manchester. The co-operative movement had a national network of branches, shops and department stores and the Co-operative Wholesale Society produced and packaged foodstuffs, household products, clothing, footwear and furniture.

127. Stanislawa de Karlowska. *Fried Fish Shop*. 1908. Courtesy of the Trustees of the Tate Gallery, London. Fried-fish shops were common in London and other large cities from the 1880s onwards and provided the working class with cheap, ready cooked food.

128. *Jingles for Juveniles* was produced by the Co-operative Wholesale Society to teach children the benefits of co-operation. John Johnson Collection, Bodleian Library, Oxford.

129. Advertising leaflet. John Johnson Collection, Bodleian Library, Oxford. By the Edwardian period there were over 200 large stores throughout the country.

127

128

There was a young lady called Mabel
Said "To get a nice blouse I'm unable"
But a friend said "My dear,
You have no cause to fear
With CWS on the label".

129

"I've just been to *Peter Robinson's.*"

★ SEE OVER.

"NOW FOR PORTLAND ROAD UNDERGROUND STATION."

4

SEX AND MORALITY

Sinning on a Tiger Skin or Keeping the Beast at Bay

Lucy Bland

Elinor Glyn's *Three Weeks*, written in 1907, prompted this anonymous poem:

> Would you like to sin
> With Elinor Glyn
> On a tiger-skin?
> Or would you prefer
> To err with her
> On some other fur?

The choice was clearly not open to most Edwardians.

Three Weeks told a tale of heated passion and doomed romance between a mysterious and beautiful slavic queen and Paul, 'a splendid English young animal of the best class'.[1] Stretched out on a tiger-skin, undulating like a snake and purring like a cat, she initiates him in the art of love-making. No explicit detail is given of course, but the imagery and innuendo leave little to the imagination. Widely acclaimed (an overnight bestseller), *Three Weeks* was also widely condemned. Elinor Glyn's name became synonymous with exotic, *risqué* adultery and sexual immorality. High society's hostile reaction to the book and to Elinor Glyn exemplified its hypocrisy. While participating in endless, if discreet, extramarital affairs at their country-house parties, most members of the upper classes simultaneously embraced public propriety. Part of the objection to *Three Weeks* must surely have been its positive depiction of an older woman with strong sexual desire, in a relationship with a younger man which she initiates and controls. She ends up dead, it should be added, but the blame is laid squarely at the feet of her evil, drunken husband rather than on her rash adultery.

The Victorian ideology of the ideal woman as an asexual 'angel in the house' still lived on. For every exotic tiger-skin queen there were a thousand very different representations of women's sexuality. To some Edwardians the problem, whatever your gender, was the presence of sex in any form. For example, to philanthropist Louise Creighton, widow of the late

Bishop of London, 'the sensual desires, the flesh, are what have to be kept in subjection, and to do this the wisest plan is to think . . . and speak about them as little as possible'.[2] Easier said than done – especially when you were surrounded by 'suggestive' cultural depictions such as 'naughty' seaside postcards, the knowing winks of music-hall stars or the connotations of much 'modern' literature. The fact that the latter generally had to be sought out by the reader indicates that the Edwardians were almost as obsessed with *looking for* sexual implications as the Victorians. But as we shall see, it was not only an obsession with sexuality but also with building a new sexual morality.

The discussion so far, and the title of this article, may have wrongly implied that Edwardian views on sex could be divided into two opposing camps: a 'liberated' view which saw (hetero)sexual expression as 'natural' and healthy, and a 'repressive' view which wanted to banish sex from all corners of the earth. Neither view is a true representation. On the one hand, the supposedly emancipatory ideas being developed in this period by sexologists such as Havelock Ellis (Freud's ideas were not influential in Britain until after the First World War) were in many re-

130. Elinor Glyn. From *The It Girls* by M. Etherington Smith (Hamish Hamilton).

spects far from liberating – especially for women. They entailed new blue-prints on how people should ('naturally') behave sexually, and anyone stepping outside those dictates was acting 'against nature'. If a woman – at least a married woman – was now thought by some sexologists to be capable of sexual response, she was not meant to *initiate*. And if she didn't respond at all to the wooing of her 'mate' she was also behaving 'unnaturally'. On the other hand, not all those individuals and organizations committed to a moral reformation were seeking the complete silencing of the sexual; many wanted *prescriptions,* not simply prohibitions.

Sanctifying Sex

Although the most prominent morality group of the Edwardian period, the National Vigilance Association (NVA), could be characterized as fixed on banishing all sex and legislating for morality, other moralists diverged from its views. As the Edwardian period progressed, a new kind of morality lobby developed. It drew on both the language of religion and social purity, with its emphasis on 'man's' capacity for self-control and will-power for moral ends, and the language of medicine, with its emphasis on cleanliness and disease. It also drew on Social Darwinism, in particular on eugenics.

Social Darwinism was a loose-knit doctrine, applying concepts from the new evolutionary biology of the late nineteenth century (such as 'survival of the fittest', 'struggle for existence') to the study of social institutions. Eugenics, concerned that natural selection in modern conditions had gone off the tracks and that it was no longer the 'fittest' who were surviving, sought active intervention in favour of methods for breeding 'fitter people'. It saw itself as 'the scientific study of all agencies by which the human race may be improved'.[3] 'Race' tended to refer to the 'human race', the 'white race', or the 'British race', according to the context. The obsession with 'racial fitness' needs to be seen in relation to the threat to Britain's imperial pre-eminence

from Germany, Japan and the United States. In relation to sex, the imperatives were for a practice geared towards the healthy reproduction of 'race' and nation. In its subordination to propagation, the sex instinct became known as the 'racial' instinct.

Victorian ideology designated human sexual desire the 'beast in man' (and I say 'man ' advisedly given that women were thought, ideally, to be asexual). Human sex was now being characterized as distinctive in that it involved the capacity to love. Sex was increasingly seen as the physical basis of love,[4] with love and sex subsumed to the desire to procreate responsibly. While promiscuity was generally seen as 'natural' for men in the nineteenth century, by the twentieth many moralists and medical men were starting to claim that promiscuity was unnatural for *both* sexes. It was *subhuman* (since believed loveless, thus lacking the 'human ' side to sex), *purposeless* (seeking merely immediate gratification rather than the long-term satisfaction of love and procreation), and *irresponsible* (entailing the risk of venereal disease). Nevertheless in practice this did not lead to widespread condemnation of the double standard (the view that lack of chastity was understandable, in a man but unforgivable in a woman), except from feminists. It was always promiscuity in *women* which was seen as particularly undesirable and unnatural, partly because it did not appear to be related to the pursuit of a woman's 'natural' desire for motherhood. Male homosexuality was also deemed unnatural because 'purposeless' (non-reproductive). Lesbianism was generally not recognized at all, given the dominant definition of sex as penetrative and heterosexual, and the lingering view of women as largely non-sexual beings.

Yet, as I have already indicated, a woman was starting to be recognized as having sexual desire, although the desire's expression was only deemed legitimate if she was married, desired solely her husband, and only *responded* to his awakening embraces rather than took the sexual lead. And, of course, above all, she had to be

motivated by the desire for a child. We can now perhaps understand better not only the hostility directed towards *Three Weeks* but also the way in which the heroine, although exotic and foreign, was also explicable: she united sex with love and greatly desired a child, with success on both counts.

The above-mentioned new morality lobby not only combined disparate ideas but entailed a new political alliance. As Frank Mort has pointed out in his discussion of medico-moral politics, clerics, medics, eugenists, imperialists, even Fabians and a number of feminists joined together in furtherance of a new 'responsible', 'healthy', British 'racial' morality. But before elaborating on the nature of their concerns, it is important to consider the pursuits of the group central to Edwardian moral politics: the National Vigilance Association (NVA).

Legislating Morality

The NVA sought both the prohibition of imagery they found offensive and the curtailment of certain sexual behaviour, including the sexual abuse of women and children. They were active in getting incest on to the statute book as a criminal offence in 1908; until then it had been an ecclesiastical offence only. A number of feminists had joined the NVA at its inception in 1885 and they had enthusiastically contributed to its work of countering sexually abusive behaviour. But many came to condemn its 'solution' to prostitution, namely the harassment of prostitutes. These feminists thus left the NVA and by the Edwardian period only a few remained as members. Above all, the NVA called on the law to act as the central educator and protector of the British public. To William Coote, the secretary of the NVA, 'the law is the guardian angel in the matter of public morals'.[5]

The NVA focused on a wide range of cultural representations which it found offensive or indecent – literature, plays, music-hall sketches, dance, postcards. Such was its influence that it was often successful in getting the offending item removed. The fact that the Theatre and

Music-hall Committee of the London County Council (LCC) was largely sympathetic to the aims of the NVA helped enormously. The Local Government Act of 1888 had transferred to the new LCC certain powers previously held by the justices. While the Lord Chamberlain continued to act as censor of London's plays, the task of keeping a watch on other forms of entertainment fell to the LCC. This included the licensing of nearly four hundred music- and dancing-halls.

One of the entertainments to which the NVA took exception in this period was termed 'living statuary'. It had first been introduced to England in 1893 by the music-hall entrepreneur Charles Morton, at the Palace Theatre, Cambridge Circus. Famous scenes from art and history were depicted in tableaux by the posing of actors. In some of these the actors were partially undressed; where accuracy necessitated nudity, they wore tight, flesh-coloured garments giving the semblance of nakedness. The NVA secretary Coote quickly managed to obtain a promise from Charles Morton that any pose found objectionable by the LCC would be withdrawn. Although living statuary continued to be staged at various music-halls, the NVA paid it little further attention until 1907. Along with the London

131. The Seldoms Living Statuary, 1907. Mander and Mitchenson Theatre Collection.

132. Ethel Walker. *The Forgotten Melody*. 1902. Laing Art Gallery, Newcastle upon Tyne (Tyne and Wear Museums Service). The daughter of a wealthy Edinburgh ironfounder, Ethel Walker's early works presented middle-class femininity as leisured and accomplished, a view informed by her class.

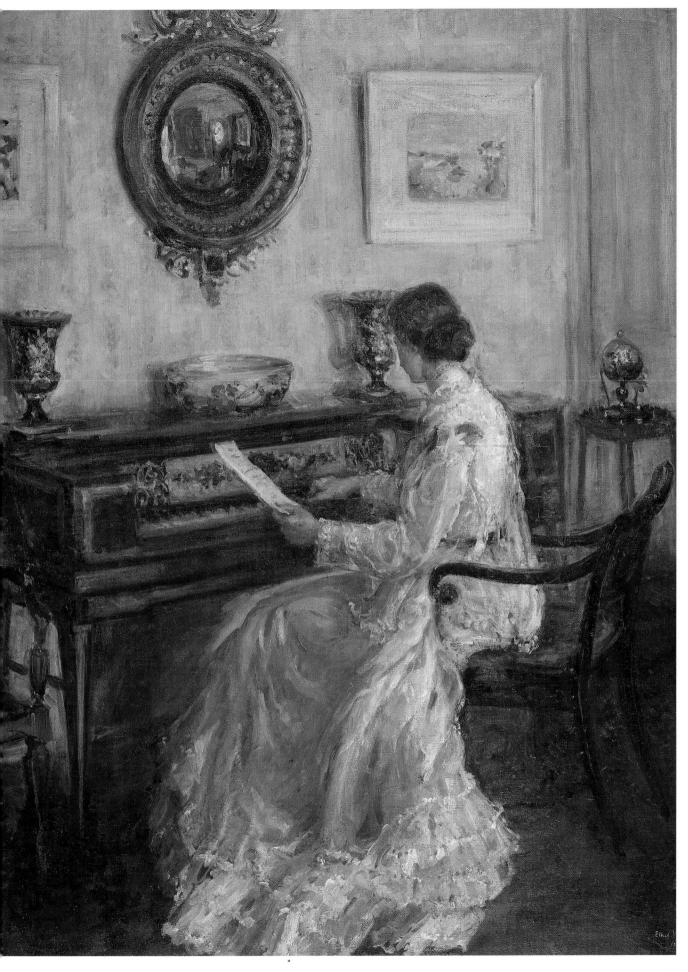

133

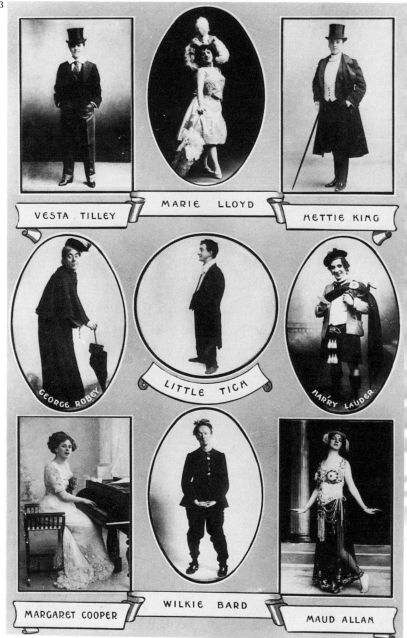

Council for the Promotion of Public Morality (LCPPM), an organization headed by the Bishop of London, the NVA then sent a deputation to the LCC demanding it be banned. The deputation claimed that living statuary demoralized both spectators and performers, it impeded efforts 'to raise the spirit of purity and self-control among boys and girls', and they felt that 'the people who go to music-halls ought to be protected against anything which may exert a depraving or corrupting influence'.[6] In other words, it was necessary to 'protect' the working classes, who do not know any better – a continuation of the class bias central to so much philanthropy of the nineteenth and early twentieth centuries. Initially the LCC declared itself unable to prohibit the living statuary, but under further pressure it capitulated.

The NVA's attempt to ban the Canadian dancer Maud Allan the following year was less successful. At the Palace Theatre she appeared 'in a wisp of chiffon and bare legs', finishing with Salome's dance, which, according to a contemporary observer, was 'considered scandalous, for she was all but naked and had St John's head on a plate and kissed his waxen mouth'.[7] Unsurprisingly, the NVA objected to 'the inadequate clothing and the dance of Salome'.[8] The LCC explained that her high patronage – she had the support of the King and of the Prime Minister, Asquith – rendered her untouchable. The Manchester branch of the NVA had more success and her Solome dance was banned in their city.

If it failed to banish Maud Allan from the London stage in the summer of 1908, by the winter the NVA had managed to prosecute the publisher of a book called *The Yoke*. Their journal was delighted: 'We . . . rejoice to find such unanimous opinion on the part of the Press in favour of our prosecution, and against permitting the purveying of this immoral garbage under the assumption that it is literature.'[9] The NVA had successfully prosecuted other books in the past – for example, the works of Zola and Balzac.

The Yoke tells of Angelica, middle-class, beautiful, unmarried and forty, whose fiancé, a widower, had died twenty years earlier, leaving two-year-old Maurice in her care. The narrative opens with Maurice, now twenty-two, training to be a barrister. Under her upbringing he had become 'a fine, straightforward, upright young gentleman. She believed that he had no vices.' But Angelica is worried that Maurice's sexual desires will lead him to visit prostitutes and thereby risk venereal disease. To keep him 'pure' until he is ready to marry, she realizes 'there was one way to save Maurice, one only; the yoke that had lain heavily on her all the days of womanhood . . . that yoke could be broken'. The 'yoke' was that of chastity, and the book explicitly recognizes a woman's sexual needs. Her fiancé had died 'but He (God) had not removed – and He appeared to have no immediate intention of re-

3. Card showing music-hall ars, 1908, including, lower ght, Maud Allan as Salome. ander and Mitchenson heatre Collection.

4. The Empire Promenade, 002. Mary Evans/Fawcett brary. The Empire Music all in Leicester Square was orld famous; it was fre- uented by upper- and iddle-class men and prosti- ates, 'the aristocrats of their rofession'.

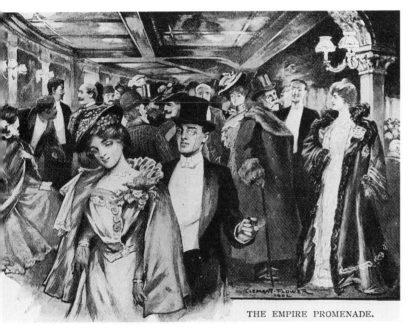

THE EMPIRE PROMENADE.

moving – those fundamental instincts which are the basis of all sexual love'.[10] Maurice was to be 'saved' through her 'giving' herself to him. Maurice's friend Chris has no such solution of-fered; he goes to a prostitute, catches syphilis and kills himself. By the end of the book Maurice has met his future wife and Angelica delivers him up to her 'clean' and 'pure'.

The book is thus in certain respects highly moral, but both its open portrayal of sex as a natural instinct needing gratification, as strong in a woman as in a man, and its vindication of ac-tion akin to incest, rendered it beyond the pale to the NVA. Significantly, when the summons was brought against the publisher *The Yoke* had been in print nearly two years and was in its eighth edition, but it had only been in a cheap paperback for a few months.[11] The desire to pro-tect the young and the 'impressionable' working class was probably the crucial instigator of the NVA's tardy action.

Directing the Racial Instinct

If the NVA was concerned to silence all reference

to sex, the National Social Purity Crusade (NSPC) and its secretary, the Revd James Mar-chant, had rather different objectives. It was true that the latter shared its hatred of 'noxious literature' with the NVA, but the bulk of its energy became directed towards considering how to counter the dysgenic (anti-eugenic) im-plications of the falling birth rate and the gen-eral 'degeneration' of the British race. Its answer was a crusade committed to educating the pub-lic in the tenets of eugenical sex and marriage, encouraging a sex education of the young which directed them towards healthy and 'responsi-ble' marriage and parenthood and away from promiscuity. It also sought legislation that in-volved genetic control of the feeble-minded, thereby curbing the reproduction of 'degener-acy'.

The NSPC had originally grown out of the NVA, but Marchant and Coote acrimoniously parted ways early on. The Crusade proceeded in fits and starts. After a burst of activity in 1902–3 it virtually disappeared until 1908, when Mar-chant announced a Forward Movement commit-ted to educating the public in the matter of the nation's morals. In late 1910 the Crusade changed its name to the National Council for Public Morals (NCPM). Its eugenical and im-perialist slant now fully developed, it presented itself as set on 'the promotion of the moral and physical regeneration of the race'.[12] In May 1911 it presented its manifesto and launched a series of 'Tracts for the Times'. The first, entitled *The Problem of Race Regeneration*, was written by sexologist Havelock Ellis. Here was the sup-posed emancipator collaborating with the moralists! Yet Ellis was in agreement with many of the NCPM's arguments. He referred to it as 'a very influential body, with many able and distin-guished supporters. Law-enforced morality . . . constitutes but a very small part of the reforms advocated by this organization . . . [which] has lately to a considerable extent joined hands . . . with the eugenics movement, advocating sexual hygiene and racial betterment.'[13] Thus their meeting point was eugenics. To aid race regen-

eration, Ellis argued not simply for 'sex hygiene' (eugenical sex education), but also for the voluntary sterilization of the 'feeble-minded', 'to allow the unfit to make themselves "eunuchs for the Kingdom of Heaven's sake" '.[14]

During the Edwardian period sex education was increasingly put forward as an important remedy for Britain's moral ills. There was a proliferation of leaflets, pamphlets and books directed either at the child or adolescent or at their various educators (parents, clergy or teachers). Although there were certain continuities from Victorian tracts – notably a stress on self-control and the dangers of masturbation, now extended to girls as well as boys – a number of *new* themes were in evidence. Most proclaimed that the greatest prevention of and protection from sexual vice lay with the removal of sexual *ignorance*. Armed with sexual knowledge, no boy or girl would contemplate a sexually impure act, let alone commit one. It was time to 'speak out' frankly about sex, to banish silence and ignorance for ever. To be forewarned was to be forearmed.

This 'knowledge' was both to protect and to direct. It consisted of certain biological and ethical 'facts of life' set within an evolutionary context. The purpose of sex was presented as procreation, and for humans, also love – the distinctly *human* aspect of sex. Seeing sex as having a purpose by implication gave sex a 'natural' (and hence desirable) direction. To 'keep' yourself 'pure' and 'clean' for the 'racial task' of healthy child production entailed chastity, succeeded at marriage by sexual continence. Some went so far as to suggest that people with bad health 'have no right to marry' since 'true patriots should consider the welfare of the race before their personal gratification'.[15]

Although girls were to be given sex education, there was ambivalence as to *how much* they should actually be told. For their own protection, girls must be warned of the dangers, but despite explicit statements that innocence equalled fatal ignorance, these texts also retained a desire to *maintain* such innocence in

girls – again in the name of protection. What was desired was 'instructed innocence'.[16] One sex educator believed girls should expect the very best of all men, while simultaneously watching themselves 'lest we make it harder for any man to be a true knight'.[17] By implication, the responsibility for any 'unknightly' behaviour was laid at the feet of the girl. Another pamphlet cajoled, 'on you depend the purity and moral worth of that England that is to be . . . Prefer death to selling . . . body and soul, thereby dragging down a man also to his fall'.[18] Thus we find contradictory ideals. A girl was to be kept in partial innocence-cum-ignorance while simultaneously being expected to be responsible for her own sexual behaviour, that of the man's and for the morality of the entire country!

It was assumed to be so much *harder* for a boy to 'refrain'. And he certainly could not be 'saved from impurity' if 'he gets into the habit of exchanging glances with girls . . . socially inferior, if he reads suggestive books and looks at stimulating pictures and sights'.[19] The evils of 'noxious literature' and the like were never completely out of the minds of most sex educators, despite their adherence to the new *prescriptive* morality. A few prohibitions always seemed to co-exist with the new directives.

Seeking An Equal Moral Standard

There was yet another important morality lobby: feminism. Today the feminism of the early twentieth century is generally thought of simply in terms of the heightened struggle for the vote. However the suffrage campaign was accompanied by an increasing commitment to the fight for an equal moral standard – for men to live by the same standards they demanded of women. Feminists linked the demand for sexual morality with the demand for the vote; once women had the vote, the argument went, not only would they be stronger, more independent and self-respecting, they would also be able to introduce legislation which would at last provide them with real protection.

Even without the vote, feminists were con-

135. Charles Shannon. *The Sculptress*. 1906. Musée d'Orsay, Paris. The sculptress is Kathleen Bruce, then at the beginning of her professional career. She became well known for her portraits and public statues.

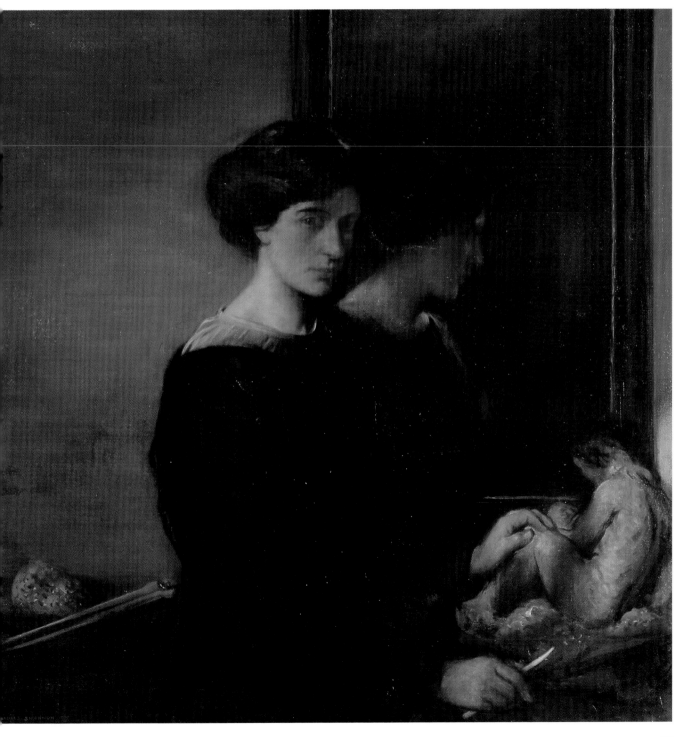

WHITE SLAVE TRAFFIC

SWEATED LABOUR

-M HUGHES-

THE SCYLLA AND CHARYBDIS OF THE WORKING WOMAN.

136

136. M. Hughes. *The Scylla and Charybdis of the working woman.* Mary Evans/Fawcett Library. The working-class woman steers her course between 'sweated' labour and prostitution.

137. Christabel Pankhurst speaking in Hyde Park, 1909. Mary Evans/Fawcett Library.

tinuously demanding better laws and their just administration. For example, one of the concerns of the period was white slavery – the coercion of women into prostitution. The 1885 Criminal Law Amendment Act, which had raised the age of consent from thirteen to sixteen, had also contained a clause leading to the closure of many brothels. A consequence of this was a rise in the number of male pimps moving in to control women on the streets. Feminists called for legislation to deal with this problem. They were also very concerned with the prevalence of sexual abuse of girls and women, and the scandalously mild sentences meted out to the accused. Thus the suffrage group the Women's Freedom League started weekly reports in its paper on court cases of sexual abuse. They compared the very low sentences given for male abuse of women and children with the much higher sentences given for property crimes or crimes committed by women. For example, there was a case of indecent assault of a four-year-old girl for which the male offender got two months, compared with the fifteen months given to a man for the theft of a bottle of wine. To get information on these cases and to support the female victims, some feminists adopted direct action tactics. They would attend court hearings and, despite magistrates and judges calling for all women to leave the court each time a case of sexual assault came up, they would refuse to move. Such cases were considered unfit for 'decent' women to listen to. Unsurprisingly, women

were calling for women magistrates, judges, jurors and police.

Feminists picked up on the dominant definitions of sex, but through incorporating them into their sexual politics they radically transformed them. In arguing for women's and children's protection from sexual dangers, feminists frequently drew on the current anxiety over national health, motherhood and the declining birth rate. Women were being accused of irresponsibility in their maternity and selfishness and degeneracy in their sterility. Feminists, however, accused men. It was men, through their sexual licentiousness, who had brought disease into marriage; this was the cause of women's sterility and infant mortality and morbidity. The most (in)famous feminist tract was Christabel Pankhurst's *The Great Scourge and How to End It.* Drawing on medical statistics, she claimed that 75–80 per cent of all men were infected with gonorrhoea and 'a considerable percentage' with syphilis. Although she was ac-

137

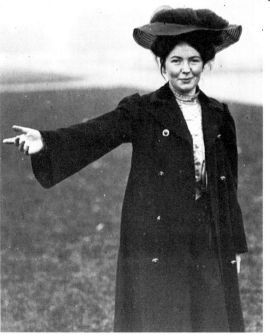

138

139

138. Advertisement for abortifacients, 1912. *Myra's Journal,* November 1905. British Library.

139. *The Suffragette,* cover, 17 October 1913. Fawcett Library.

THE FORCES OF EVIL DENOUNCING THE BEARERS OF LIGHT.

cused of great exaggeration, the medical profession was producing similar figures. She announced that 'the sexual diseases are the great cause of physical, mental and moral degeneracy'. With a number of other feminists, she argued that 'women's diseases' were not intrinsic to the female constitution, but were rather the effects of VD surreptitiously imposed by philandering husbands on their unsuspecting wives.[20] Frances Swiney, the feminist theosophist, saw the 'hidden scourge' as part of a wider degeneracy instigated by men. 'The degeneracy we deplore lies at the door of a selfish, lustful, diseased manhood . . . Men have sought in woman only a body. They have possessed that body. They have made it the refuse-heap of sexual pathology.'[21] Pankhurst urged women not to sacrifice their bodies to polluted men; she was convinced that 'there can be no mating between the

spiritually developed women of this new day and men who in thought and conduct with regard to sex matters are their inferiors.' To bring about lasting change one needed 'Votes for Women, Chastity for Men.'[22]

The cover of the *Suffragette* clearly illustrates some of these themes. Women felt their spiritual superiority, their purity, to be a *shield* that protected them from the pollution of (male) indecency (the bestial, physical side of sex). Further, it was a 'sword of the spirit' that acted as a weapon in the public space controlled by men.[23] Joan of Arc, a favourite heroine for suffragists, was exemplary in her self-sacrifice for freedom and in her purity (her virginity). The physical side of sex was seen as a mark of the beast, rooted in our evolutionary past. Women were thought to have evolved higher than men in this respect, to a state in which spiritual love, not physical lust, was uppermost. This tended to mean that women were seen as passive sexual *victims* and any woman who was sexually active was thereby deemed aberrant. Not surprisingly, there were certain feminists – Rebecca West and Stella Brown, for example – who disagreed with this view. They started to adopt the definitions and language of sexology since it seemed to provide the only way of seeing women as *legitimately* sexual. But for those feminists who were demanding an equal moral standard on their *own* terms, sexology entailed the 'requirement' that women be sexually active and sexually available on terms more desirable to men.

Sexuality Experienced

Did the NVA's prohibitions affect people's desires and acts? Did the sex education of the NSPC/NCPM and others actually direct the subsequent sexual behaviour of those subjected to it? And did women and men respond to the feminist demands for male chastity – did women insist on it, did men comply? It is impossible to give definite answers to these questions. Few records seem to have been kept of men and women's actual sexual experiences in this period. What we do know however is that both

140

140. Advertisement for abortifacients, 1905. *News of the World*, 7 January 1912.

the birth rate and the rate of illegitimacy had been declining since the 1870s, with the birth rate falling particularly among the middle classes. It has been suggested that this was partly due to Edwardians engaging in less sexual intercourse.[24] It was also clearly related to greater use of birth control.

Feminists, well aware that many married women suffered unwanted sex and involuntary childbearing, called for 'voluntary motherhood' through the practice of 'continence' – the spacing of sexual intercourse and thus of pregnancies. They were against mechanical birth control because they felt it reduced the woman to the status of a prostitute, as well as being in itself harmful (and the medical profession assured everyone of the latter). Where birth control was in use, the most common form practised was withdrawal. Some people did use mechanical means: sheaths were widely available in barber shops, and the 1890s had seen an upsurge of commercial literature publicizing sex manuals, contraceptives and abortifacients. Although abortion had been illegal since 1803, many working-class women (and probably a fair number of middle-class women) took pills or herbs to 'bring on' a period.[25] Whether or not people were restricting their offspring or restraining themselves for eugenical reasons is another matter! It is far more likely that financial constraints as well as women's ill-health from continual childbearing were the important considerations.[26] That many women may now have felt able to insist on male restraint or continence is likely to have been related to the circulation of feminist ideas; the rise of sex education manuals may also have had some impact. 'Ignorance' however was not banished forever; many were still entering marriage with little knowledge of sex and reproduction.

Few men and women lived in heterosexual partnerships outside of marriage, despite their depiction in certain 'scandalous' novels, for example H.G. Wells's *Ann Veronica* (1909). 'Free love' was generally disapproved of, even by feminists, but there were exceptions. The anarchist-feminist journal *The Freewoman* gave space to a frank discussion of sex and marriage and some of its contributors (male and female) supported 'free love', although they all saw it as involving a *monogamous*, preferably long-term, relationship. As for living in homosexual relationships, male homosexuality, but not lesbianism, had been a crime since 1885. Given that lesbianism was barely recognized by anyone at all, some women were able to live with other women in relationships that might today be termed lesbian (and thus seen as sexual) but were not then so construed.

Contrasting Moralities

If we compare the competing sexual moralities of the NVA, the NSPC/NCPM and suffragism, we notice certain clear contrasts. While the NVA was concerned to banish virtually all represen-

141. William Orpen. *A Bloomsbury Family.* 1907. Scottish National Gallery of Modern Art, Edinburgh. The ideologies of the family and motherhood strengthened during the Edwardian period. This patriarchal document reinforces the dominant relations of power in the family. The artist Mabel Pryde stands at the back of the room, whilst her husband, the painter William Nicholson, seated, presiding over the table.

142. 'Don't be shocked, Aunt Cathie, but I occasionally smoke.' Ladies Realm. 1908. Mary Evans/Fawcett Library. More women now smoked, although it still carried a sexually risqué connotation.

" 'Don't be shocked, Aunt Cathie, but I occasionally smoke.' "

tations which it took to be sexually indecent, it was particularly concerned with representations of the bodies and sexuality of *women*. The NSPC/NCPM was likewise concerned first and foremost with women and girls, but their objective was the control and directing of female sexuality into eugenical motherhood. Most feminists, however, took *men's sexuality* as their central object. On the one hand, men were to be prohibited from committing sexual abuse of women and girls; on the other, chastity was prescribed as the only way both to save the country from degeneracy and to transform relationships between the sexes. Men, for once, would have to behave responsibly, and women were forcing them to do so. Or so feminists believed.

After the War, the claim of sexologists such as Ellis became dominant: that everyone, including women, 'naturally' needed a regular (hetero) sexual outlet. The older feminist tradition which perceived chastity as *empowering* for women and essential for men was thereby undermined,[27] as also was the feminist demand for an equal moral standard. A new configuration of morality groups took to the public stage and the demand that men as well as women should take responsibility for sexual encounters went temporarily into abeyance. Today, in the 1980s, moral politics have shifted yet again. Mary Whitehouse and the rest of the 'moral right' have their roots in the NVA; feminists are not making demands identical to those of our foremothers, but the insistence on *men* taking responsibility is still as pertinent today as ever.

5

SUFFRAGE CAMPAIGNS

The Political Imagery of the British Women's Suffrage Movement

Lisa Tickner

... the Woman Suffrage Movement differed from the general run of political strife ... every rank and grade took part in it. And it was the first political agitation to organise the arts in its aid ...
Cicely Hamilton[1]

Petitions are played out ... Petitions go into Parliamentary waste-paper baskets. They cannot put a procession of fifteen thousand women into waste-paper baskets ... women of every class, of every profession and calling ...
Emmeline Pethick-Lawrence[2]

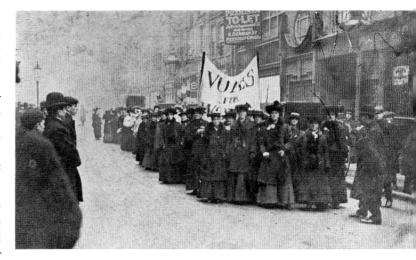

144. 'Votes for Women' procession from Caxton Hall to Parliament, 19 February 1906. *Daily Mirror* photograph, Museum of London.

British women fought for the vote for more than fifty years.[3] Their struggle neither began in the Edwardian period nor ended in it, but during those years the campaign was revitalized and transformed. The old established National Union of Women's Suffrage Societies (NUWSS) – heir to the organizations founded in the 1860s and consolidated since 1897 under the presidency of Millicent Fawcett – was joined by the Pankhursts' Women's Social and Political Union (WSPU) in 1903, and its splinter-group, the Women's Freedom League (WFL), in 1907. Both the WSPU and the WFL were frustrated with the ladylike tactics of Victorian pressure groups and helped to establish a militant campaign. But what distinguishes the Edwardian suffrage movement is not only its mili-

tancy (which culminated in the arson attacks of the WSPU in 1913) but a new politics of spectacle and pictorial propaganda. In 1907 the Artists' Suffrage League was founded and in 1909 the Suffrage Atelier. Numerous by-elections and the two general elections of 1910 provided a political focus for the circulation of propaganda and stimulated the production of posters and postcards. Up to 40,000 women at a time took part in a series of elaborately orchestrated demonstrations between 1907 and the suspension of suffrage activity on the outbreak of war in 1914.

Before the 1832 Reform Act women had not voted, but then neither had most men. The 1832 Act created the middle-class franchise, but by employing the term 'male person' excluded women from it. One of the first liberal acts of a reforming age had as its corollary the effective limitation of women's rights *as women*. The Reform Acts of 1867 and 1884 enfranchised whole new sections of the community, gave the majority of men the vote for the first time, and in the process left sex as the principal ground for disqualification. After 1884 the debates around 'fitness' for citizenship (which had previously taken place in terms of wealth, class, literacy and education) were conducted exclusively in terms of gender. Women were left out of the democratizing process on the grounds of their

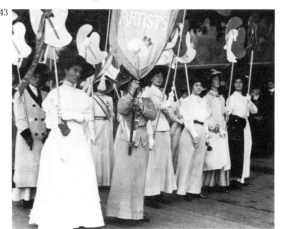

143. WSPU procession, 23 July 1910: artists from the Suffrage Atelier with palette and ribbons. Nurse Pine Collection, Museum of London.

143

proper exclusion from public life.

The success or failure of the women's cause was thus intimately bound up with deep-seated beliefs about the nature of femininity and the proper place of women. (An idealized 'womanliness' belonged in its 'separate sphere'; deviant and unnatural femininities were material for clinical investigation on the one hand, for the music-hall and popular postcards on the other.) Edwardian suffragists were obliged to counter established, sometimes conflicting, but always more dominant and conventional representations of middle-class femininity. Ideas about women were not the private mental property of individual women and men, but permeated the legal, political, and social institutions and practices that perpetuated them. But neither the representations nor the practices that secured women in subordinate positions were immutable. Even long-cherished beliefs were subject to fatigue, and threatened by the impact of new industrial, economic, and political forces in the pre-war period. And ideas about women were productive as well as repressive, so that suffragists were concerned not just to refute existing notions of femininity, but to adapt and exploit them in the service of their cause.

Argument Exhausted

Nineteenth-century feminists, turning to the vote as the last of what Millicent Fawcett called 'a series of intolerable grievances' to be redressed, adopted the tactics of a pressure-group campaign.[4] They published journals, organized petitions, lobbied MPs, held public meetings, and established a network of local branches. And yet their weapons were pitifully few. As a sex they were without political or economic power, divided in their class allegiances, and isolated in their separate spheres. They had no forum in which to argue for their rights and no means of compelling attention which did not 'unsex' them and thereby compromise their claim. It was inconceivable in the 1860s, or even at the turn of the century, that they could mount the kind of demonstrations which had influenced the passage of the great Reform Bills. In the House of Commons debate on women's suffrage in 1892, Asquith had expressed the view that, 'as to the great mass of the sex, the only thing that can be asserted with truth is that they are watching with languid and imperturbable indifference the struggle for their own emancipation.'[5] As Prime Minister (from 1908) he continued to demand *proof* that a substantial majority of women wanted the vote, and yet it was far from clear what form this proof might take. The political parties were each divided on the issue, suffragists were uneasy about a referendum (and loath to accept the verdict of a franchise that excluded them), and the systematic opinion poll did not exist. Women were caught in the circuit of two related propositions: that respectable women were indifferent to the vote and that organized feminists did not deserve it.

With the defeat of a women's amendment to the Reform Bill of 1884 interest had waned, both in Parliament and in a disheartened suffrage movement, for which these were, in Lady Frances Balfour's phrase, the 'doldrum years'. But the prospect of a general election spurred suffragists into a new phase of activity around 1905. The WSPU, for two years a small and provincial grouping centered on the Pankhurst family in Manchester, moved to London, broke with the Independent Labour Party and the constitutionalists, and during the autumn of 1905 and the spring of 1906 developed the militant tactics that were to make a tremendous (if controversial) impact on the campaign as a whole. In October 1905 Christabel Pankhurst and Annie Kenney disrupted a Liberal election meeting at the Free Trade Hall in Manchester. Hustled outside, they attempted to address the crowd as it left, were arrested and, on refusing to pay their fines, imprisoned. Militancy in its first phase consisted of minor insurgencies on this pattern, but it was enough to bring the WSPU to prominence, to break the stalemate caused by public apathy and press indifference, and to make the women's cause a topical issue in the run-up to the general election of 1906.

The landslide Liberal victory of 1906 was the greatest electoral triumph in the party's history. The number of Liberal MPs was almost doubled and a majority of members from all parties in the new House had pledged support for women's suffrage. But the women's cause was not advanced, and in the face of government vacillation or indifference the WSPU increased the scope of militant activity. They were, Mrs Pankhurst believed, at a crossroads:

> We had exhausted argument. Therefore, either we had to give up our agitation altogether, as the suffragists of the early eighties virtually had done, or else we must act, and go on acting, until the selfishness and obstinacy of the government was broken down, or the government themselves destroyed.[6]

This was not the constitutionalist position. They were against militant activity on principle, and they also believed it was counter-productive. After 1909 the tension between the NUWSS and the WSPU threatened to pull the suffrage movement apart, but in its early years there is no doubt that the WSPU brought recruits to a flagging cause, gave new life to the movement, and provoked the traditional suffrage societies into a reassessment of their own methods. What linked the constitutionalists and the militants (united on ends but not on means) was the use of a new kind of political spectacle, and the production of an iconography of their own. For the WSPU it complemented and rehearsed their acts of militancy and martyrdom. For the NUWSS, who sought a revitalized campaign without resort to force, it took that place.

The 'Mud March', 1907

At the end of 1906 the constitutionalists planned a large open-air demonstration to coincide with the opening of the next session of Parliament in February 1907.[7] The Artists' Suffrage League was formed in January to help with the preparations, and more generally 'to further the cause of women's enfranchisement by the work and professional help of artists'.[8] Organizing a demonstration was in many respects a logical next step from organizing a petition. Spectators could see that suffragists were not the shrews and harridans of the popular press, and women's physical presence did away with the frequent objection to petitions: that they were fraudulent, or signed in ignorance and haste.

But there was still a danger that in taking to the streets as men had done to redress their grievances, women would bring themselves and their cause into disrepute. This apprehension is almost palpable in accounts of the preparations for 9 February 1907. But if Mrs Fawcett and Lady Frances Balfour – together with other women of unimpeachable respectability and social standing – could survive the experience of marching from Hyde Park to the Exeter Hall with 3000 members of the NUWSS, there was no need merely to endure the experience; it might even be possible to enjoy it. According to a participant writing in the *Manchester Guardian* it was not the status implied by the cars and carriages alone, the festive splashes of red and white in banners and rosettes, or the mix of working women, artists, doctors, nurses, teachers, and writers, but the whole spectacle of thousands of women 'who would not naturally court the public gaze, tramping through muddy streets for the sake of an ideal' that 'bettered all our old arguments and our faultless logic'.[9] The 'Mud March',[10] modest and uncertain as it was by subsequent standards, established a pattern for ordered, large-scale processions accompanied by banners and bands and the colours of constituent societies. It was a pattern that drew selectively on the precedents of state ritual (developed in the heyday of 'invented traditions' between 1877 and 1914),[11] on labour movement activities which had influenced the WSPU, and on a more diffuse Victorian and Edwardian fascination with pageantry which the suffragists fused with the political demonstration in their own and, as it was remarked at the time, particularly 'feminine' kind of spectacle.

145. Caroline Watts. *The Bugler Girl*. Published by the Artists' Suffrage League, for the NUWSS procession of 13 June 1908. Schlesinger Library, Radcliffe College, Cambridge, Mass.

102

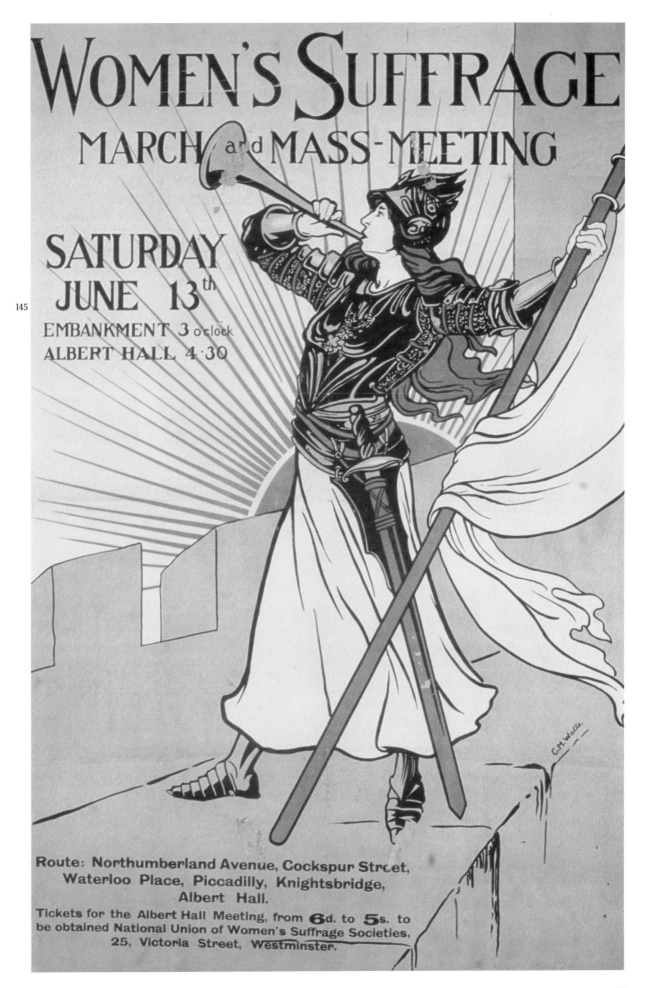

Spectacle as Politics, 1908

Both the NUWSS and the WSPU planned further demonstrations for 1908. These plans can only have been confirmed by the contribution of Herbert Gladstone, the Home Secretary, to a debate on the second reading of a women's suffrage Bill in February 1908:

> On the question of Women's Suffrage, experience shows that predominance of argument alone, and I believe that this has been attained, is not enough to win the political day . . . [Men] know the necessity for demonstrating the greatness of their movements, and for establishing that *force majeure* which actuates and arms a Government for effective work. That is the task before the supporters of this great movement . . . Of course it cannot be expected that women can assemble in such masses, but power belongs to the masses, and through this power a Government can be influenced into more effective action than a Government will be likely to take under present conditions.'[12]

Gladstone's statement was taken to indicate, as Sylvia Pankhurst put it, that 'the Government was not hostile, and waited only a larger manifestation of demand.'[13] The NUWSS demonstration of 13 June 1908 and that of the WSPU on 21 June were meant to establish the strength of that demand.

If the novelty of the spectacle provided by the Mud March had rested on the impropriety of women demonstrating *en masse* in the public streets at all, that card was a risky one, and could not be played twice. The solution was to 'embroider' the precedent of 1907: symbolically, by elaborating its arguments and orchestrating their presence as spectacle; and *literally*, through the production of a series of art needlework banners that would embellish and articulate the procession at the same time as they guaranteed the 'womanliness' of its participants. With elegant sleight of hand, women responded to the accusation that they were 'making a spectacle of themselves' by doing precisely that, in full self-consciousness and

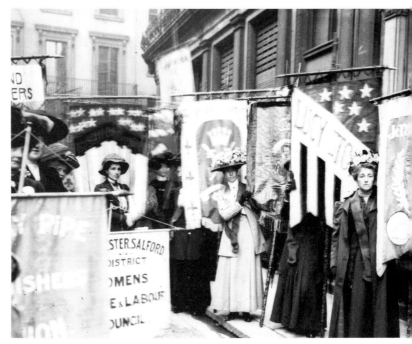

146. Attending the NUWSS march, 13 June 1908. Museum of London.

with great ingenuity. They were indeed part of the spectacle, but they also produced and controlled it. As active agents they had no need passively to endure the gaze of curious or indifferent bystanders; they could invite it, respond to it, work with it, and move on. Their bodies were organized collectively and invested politically, and were therefore resistant to any purely voyeuristic appropriation.

Huge crowds watched these demonstrations and assembled at the public meetings with which they ended, but still larger numbers read about them in the daily press. Virtually every national daily, all the important periodicals, and most of the provincial and local London newspapers published accounts of the march of 13 June, which stressed the impact of its pageantry, the dignity and social diversity of its participants, and its organization as a public event. Leader writers were compelled by its topicality to discuss the political aims of the campaign. Suffragists were confirmed in their belief that the time for reticence was past. As Lady Frances

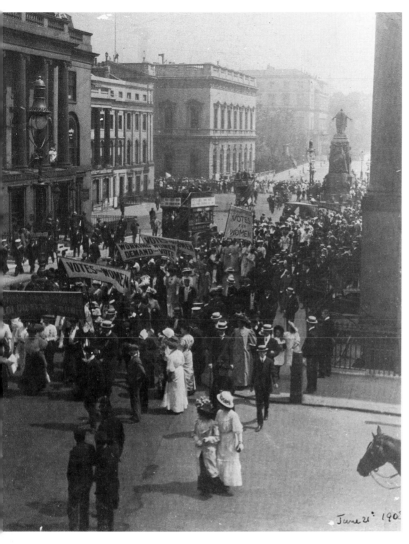

7. WSPU procession, 21
June 1908. Museum of London.

fragettes that mighty mobs of people are brought together. The newspapers at present advertise the movements of the militant maids and matrons before a demonstration, during a demonstration, and after a demonstration. Publicity is the life-blood of the campaign.[15]

But suffrage spectacle was not just for the onlooker. Suffragists themselves, directly and through their own rapidly expanding press, were also part of its audience. They were organized and educated and entertained by it, as the grim endurance of 1907 gave way in 1908 to reports of triumphant contingents arriving flushed and victorious at the Albert Hall. Women experienced their collectivity in the act of presenting it to the public gaze. The suffrage campaign 'was our Eton and Oxford, our regiment, our ship, our cricket match' as Rachel Ferguson observed;[16] or, as Emmeline Pethick-Lawrence put it more prosaically, 'our education in that living identification of the self with the corporate whole'.[17]

'An army with banners'

On the morning of 13 June 1908 The Times published a long article by Mrs Fawcett which promised London 'the opportunity of seeing a street procession unique in character, not only in this country, but also in any part of the world'. The sense of a consciously cultivated spectacle marks an important shift from the procession of 1907. What determined the success of that spectacle more than anything else were the banners produced for it. Banners celebrated a 'women's history' in their iconography, their mottoes, and their collective workmanship. They mobilized women's needlework skills – so much a part of the feminine stereotype as to be almost a secondary sexual characteristic – at the same time as they challenged the terms on which 'femininity' was prescribed.[18] Even the anti-suffrage Times referred to the banners displayed in Caxton Hall before the procession as the 'art exhibition of the year'.[19] Suffragists exploited their useful ambivalence: soothing and subversive, artistic and political, feminine and feminist.

Balfour put it, all the precedents pointed to the public demonstration as a political lever with which to effect constitutional change. A cabinet minister 'had asked that women should show themselves in masses before he and his government can really believe they need and desire the Franchise. If these things are demanded of women they must be done.'[14]

What justified the suffragists' use of spectacle as a political strategy was the hold it gave them on the newspapers – especially the new, popular, national, halfpenny dailies, with their halftone photographic facilities and appetite for sensational events – and, through the newspapers, on public attention in the country at large. Pamphlets and meetings made dull copy when one woman breaking a window could make all England ring. This was the militant discovery, and both militants and constitutionalists learned to exploit an appetite for something topical, sensational, and capable of vivid illustration. The Referee in 1908 was acute, if unsympathetic, in observing that it was

> only by means of the wide publicity given by the Press to the intentions and actions of the suf-

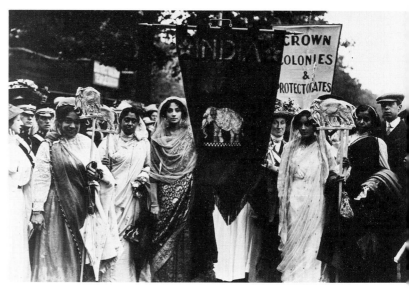

Mary Lowndes – chairman of the Artists' Suffrage League and designer of many of the banners carried in the NUWSS procession – borrowed from nineteenth-century medievalism the claim that in 'all the ages it has been woman's part to make the banners, if not to carry them',[20] and mourned the loss of that tradition. Fighting heroes now came tailor-fitted 'and any flags they want can be ordered from the big manufacturers'. But with the new century came new political societies 'started by women, managed by women and sustained by women', and 'now into public life comes trooping the feminine; and with the feminine creature come the banners of past times, as well as many other things which people had almost forgotten they were without.' By conventional criteria, of course, the feminine could by definition *not* come trooping into public life; it was the use of embroidery that enabled women to speak the 'feminine' in the public and political arena.[21]

Mary Lowndes conceived of a banner as less of a painting and more of a flag. Her training as a stained-glass designer encouraged the use of bold appliquéd shapes, striking combinations of rich greens and blues, vermilions and magentas, and the free use of a heraldic vocabulary. Women's banners were generally smaller than union banners and inclined to the emblematic, rather than the allegorical and pictorial. The use of figurative females 'all wreathed in scrolls and laurels'[22] they left to the men: their roots were in the middle-class tradition of arts and crafts embroidery, rather than in a vernacular tradition of popular imagery and fairground motifs. But in the end a distinction between union and suffrage banners which suffragists had themselves promoted was used to divide them. Suffrage banners were praised in the press for their picturesque elegance at the expense of labour images ('tawdry and muscular'), but the femininity admired in them came close to repressing their politics and inhibiting their effect.[23]

The NUWSS procession of 13 June 1908 was followed a week later by the WSPU demonstration and mass meeting of the 21st. The occasion was by most accounts less picturesque (with fewer banners),[24] but the atmosphere was more assertive and the crowds much larger. Preparations had been going on for many weeks. A quarter of a mile of park railings had been taken up, thirty special trains organized to converge on London from all over the country, a wall poster thirteen feet by ten produced with life-sized photographs of the women who would chair the twenty platforms in Hyde Park, quantities of handbills distributed and pavements chalked with notices. Shop windows were filled with displays in the new militant colours (purple, white and green), wax portraits of the WSPU leaders were unveiled at Madame Tussaud's, and three days before the procession Mrs Drummond had harangued MPs on the terrace of the House of Commons from the cabin roof of a chartered steam launch.[25]

148. Indian deputation at a women's suffrage march. Museum of London.

149. Chalking the pavement. People's Palace, Glasgow.

150. *Marie Curie*. Banner designed by Mary Lowndes for the NUWWS procession of 13 June 1908. Museum of London.

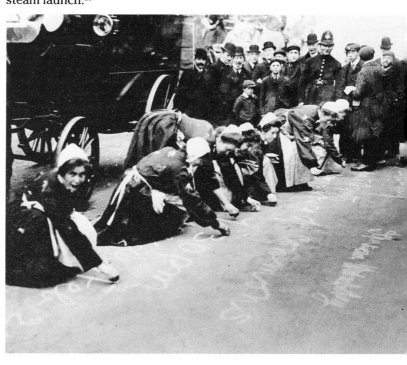

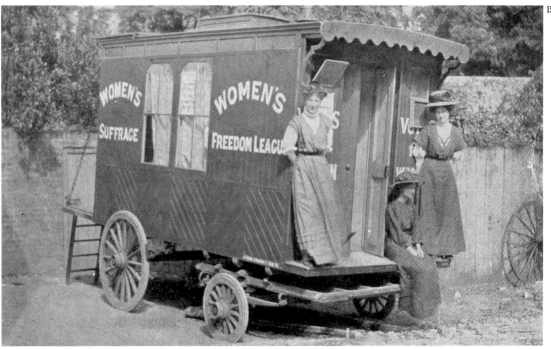

151. 'A Halt at Chichester', Women's Freedom League caravan. Photograph by Winifred Turner. Mary Evans Fawcett Library. In the summer and autumn of 1908 the Women's Freedom League and the NUWSS both set out on caravan tours of Britain, speaking in many towns, country villages and seaside resorts in their campaigns for women's right to the vote.

Seven processions, one from each main railway station, converged on Hyde Park on the afternoon of the 21st, bands playing and flags flying as 30,000 women wound their way through the waiting crowds to the various platforms. *Votes for Women* claimed that 'the number of people present was the largest ever gathered together on one spot in the history of the world'[26] and *The Times* was scarcely more sober, estimating a figure of up to half a million while acknowledging that 'like the distances and numbers of the stars, the facts were beyond the threshold of perception'.[27] With a bugle call from the central pantechnicon at five o'clock the resolution was put simultaneously from every platform: 'That this meeting calls upon the Government to give the vote to women without delay.' Immediately 'thousands of hands and hats were raised in enthusiastic salutation, and from thousands of voices rose a great cheer. To the eye the effect was as if the level of the great tide that flooded the Park had suddenly risen by a foot.'[28] With three shouts of 'Votes for Women!' the meeting closed.

These two impressive and successful demonstrations came at a time, however, when Herbert Asquith had succeeded Sir Henry Campbell-Bannerman as Prime Minister. He was an implacable opponent of women's suffrage and did not need *The Times* to prompt him (though it did) that even 30,000 demonstrators and a crowd of up to half a million were still not proof that an overwhelming majority of Englishwomen wanted the vote. Emmeline Pethick-Lawrence announced in *Votes for Women* on 25 June that, 'We have touched the limit of public demonstration ... Nothing but militant action is left to us now.'[29]

The NUWSS, opposed to militancy, blamed the Government for provoking militant acts through its own delays and evasions, and for lack of political insight: the 'suffrage problem' would be solved by the vote and not by violence on either side. By the end of 1909 the constitutionalists and the militants were at loggerheads, and the suffrage issue itself, overshadowed in Parliament by the constitutional crisis brought about by the Lords' veto of Lloyd George's budget, appeared to have reached an impasse. But the parliamentary crisis in turn provoked a general election (called for January 1910) and this provided the suffragists with the focus for a vigorous campaign that would rescue their cause from the political stalemate of 1909. New posters were produced by the Suffrage Atelier; by the WSPU, which concentrated on the implications of the constitutional crisis and the scandalous force-feeding of suffragette prisoners;[30] and by the Artists' Suffrage League, which sent out 2,708 copies of their eleven poster designs, 6,488 postcards, and 65,000 pictorial leaflets on behalf of the NUWSS.[31]

The Parliamentary Campaign

The election returned the Liberals to power with a much-reduced majority, and the parliamentary campaign entered a new phase with the formation of an all-party 'Conciliation Committee'.[32] In February 1910 this committee drew up a bill to enfranchise single women householders and a number of married women occupiers (about a million women altogether). The militants announced a truce and both wings of the campaign drew closer together to support the bill's successful passage. On 14 June it passed its first reading, and on 18 June the WSPU and the

Women's Freedom League organized major demonstrations in its support. The Conciliation Bill was women's best chance of a Government measure in forty years, and hopes ran high. The bill passed its second reading but was immediately referred to a committee of the whole House, a manœuvre which effectively extinguished its chances. On 23 July – that is, ironically, on the day of a second demonstration in its support – Asquith refused facilities to further the bill that session. By November, the conference with the Lords had broken down, the constitutional crisis was unresolved, and Asquith announced another election. Parliament was dissolved. It was clear that the Conciliation Bill was shelved.

The second general election of 1910 left the position of the parties virtually unchanged. The Conciliation Committee redrafted its bill, which passed a second reading in May 1911. It was again referred to a committee of the whole House, but under pressure Asquith agreed to grant facilities for a third reading in 1912. Despite the delay, the tide seemed to have turned again and Christabel Pankhurst was confident that women could expect to take part 'as voters in the election of the next and every future parliament'.[33]

On 17 June all the suffrage societies, including the NUWSS and the WSPU, joined for the first (and last) time in a demonstration of 40,000 women that reflected a new spirit of unity in the movement and a new confidence in its success. The 'Women's Coronation Procession' was the most spectacular, the largest and most triumphant, the most harmonious and representative, of all the demonstrations in the campaign. It was the culmination, not only of months of negotiation and hard work, but of all the organizational and artistic skills which had transformed the propaganda campaign since the Mud March of 1907. With it, they reached the limit of public spectacle, not just as a political device but as a practical possibility, and they never attempted to organize in this way or on this scale again.[34]

Pictorial Propaganda

A sense of suffrage processions has to be pieced together now from press reports, old photographs, and the fragmentary memoirs of participants. The graphic imagery of the campaign is more accessible in that the posters and postcards survive, but they do so precariously, losing much of their original significance outside the context which gave them meaning. Suffragists countered the arguments of their opponents on the platform, in the press, and through images designed to assert both the justice and the expediency of their cause. They argued that women wanted the vote and deserved it, that the women's vote would bring social reform, that women needed a say as women in legislation that affected the circumstances of their lives both at work and at home. ('Politics governs even the purity of the milk supply. It is not outside the home but inside the baby'.)[35] They put graduates and professional women in their posters and processions to demonstrate that women were intellectually capable and emotionally stable; they mocked the protection afforded by men's chivalry as a mere 'code of deferential behaviour affecting such matters and contingencies as the opening of doors, the lifting of hats, and the handling of teacups';[36] and they countered one of the principal arguments of their opponents by claiming that there was no need for the vote to be backed by physical force in a modern and civilized society.[37]

'Society is a battlefield of representations,' as T. J. Clark puts it, 'on which the limits and coherence of any given set are constantly being fought for and regularly spoilt.'[38] Skirmishes for the definition of ideal and deviant femininities took place across the Edwardian suffrage campaign and beyond it. Representations of femininity received currency (and detail and inflection) in all the rich variety of graphic material of the period – and these were the great decades of printed ephemera and popular illustrated journalism of all kinds. Much of it was produced from such 'informal' sources as commercial lithographers, advertisers and postcard manu-

facturers, and contributed almost incidentally to a public imagery of the female form. These images were not consciously propagandist, nor were they always unsympathetic, but taken as a whole with the illustrated press they produced a rich sediment of anti-feminist and even explicitly misogynist material. This informed the 'higher' levels of debate and was certainly cited in them. 'I know that the great weight of popular opinion is utterly against this proposal,' Hilaire Belloc maintained in the women's suffrage debate of July 1910. 'Members must know it. In the songs of the populace, in their caricatures, in their jokes, in their whole attitude towards the movement, the populace dislike it.'[39]

Suffrage imagery, especially when it was centered on some icon of womanliness, held up a mirror that invited identification and offered reassurance to potential converts and to suffragists themselves. The assumption that the 'public' woman was an unsexed harridan ran deep. Victorian and Edwardian publics expected to see the virtues and vices of femininity *written on the body*, and were coached by moralists, novelists, journalists, illustrators and the writers of etiquette manuals in the detailed interpretation of physiognomy, gesture and pose. Since this was a visual matter the depiction of a recognizably 'womanly' woman – recognizable, that is, through the traits by which she was conventionally defined – pursuing her legitimate female interests unscathed in the arena of public affairs carried an impact that written description could never convey. Pro and anti arguments were alike the *product* of representations and subject in turn to the impress of the pictorial resources at their disposal. (The use in suffrage imagery of an allegorical female figure derived from Pre-Raphaelite and art nouveau painting, for example, may have absolved them from the sin of 'unwomanliness' at the cost of blunting the analysis of the ideological construct of 'womanliness' itself.) But it would be wrong to see these resources solely as constraints on the construction of suffrage propaganda when they represented at the same

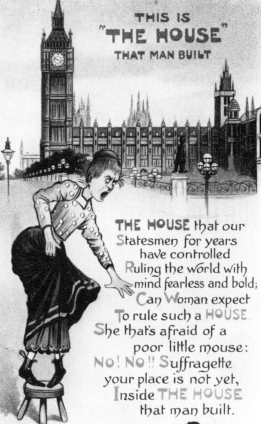

152

time its conditions of existence. There was no alternative tradition of repressed but 'feminine' meanings to bring into play.

Popular illustration had long driven a wedge between the normal and contented mother and the frustrated spinster, who became the prototype feminist shrew described by *Punch*: 'The women who want Women's rights / Want, mostly, Woman's charms.'[40] (An MP in the 1871 debate thought the House should demand photographs of the women supporting the Bill – scarcely a requirement of the labourers enfranchised in 1867 and 1884.) Because their exclusion from the franchise was justified chiefly on grounds of sex, suffragists had to produce counter-meanings around new definitions of femininity or use con-

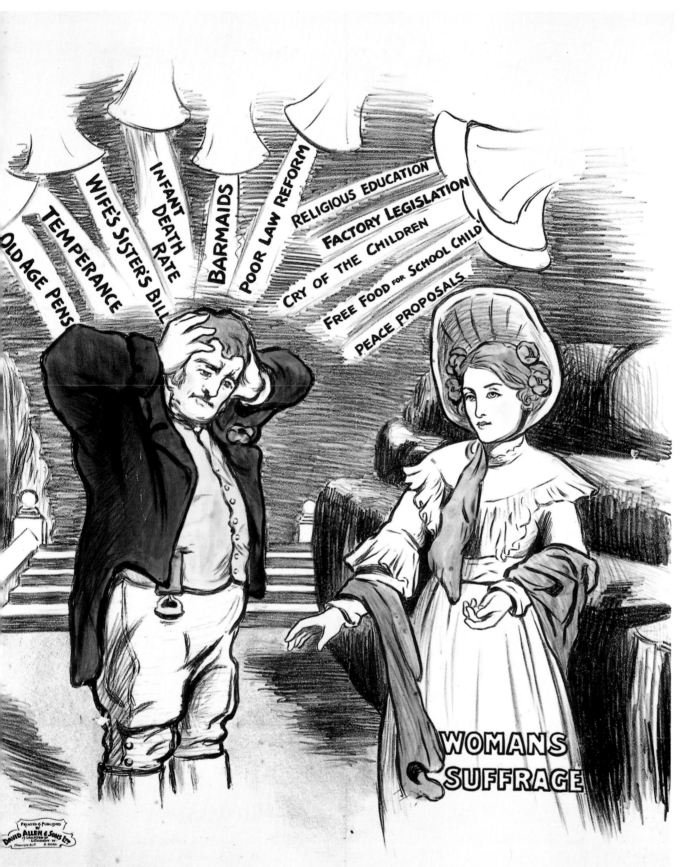

154 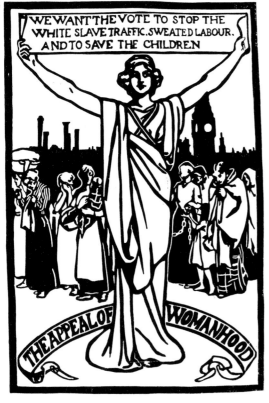 155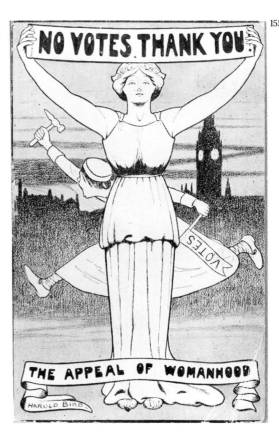

154. Louise Jacobs. *The Appeal of Womanhood*. The Suffrage Atelier, 1912. Museum of London. This was designed in response to Harold Bird's anti-suffrage poster, *No Votes Thank You*. The mother, laundresses, prostitutes and chain maker visible in the little catalogue of misery and exploitation are set out against the towers of Parliament behind the Madonna of Mercy figure.

155. Harold Bird. *No Votes Thank You*. National League for Opposing Woman Suffrage, probably published in 1912. Museum of London. Note the anti-suffragist as 'womanly woman' and behind her the hysterical feminist.

156. *The Modern Inquisition*. Museum of London.

ventional designations (like 'womanliness') in new ways.

There was no single answer to the question of how to depict women, as domestic, heroic, or oppressed. Suffrage imagery shares these functions out across a range of representations addressed to different arguments in the campaign. Among its cast of characters the Working Woman offered a reproach to 'anti' privilege, and the Modern Woman stressed the rights of women in the fruits of modernization: social mobility, urbanization, the growth of education, and the extension of the franchise. Particular struggles took place in pro and anti imagery between the allegorical Militant of the suffragists and the pathological Hysteric deployed against them by their opponents, and for the high ground of Womanliness – the terrain of an ideal, maternal, and bourgeois femininity – which neither side could afford to concede. What linked the representations which they produced was not a common content, but their strategic use: not a relation to women in the 'real' world, but a deployment within and against the femininities 'on offer' in the Edwardian period.

Working women were an important group through which to invoke women's resourcefulness, competence, and capacity for social and economic independence. They were a reminder of the dramatic increases in the numbers of women teachers, nurses, shop assistants, clerical workers and civil servants that had taken place since the founding of the Society for Prom-

oting the Employment of Women in 1859. Working-*class* women, especially those at the bottom of the heap like the sweated seamstress in 'Votes for Workers',[41] offered a special instance of economic and sexual oppression. Suffragists believed that the regulation of work was in effect bound up with the regulation of femininity, through a particular division of industrial labour and the maintenance of women's economic dependence. They argued against protective legislation for industrial women, on the grounds that without the vote women had no say in legislation that determined the terms and conditions of their employment. This brought them into bitter conflict with socialists like Mary Macarthur, who were not prepared to have the efforts of the Women's Trade Union League undermined by a middle-class appeal to the freedom of contract in a market economy.[42]

The point is that conflicts between the economic interests of men and women of the industrial working class were not a natural consequence of sexual antagonism, but the product of the mobilization by capital of an existing division of labour within the family. Women's social and economic dependence, and men's fear of being undercut by a reserve army of female labour, were both buttressed by the ideology of the family, and both were important structural elements in the foundation of the capitalist mode of production.

Suffragists were partly justified, if also tactless, in identifying a conflict between the need

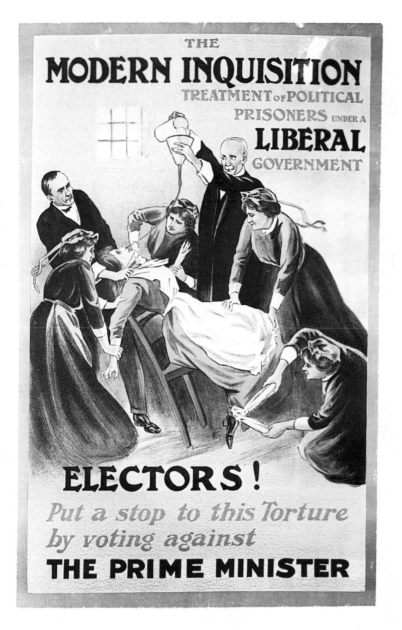

THE
MODERN INQUISITION
TREATMENT of POLITICAL
PRISONERS under a
LIBERAL
GOVERNMENT

ELECTORS!
Put a stop to this Torture
by voting against
THE PRIME MINISTER

from the investigative activities of contempory philanthropists, journalists, photographers and social reformers, was a potent icon of exploitation and one that usefully cut across other tendencies to generalization, idealization or burlesque in the representation of women. But it was a 'type' nonetheless, and it might be argued that in their concentration on the extremes of economic and sexual exploitation in sweated labour and casual prostitution, the suffragists enforced the representation of working-class women as victims, rather than as women organized in their own interest.[44] The imagery of the working woman contrasted with the womanly woman who stoops to save her, or the comfortable woman who like the bad Samaritan turns away, was in a sense itself a well-meaning form of exploitation: that of the image of the sweated worker to refer to, and further the progress of, the suffrage campaign.

In December 1908 a leader in *The Times* suggested that: 'One does not need to be against woman suffrage to see that some of the more violent partisans of that cause are suffering from hysteria. We use the word not with any scientific precision, but because it is the name most commonly given to a kind of enthusiasm that has degenerated into habitual nervous excitement'.[45] Developments in nineteenth-century medicine located the woman's body as a site of special disturbance and difficulty. Michel Foucault has described this as a contemporary 'hysterization of woman' which involved 'a thorough medicalization of their bodies and their sex . . . carried out in the name of the responsibility they owed to the health of their children, the solidity of the family institution, and the safeguarding of society[46] – that is, in the name of those very institutions which, according to their opponents, suffragists set out to destroy. On the one hand *all* women were vulnerable to hysteria: as the prominent anti-suffrage clinician Sir Almroth Wright put it, 'no doctor can ever lose sight of the fact that the mind of woman is always threatened with danger from the reverberations of her physiological

to ameliorate women's vulnerable and exploited position in the labour force, and the struggle of unionists to suppress female competition in pursuit of the 'family wage'. The image of the Angel in the House had come to obscure the fact that a majority of women had always done hard physical work inside and outside the home, but 'women's' work passed unnoticed because it was compatible with femininity – as conventionally defined – and incompatible with the concept of work as *waged* labour that prevailed with the break-up of the pre-industrial productive household. Anti-suffragists were never quite satisfied with the invocation of womanly women who neither wanted nor needed the vote, but were prepared quite unscrupulously to evoke the spectre of 'petticoat government' in the home or the state.[43]

The image of the working woman, derived

113

emergencies;'[47] on the other, feminism and hysteria were all too easily mapped on to each other. Feminism became a condition of sexual disorder, for which Almroth Wright prescribed emigration and motherhood in the service of the empire.

Officially the antis based their case on complementarity: on the idea that men and women had different roles and temperaments, and that it was an offence against God and Nature for either to trespass on the duties and activities of the other. In practice this argument developed through an idealization of 'womanliness' on the one hand, and through the categorization of deviant femininities, and their identification with feminism, on the other.[48] ('For the happy wife and mother is never passionately concerned about the suffrage. It is always the woman who is galled' – by physiological and other hardships.)[49] One outcome of the 'hysterization' of women's bodies that Foucault refers to – and popular imagery effects – was the assertion of women's essentially *biological* destiny in the face of their increasingly mobile and transgressive social roles.

'Hysteria' was a key term in the regulation of femininity, through its spread across common parlance as well as in its increasingly specialized articulation within the developing disciplines of medicine and psychiatry. Its lay usage was guaranteed by its 'scientific' authority, which in turn absorbed much popular prejudice on the physiological and intellectual deficiencies of women. Anxieties about the fluidity of a mass electorate, produced by the Reform Bills of 1832, 1867 and 1884, were further increased by fears that hysterical, fickle and politically ignorant women would endanger the stability of the imperial state. The effectiveness of militant propaganda had at some point to be determined by the extent to which it could retain its status as *political* representation and activity, and not be reduced to the category of feminine hysteria. If the suffrage movement posed not a demand to be met but a symptom to be treated, its cause was lost.

'More Allegories!!', Maud Arncliffe-Sennett wrote in her scrap book. 'They label Woman – Liberty, Justice, Humanity & rob her of every power or share in these abstract names.'[50] The purpose of the Militant Woman in suffrage imagery was to take this power back; to throw over individual acts of violence the mantle of Joan of Arc (the most popular figure in suffrage processions); in the face of accusations of hysteria, criminality, and incompetence to assert the inevitable victory of women in their own emancipation, and over all that was venal and bumbling in the world; to counter the image of the hysteric as powerless victim and deviant with the image of an active if allegorical agent of moral, social, and political reform.

The Militant Woman remained exclusively an allegorical type. She had, arguably, little to do with women and the daily experiences of their lives. The suffragists wrenched her meanings round to serve their cause. She was not domesticated. She claimed her 'womanliness' from another source, which was that of a long tradition of winged Victories, mythical heroines and personified virtues.[51] The task for suffrage art and rhetoric was to reinhabit this empty body of female allegory, to reconstitute the feminine gender of abstract virtues, to reclaim their meanings on behalf of women and a particular campaign.

The Womanly Woman was a more ambiguous construct. Womanliness made certain modes of behaviour and spheres of action legitimate and ruled out others; but it also gave (middle-class) women a sense of identity and the moral authority with which to pursue a socially regenerative role.[52] The vote was often presented as the key to social reform, not only because philanthropically minded suffragists genuinely believed that to be the case, but because it was a formulation which could be produced from the valued position of 'womanliness'. The 'unwomanly' suffragists claimed to embody true womanly compassion in fighting for all women degraded by social and economic circumstance. As mothers they argued their right to have 'the home and

157. *Mrs How Martyn makes Jam*, no.3 of Suffragettes at Home, published in *The Vote* and as postcards by the Women's Freedom League, 1909. Museum of London.

158. John Hassall. *A Suffragette's Home.* National League for Opposing Woman Suffrage, 1912. John Johnson Collection, Bodleian Library, Oxford.

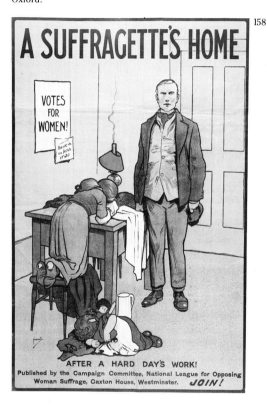

A SUFFRAGETTE'S HOME

VOTES FOR WOMEN!

AFTER A HARD DAY'S WORK!

Published by the Campaign Committee, National League for Opposing Woman Suffrage, Caxton House, Westminster. *JOIN!*

the domestic side of things . . . more fully represented in politics', as Mrs Fawcett put it.[53] They adopted the arguments from complementarity of their opponents and turned them round: the state needed 'womanly ' virtues; if public life was sordid women would clean it up.

Since most women either continued to live as wives or mothers or retained the aspiration to do so, suffrage propagandists were wise to concentrate on the uses to which womanliness could be put, rather than on the fruitless task of displacing it altogether. Despite its difficulties it was a powerful device with which to stitch together the 'we' of suffrage propaganda with the 'you' to whom it was addressed. Whether as the angel of mercy interceding on behalf of the exploited and oppressed ('The Appeal of Womanhood'), or in humbler guise (as 'Mrs How Martyn Makes Jam')[54],the identification of womanliness with the campaign offered the assurance that suffragists were not unfeminine, and invited womanly women to join them.

More specifically, the cause was structured to offer a point of identification from which the social problems which it evoked – exploitation and injustice of one kind or another – might be resolved. But to do this suffragists had to maintain a grasp on 'Womanliness' in the face of anti-suffrage efforts to dislodge them. The Womanly

Woman was at the same time an empty category (a mere doubling of terms) and a point of constant reference: a rich conglomerate of partly contested qualities which neither the suffragists nor their opponents could afford to relinquish. The antis identified themselves as womanly and their enemies as hysterics. Suffragists presented themselves as the true, the modern, the *evolved* embodiment of a womanliness to which they gave a new, expanded, and public frame of reference.

Womanliness had an imaginative centrality in Victorian and Edwardian culture that, like all normative and stereotyped categories, was partly at odds with the messiness and pragmatic complexity of lived experience. Its cultural significance did not derive from the actual political, legal, or economic positions of women

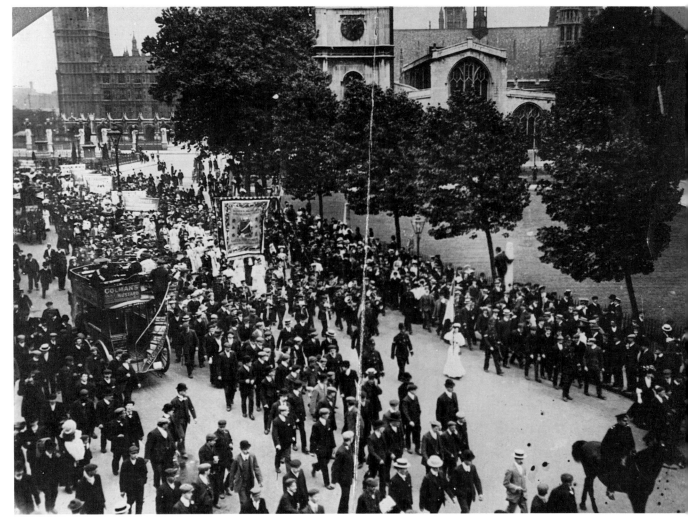

159. WSPU procession, 21 June 1908. Museum of Londo

(which it did not reflect, but helped to maintain), but from the enormous symbolic significance accorded to femininity as the repository of natural feeling and spirtuality on the one hand, or of fears for the social order as they were displaced onto the regulation of sexuality on the other. In reality women were participants in the social and industrial life of the nation in ways that an imagery of working-class and 'modern' women was intended to emphasize. But in the symbolic register the meanings accruing to femininity were the embodiment of women's physical possibilities alone – motherhood, nurturance, sexual pleasure, and comfort (or conversely the instinctual, the excessive, the disordered, the hysteric).

On 4 August 1914 England declared war on Germany. The war put an end to organized suffrage agitation, but paradoxically provided the catalyst that finally released the women's cause from the parliamentary stalemate in which it had been caught. The franchise issue was reopened by the question of the enlisted man's vote, and in the face of women's war work significant sections of the anti-suffrage press and some leading opponents recanted their views. Suddenly there was an unexpected congruence between suffrage representations of an active and capable womanhood and the Government's need of it: a novel 'fit' between the graduate, the worker, or the militant figure of Joan of Arc in suffrage imagery, and the representation of women on official recruitment posters directed at women.[55]

In March 1917 Asquith himself moved the resolution in favour of a bill which would include a limited franchise for women. The Representation of the People Act, the last of the great Reform Bills, became law on 6 February 1918. Mrs Fawcett sat in the Speakers' Gallery to watch its passage, as she had looked down from the Ladies' Gallery on the scene of John Stuart Mill proposing a women's amendment to the Reform Act of 1867 more than half a century before. All adult males received the vote, and so did all women over thirty who were householders, the wives of householders, university graduates, or occupiers of property worth £5 per year. Women did not receive the vote 'as it is, or may be' granted to men until 1928. But the old concept of household suffrage, like that of 'fitness' for the rights of citizenship from which women were assumed by nature to be excluded, was finally displaced.

6

ARCHITECTURE AND DESIGN

Heart of Empire/Glorious Garden: Design,
Class and Gender in Edwardian Britain

Lynne Walker

The Edwardian Empire generated a wealth and self-confidence which were enshrined in the highly capitalized development of British cities. Big business and municipal patronage financed some of the most prestigious Edwardian building schemes. In Liverpool, for example, the competitive patronage of the shipping industry underwrote major development on the prominent Pier Head site: Mersey Docks Building (1903–7); the Liver Building for the Liverpool Friendly Society (1908–11); the Cunard Building (1914–16); and the White Star Building (1895–8). Well away from the quayside, Liverpool Cathedral, begun in 1904, was the last Gothic cathedral built in England. In Newcastle, the seemingly healthy state of the economy, and the especially buoyant condition of the shipping and engineering industries, convinced bankers and insurance companies completely to rebuild Collingwood Street with buildings that rivalled Renaissance palaces in grandeur and conspicuous consumption. Newcastle architects Oliver and Leeson, for example, designed the Sun Fire and Life Office (1902) and Barclay's Bank (1908) as part of the Collingwood Street redevelopment.

A prosperous shipping industry, commerce and insurance companies were also at the heart of Glasgow's urban growth during the Edwardian period. Glasgow architects had a notable respect for Scottish vernacular architecture, structured by Arts and Crafts ideas (Glasgow School of Art, 1897; library, 1907–9). They could also draw on an unbroken nineteenth-century classical tradition and a close study of American structural achievements to produce an architecture appropriate to the 'Second City of Empire'. The status and progressive commercial outlook of Glasgow were represented in buildings such as McGeoch's Store (1905–6, John Burnet) and Lion Chambers (1905–6, Salmon & Gillespie).

Edwardian London was consciously reshaped to represent the power and prestige of Empire. In spite of its growth in the nineteenth century, London was without the broad, well-ordered

160

boulevards, formal vistas and monumental classical architecture of Paris, so admired by British architects who had visited the French international exhibitions. But while looking to France for architectural precedents – the expression of a burgeoning nationalism and affluent self-confidence through Beaux-Arts urban planning – British architects also picked up the threads of nineteenth-century classicism and looked back to what was perceived as the 'English national style' created by Jones, Wren, Vanbrugh and Hawksmoor.[1]

This transposition sometimes required a sleight of hand. For example, in *The Mistress Art* (1908), the architect Reginald Blomfield recommended French urban architecture as 'worthy of the tradition of Imperial Rome'.[2] The *Entente Cordiale*, the alliance between France and England made in 1904, contributed greatly to the popularity in Britain of French planning methods, French-inspired buildings and interior decorative schemes for a variety of building types: the fashionable Ritz Hotel (1903–6); the Edward VII Galleries of the British Museum (1904–14) – named after the British signatory of the Anglo-French pact – and the lavishly elegant Methodist Central Hall, Westminster (1905–10).[3]

'To improve is the order of the day',[4] Arthur H. Beavan observed in his book, *Imperial London*, published in 1901. In that same year the first and prime example of French Beaux-Arts urban planning in the service of British nationalism, the Queen Victoria Memorial, was commissioned by King Edward VII as a tribute to his mother. Sir Aston Webb's winning design replanned and upgraded the Mall to an Imperial processional way, linked to the Strand, and the City beyond, by Admiralty Arch.[5]

Such formal, classical architecture symbolized 'the heart of the Empire'. Meanwhile, however, Edwardian cities were being portrayed by reformers as centres of deprivation and social injustice and perceived by the middle classes as dirty, insanitary and anxiety-provoking.[6] For them, the English way of life and its traditional values were symbolized by the cottages of the English countryside, and these represented nationalism quite as much as did the monumental classical buildings of the cities.

The reality for the actual inhabitants of such cottages was, of course, somewhat different. Farm labourers often held their cottages on

161. Henry V. Lanchester and E. A. Rickards. Methodist Central Hall. 1906. Perspective by E.A. Rickards. British Architectural Library Drawings Collection.

162. Aston Webb. Admiralty Arch, London. As executed, 1909. Perspective by Robert Atkinson. British Architectural Library Drawings Collection. Admiralty Arch provided a ceremonial entry from Trafalgar Square, and, together with the Queen Victoria memorial in front of Buckingham Palace, it made the Mall into a processional route. The Admiralty offices were housed in the arch. British naval power was signified by the authoritative classicism of the architecture

insecure tenancies, many were dilapidated and cramped, and sanitation was 'non-existent'.[7] But the image of the English cottage meshed with the Arts and Crafts ideal of the simple life 'in little communities among gardens and green fields'[8] to inspire a vernacular architecture which was energetically pursued by the reforming young men in the Architect's Department of the London County Council (LCC).

Municipal Socialism

The LCC had, during its first full decade in operation in the 1890s, built accommodation for London's working classes under Parts I and II of the Housing of the Working Classes Act of 1890,[9] and some of its early schemes, for example at Millbank, behind the Tate Gallery (1901), and Webber Row, Waterloo (1902–7), were successful. But problems emerging at their first large-scale estate (Boundary Street, 1890–1900) warned of difficulties to come. Most troublesome was the fact that after slum clearance the former residents could not afford the rents in the new estate and had to move on to find other accommodation. There were also good indications that the new residents did not like living above the second storey. In response to this experience, and with their Arts and Crafts preference for rural life and vernacular buildings, the young idealists in the LCC Architect's Department, such as C.C. Winmill and R. Minton Taylor, soon came to favour cottages instead of flatted estates. The argument was put to the politicians, often informally, by the chief architects who lobbied for the reorientation of housing policy and for building cottage estates in the suburbs.[10] At this time, housing in the inner city was, in fact, actively avoided, and architects and reformers alike agreed that 'the Housing Problem is not to be solved in the slums but in the green fields' of the suburbs.[11]

Under Part III of the Act, the LCC bought and built cottage estates on green field sites which were to provide additional as well as improved accommodation for London's working classes in the first programme of its kind by a public

authority. The first estate at Totterdown Fields in Tooting (1901) was followed by the Norbury (1904) and White Hart Lane Estates (1903) and the last of the pre-war schemes, the Old Oak Estate (1909). In addition to providing well-built and comfortable houses which were informal but dignified, the LCC architects were sensitive to the symbolic nature not only of building types and styles, but of individual features.[12] Each house had its own back garden and nominal front garden, in accordance with the advice given to public authorities by Barry Parker and Raymond Unwin in *Cottage Plans and Commonsense*, a Fabian Society Tract of 1902. Perhaps the best of all the LCC cottage estates, White Hart Lane demonstrates the benefits of Parker and Unwin's principles of lower density, varied vernacular features, carefully designed interior fittings, more trees, gardens and a communal green space. It showed what could be accomplished with adequate funding (in this instance, provided by a Jewish philanthropist, Samuel Montagu, Lord Swaythling, to encourage emigrants to move out of the East End). But the scheme was plagued by inadequate public amenities. There were few schools, and an

163. Detmar Blow. Country Cottage, Bacton, Norfolk, 1902. British Architectural Library Drawings Collection The Edwardian middle-class dream – a country cottage and the simple life.

164, 165. Gertrude Jekyll. Planting plan for, and photograph of, the garden at Millmead, from Lawrence Weaver, *Gardens for Small Country Houses* (1910). Gertrude Jekyll, one of many women gardeners of the Edwardian period, worked both for her own clients and in collaboration with architects such as Edwin Lutyens. Her planting plans were characterized by groupings and interlacing of flowering perennials and shrubs in broad herbacious borders to produce a show of colour throughout the season. Her garden plans use pergolas and trellising near the house with woodlands, underplanted with shrubs, ferns and flowers, and variegated with pools and walks, beyond

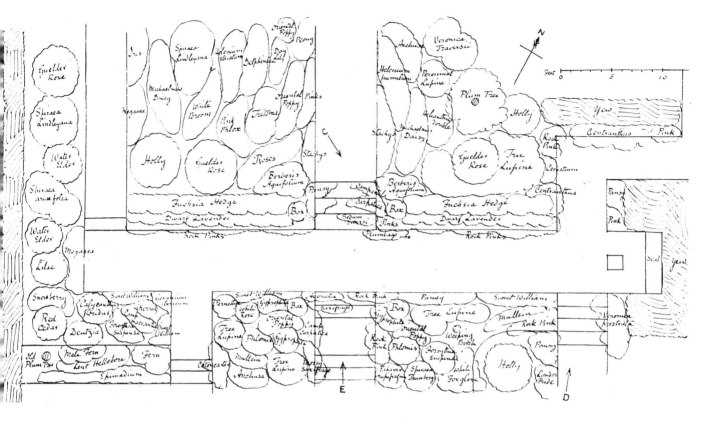

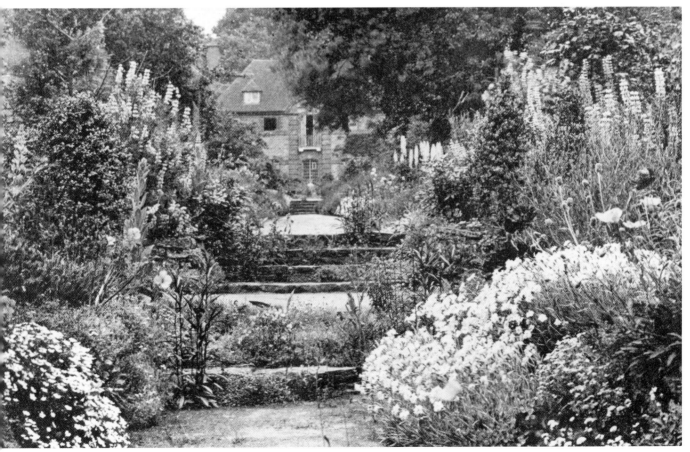

166. Architects Department, London County Council. White Hart Lane Estate, 1900. English Heritage, London Division. One of four cottage estates built by the LCC between 1901 and 1911 which provided accommodation in Garden City-like surroundings for the urban working classes.

167. Edwin L. Lutyens. Deanery Garden (originally called The Deanery), Sonning, Berkshire, 1901. Photograph *Country Life*.

168. Edwin L. Lutyens. Drawings for Deanery Garden, British Architectural Library Drawings Collection. Architect-designed vernacular architecture for the proprietor of *Country Life*. The garden, which quickly became associated with its name, was laid out by Gertrude Jekyll, garden-maker and craftswoman.

underground station, though initially planned, was never built.[13]

The defeat of the Progressives by the Moderates in the LCC elections of 1907 cut and slowed down the cottage housing policy of the previous years, and to avoid competition with speculative building one of the first acts of the new authority was to put up for sale most of the land purchased for cottage estates, which included one hundred and eighty acres at White Hart Lane.

Country Life

The agricultural depression of the late nineteenth century had removed land as the chief source of wealth in England, so that by 1901 money to pay for a country house had to be made either in urban centres of trade or in the Empire. But both cultural identity and social standing could be obtained, processed and given the patina of age by building a house in the country, especially if it were an old house restored or a new house made to appear as old and as venerable as the countryside itself. Deanery Garden (originally called The Deanery), a house in Berkshire designed by Edwin Lutyens and completed in 1901, typifies this successful mediation not only through its use of local materials and countrified features, which link it to the local building traditions, but most cleverly and thoughtfully through its garden, which carefully knits together the geometry of the architecture and the leafy vegetation of the surrounding countryside. Planned by Gertrude Jekyll, one of the many women gardeners of the period, it brought together both schools of Edwardian garden-making, combining elements from the formal garden with those of the more informal landscape and 'wild' gardens to their mutual advantage.[14]

Old castles, which stood for ancient authority and continuity, sold well. Sometimes they were reconstructed on a lordly scale. Lindisfarne Castle in Northumberland was rebuilt by Lutyens for the Deanery Garden client, Edward Hudson. Hudson was the proprietor of *Country Life*, the

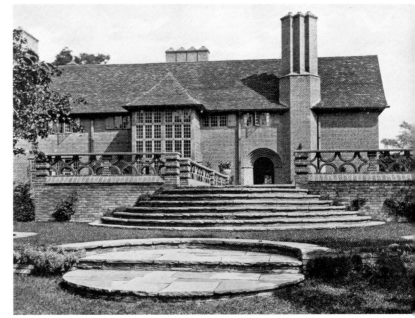

9. H.M. Baillie Scott.
Proposed House at Guildford.
The Studio, 1909. The esti-
mated cost of this house was
£500, in sharp contrast to
the cheap cottages at Letch-
worth, which cost less than
£150. It is an example of Arts
and Crafts architecture, with
a hall based on 'Old English'
barn structures, calling up
rural traditions and signifying
order and stability. The
concept of the house as a
private rural retreat is
emphasized by the garden,
with its pergola, trellising and
deep flower borders.

170

170. Photograph by Gertrude Jekyll, from her book *Old West Surrey* (1904). British Library. Gertrude Jekyll was a gardener, writer, embroiderer and photographer. Her photographs were taken primarily to record the development of her garden at Mustead Wood in Surrey. She photographed groupings of flowers, her animals, and some of her handicraft work. She also 'recorded' the vanishing world of old west Surrey in which she lived. Her photographs present nature as wild, distant, and ancient, glimpsed through its rural handicraft traditions, and carried in the memories of its old inhabitants.

magazine which from 1897 to the present day has produced the most compelling images of the English countryside for consumption and imitation by the upper middle classes on both sides of the Atlantic.[15]

For those who could not afford a large house in the country, the lure of the countryside was, none the less, just as great. 'The country cottage craze' centered on the Home Counties, where because of proximity to London and the fast, cheap, regular rail service, cottages (often first spied from a bicycle or motor car) were bought as first homes for middle-class commuters, as well as becoming increasingly popular for weekends and summer holidays.[16] The popularity of second homes and the growth of commuter housing in the Home Counties became so great that between 1901 and 1911 the trend of rural depopulation was actually reversed in Surrey, Kent, Sussex and Hampshire.[17]

In the provinces, railways determined the pattern of weekend and commuter housing development to an even greater extent than around London. Manchester, Liverpool, Nottingham, Leicester, 'the loom districts of Yorkshire',[18] and Glasgow experienced growth in outlying towns. For example, Helensburgh, a Clydeside village on the railway, became a popular middle-class outpost and acquired one of the best-known houses of the period, Hill House (1902–4), designed in the Scottish vernacular by C.R. Mackintosh. The White House, a typical cottagey product of the prolific English architect, Baillie Scott, is in a near-by street.

By 1904, cottages were considered suitable for all classes to live in, as George Ll. Morris and Esther Wood observed in their book, *The Coun-*

try Cottage, one of many written on the subject in the Edwardian period. Their attention, however, was focused on the middle classes, who were making radical departures from the domestic *status quo* in their cottage homes.

> Between these two demands – of the leisured person for a quiet and unpretentious dwelling, and of the labourer for a secure and permanent home, we have the rapidly growing desire of the ordinary man and woman, of average means, for a cottage in the country ... where the weary and convalescent may recruit their strength, and children be healthily and happily brought up.[19]

The country cottage, which turned its back on urban problems, at the same time provided its occupants with a space for experimenting with a more informal and egalitarian way of living, breaking with 'the tyranny of the town house', which relied on the labour of large numbers of servants and the subordination of middle-class women.[20] Architecturally, the change which is most apparent in the plan of the middle-class country cottage is the reduction of service accommodation, which in nineteenth-century

171. Helen Allingham. *Valewood Farm*. 1903. From *Happy England* (1903). Helen Allingham's watercolours, like Gertrude Jekyll's photographs, constructed a domestic rural idyll: women in neat clean clothes stand at garden gates or cottage doors, in gardens full of flowers which are bathed in perpetual sunshine. These images created a nostalgic vision of pre-industrial England, its crafts, its traditions, its social order. At Vale Farm, Marcus Huish, the author of *Happy England*, was pleased to note that the dairy work was in the hands of women.

country houses had consumed roughly one-third to one-half of the living space.[21]

The best-known example is Stoneywell Cottage in Leicestershire (designed in 1897 by Ernest Gimson), where severe simplifications in the plan represent the reduction in the number of servants and the abolition of separate spheres for family and servants. The kitchen, no longer the province of servants, became the room where the family ate and entertained, an arrangement unthinkable for the Victorians. In other instances, when the living room and dining room were combined, more economical use had to be made of limited space; built-in furniture, such as dining-room tables, window seats and dressers, and cosy inglenooks, became common space-saving features.

With the possibility of more middle-class women going out to work and coping with the multiple roles of business woman, wife, mother and hostess, architectural writers looked to improved technology to 'provide the quickest means of getting fires and hot water, whereby the housewife just returned from work, and probably the most tired and hungry of the family, may appease the more or less polite clamourings of husband, children, and the visitor who invariably chooses that particular moment to drop in for a chat'.[22] Esther Wood, a regular contributor to the *Studio*, argued that changing social conditions required a new way of living which was attainable in a small house in the country looked after simply by its owners and perhaps one servant. But for her, the Arts and Crafts ideal of the simple life was dependent on improved heating equipment, and she looked forward to the introduction of labour-saving machinery (the vacuum cleaner, for instance, was newly patented) for its power 'not [in] supplanting but relieving personal labour, and giving leisure for the development of interesting handicrafts'.[23] The nineteenth-century home had been perceived as a spiritual and moral refuge, but in the first two decades of the twentieth century, the moral home was replaced by the healthy home, with cleanliness and child care seen as the top priorities for a wife and mother.[24]

The Co-operative Alternative

In the rethinking of house planning which the Edwardian preoccupation with 'the great servant difficulty' created, other options in addition to smaller houses and country cottages were tried – living in mansion flats, hotels, boarding houses, and even hydropathic establishments. But the most radical solution, inspired also by the Arts and Crafts ideal of the simple life, was co-operative housing. In *The Art of Building a Home* (1901), Barry Parker and Raymond Unwin described co-operative housing for 'those who are seeking to escape from the worry of servants, the trouble and expense of jerry-built houses, and the endless small anxieties that go to the running of a separate establishment'.[25] Parker and Unwin promised that co-operative houses and flats which were simplified in plan and serviced by communal facilities would attain the simple life without loss of 'the more necessary comforts and refinements'.[26] Nevertheless, these comforts and standards were maintained by the work of servants, although much reduced in number. Co-operative housing, theoretically at least, 'could retain the privacy and individuality of a separate house, while gaining the advantage, which they have in a boarding house, of properly organized service and skilled cooking'.[27] When Letchworth Garden City was founded in 1903 communal living, like cheap cottages, was an intrinsic component. The first co-operative housing in Letchworth was Homesgarth (1909), a group of serviced flats and houses built around three sides of a quadrangle. It was developed by the founder of the Garden City idea, Ebenezer Howard, who lived there between 1911 and 1920. Its socialist architect, H. Clapham Lander, who consulted the future tenants during the design process, found their architectural needs highly individual, but with mutual agreement on the desirability of the communal dining hall.[28]

Other co-operative housing, such as York

·BIRD'S·EYE·VIEW·FROM·THE·NORTH-EAST·

Street Chambers in London (architects Balfour and Turner, 1890–2), was built in response to the growing numbers of middle-class single working women. Communal living in purpose-built flats, although designed to provide socially acceptable and comfortable accommodation, was not, however, part of a process of levelling between the classes. Distinctions between servants and mistresses remained clear and undiminished, and the creation of an architecturally separate sphere replicated in many ways the segregation and isolation of women's previous domestic confinement, although it was also related to the large number of women's clubs, colleges and other organizations which were a part of the new, more public role of women in the late nineteenth and early twentieth centuries.

Waterlow Court (Baillie Scott, 1909) was part of Hampstead Garden Suburb, the community carefully planned in the spirit of reform by Henrietta Barnet to provide a village-like environment for all classes on the edge of the capital. It contained fifty flats with a common living room, dining hall and kitchen, staffed by servants and run by a manageress. It was built around a courtyard and buffered from the outside world by a band of tennis lawns. A sense of monastic enclosure and separateness was created, neces-

sary to preserve the respectability of 'working ladies', as well as to diffuse their threat to male jobs, status and pay. The *Builder* described it as follows:

> The building, which *encloses* a central court, is approached by a *covered* way with open timber roof; which in connexion with the *cloister* surrounding the court, gives *sheltered* access to the whole building [italics mine].[29]

Contradictory ideas about women and work are thus mediated through the architecture of Waterlow Court, which becomes a metaphor for chivalrous male authority and protection and posits a natural weakness for women (and, by implication, their unsuitability for the working world). At the same time the building itself facilitated women's financial independence and personal autonomy, and as research on similar schemes in Berlin has indicated, the communal dining rooms could be an excellent place for mutual support as women compared notes and discussed the often difficult and discriminatory conditions at work.[30]

The Architectural Profession

A number of issues preoccupied the architectural profession in the Edwardian period, such as town planning, architectural education, and

172. H.M. Baillie Scott. Waterlow Court, Hampstead Garden Suburb, London. 1909. British Architectural Library Drawings Collection. Co-operative housing for single women was a new Edwardian building type generated by the growing numbers of middle-class women in paid employment

3. Ethel Charles.
llyngvase Terrace, semi-
tached houses for A. Cox
q., Falmouth, Cornwall.
itish Architectural Library
awings Collection. Ethel
arles and her sister, Bessie
arles, led the entry of
men into the architectural
ofession.

the competition system. The intense interest in town planning, for example, was shared by the Royal Institute of British Architects (RIBA), the LCC and even the normally introverted Art-Workers' Guild (the exclusive 'gentleman's club' for the elite of the Arts and Crafts Movement), and culminated in the highly successful RIBA-sponsored Town Planning Conference of 1910.

Architectural competitions were held for many of the most important Edwardian buildings, and one indication of their importance can be found in *Who's Who in Architecture*, published just before the First World War, which lists architects' designs for competitions and ranks them as prominently as completed buildings.[31] In retrospect, however, the most significant issue – albeit one neglected by historians – was the entry of women into architectural practice.

Women had designed buildings from within the amateur tradition from as early as the seventeenth century, and in the nineteenth century they practised architecture outside the auspices of the official professional body, the RIBA.[32] The successful application of Ethel

Charles in 1898 and her sister, Bessie Charles, in 1900 to become members of the RIBA brought debates about women's role in architecture to a head and provoked a fire-storm of reaction. Their presence was accepted by some male supporters but the institutional response was legalistic and bureaucratic resistance. At the RIBA, petitions circulated, barristers were consulted, the bylaws and charter of the Institute were examined, and the RIBA Council came within one vote of revoking its members' decision to admit women.[33]

Instead of a rush of women into the architectural profession after the Charleses' admission to the RIBA, the number of women architects actually fell signficantly, from nineteen in England and Wales in 1891 to six in 1901 and seven in 1911.[34] In spite of its own image of itself as sympathetic, retrenchment and self-interest, not opportunities for women, were the themes of the architectural profession in Edwardian England. The male bastions held, and, the Architectural Association, for example, did not admit women until 1917, when the pressure of war conditions and the Suffrage Movement combined to force a change in policy.

At the beginning of the twentieth century, the debates around women and architecture focused on socially constructed sexual differences. With the building slump which came in the middle of the Edwardian period the new emphasis was on unemployment within the profession and competition for jobs between women and men. The Arts and Crafts architect, R. Weir Schultz, speaking on 'Architecture as a Profession for Women' at a conference on Employment for Women at Caxton Hall in 1908, described such worries, 'among practising architects – many of whom consider quite honestly that architecture does not come within the legitimate sphere of women's work – but also amongst the rank and file of assistants, who see the possibility of less employment and of reduced wages.'[35]

The full extent of Ethel Charles' and Bessie Charles' work is not known, but their drawings

for seventeen of their designs and buildings, as well as their sketchbooks and topographical drawings which record their travels in England, France and Italy, are deposited in the RIBA Drawings Collection. They consist predominantly of domestic architecture, with other building types represented by Carnarvon and Anglesey Infirmary (1915) and a Bible Christian Chapel in Falmouth (1906), designed jointly by the sisters.[36]

Misogynist writings were part of the intimidating tactics deployed to reclaim the male preserve of architecture.[37] Women were stereotyped as beyond culture and therefore biologically incapable of the creativity required to be architects; they were supposed to lack commitment, stamina and seriousness. Ethel Charles argued in turn that women *were* mentally and physically strong enough to become architects and that the social difficulties anticipated, such as travelling to distant sites, dealing with recalcitrant builders and climbing about on scaffolding, could be surmounted.[38]

While the line was being redrawn slightly to extend women's sphere to domestic architecture, under no circumstances were women to be allowed to design 'the best architecture' or the most financially rewarding, which in Edwardian Britain meant large-scale, highly capitalized urban building projects, designed in the Grand Classical manner, the 'High Game', as Edwin Lutyens called it. Ethel Charles stated publicly that the biggest opportunities for architects of her generation lay in commercial architecture,[39] and, like her contemporary Clotilde Kate Brewster, who designed 'a municipal palazzo in Rome',[40] she tackled large-scale design with a prize-winning church in Germany (1905).[41] However, women's architectural careers were generally restricted to the domestic ghetto, for which, it was reasoned, their experience in the home and their femininity particularly suited them.

Edwardian Women and Design

Alternatively, women were directed, as they had been since the late nineteenth century, to ancillary jobs in architecture as assistants, draftswomen, or plan tracers, or to the applied and decorative arts allied to architecture, which, like domestic architecture, were less prestigious and thought to express their special feminine capacities. By 1901, the decorative and applied arts had flourished for two decades under the Arts and Crafts Movement, whose principles of simplicity, fitness, the honest use of good materials and a concern for the crafts and craft skills were to continue to dominate the design of country houses, churches and their furnishings and fittings until the First World War. Arts and Crafts principles were also applied to a wide variety of classical urban buildings. In retrospect, the Arts and Crafts Movement's commitment to hand labour and the craft workshops can seem overshadowed by the invention and development of modern products, as well as the transformation of consumer goods through mass production, distribution and advertising, initiated in the late nineteenth century. Nevertheless, the Arts and Crafts Movement was not only the artistic creed of many of the most talented and well-known designers, but also a major social force through which women were channelled into the applied arts.

In many ways May Morris (whose father William Morris was a leading Arts and Crafts figure) typified the advantages and disadvantages for women in design. At home she followed the traditional role of self-effacing and dutiful daughter, and her interest in embroidery was completely within the bounds of the patriarchal *status quo*. But through the Arts and Crafts Movement she became a teacher, writer, lecturer, craftswoman and designer of embroidery, jewellery, wallpaper and bookbindings. As head of the Embroidery Department for Morris and Company, she was an employer of women, creating a well-organized workshop staffed with highly skilled assistants, some of whom she taught herself. In fact, women were central to the activities of May Morris, who taught them, wrote books for them, employed them and sold goods to them. In 1907 she founded the Women's Guild.

The best gauge of women's role and position generally within the Arts and Crafts Movement is the Arts and Crafts Exhibition Society, the central exhibiting organization and the focal point of production and sales in the Movement. The Arts and Crafts Exhibition Society displayed craft work throughout the British Isles and featured a wide range of work from women, including exhibits from provincial designers and amateurs.

If women's participation is measured over three typical exhibitions (1888, 1896 and 1910), it is clear that, although sex roles and sexual stereotypes persisted, by the end of the Edwardian period the sexual division of labour had tended to break down within the Movement, providing women with access to a wider range of artistic and professional activities.[42] This comparison also shows that women's participation in design activities had increased during the period in question, and that more women were designers or designer-makers rather than simply executants of male designers' work.

Initially, at the Arts and Crafts Exhibition Society as in the Movement generally, most women were confined to the 'feminine' craft of embroidery, in many instances as makers of designs for men. But with the revival of craft metalwork, jewellery, enamelling, stained glass, hand weaving, appliqué, bookbinding, illustration and illumination, the range of women's work was extended. For example, jewellery, which was the predominant design activity for women in the first decade of the century, attracted large numbers of highly talented and able women, especially in the Arts and Crafts centres of Glasgow, Birmingham and London, and included Georgina Gaskin, May Morris, Phoebe Traquair, and Frances and Margaret Macdonald. Aymer Vallance wrote about women and jewellery in the *Studio* in 1901: 'The number of ladies who have achieved success in jewellery design proves this, indeed, to be a craft to which women's light and dainty manipulation is peculiarly adapted'.[43]

This kind of sexual stereotyping, which saw the work as an extension of the designer's physical femininity, reinforced the assumption that creativity is biologically determined as an essentially male activity. At the same time women worked against the ideological grain by designing and making jewellery as professionals, not (as Vallance's use of 'ladies' suggests) as unpaid amateurs. Jessie M. King, who was admired in Britain and Germany for a wide range of craft activities, made a series of designs for jewellery which was sold exclusively through Liberty's of London.[44] Jewellery such as the silver and gold necklace with an enamelled pendant designed by Phoebe Traquair which was exhibited at the 1910 Arts and Crafts Exhibition Society shows the benefits of the Arts and Crafts revival, which rejected the use of diamonds (supplied by South African mines) and favoured semi-precious stones, prominent settings and the frequent use of silver and enamel. Jewellery made by women sold very well at the Arts and Crafts Exhibition Society, as an annotated copy of the 1910 catalogue, preserved in the V & A's Art and Design Archive, shows.

The Arts and Crafts Exhibition Society of 1910 also gave students the opportunity to sell and display their work at a national venue. The Birmingham School of Art, which was developing a strong jewellery and silversmithing department, produced much successful work. Kate Eadie of Birmingham, who is typical of this success, sold her entry for £4 4s. Art schools like Birmingham, the Central School of Art and Crafts, and the Glasgow School of Art (which had roughly half women and half men in its student population by the turn of the century)[45] taught Arts and Crafts principles and provided their students with the skills necessary to professionalize themselves, and with art-school training women such as Frances and Margaret Macdonald, Ann Macbeth and Agnes Raeburn could set up their own workshops, or teach in art schools or in the state system.[46]

Like metalworking and jewellery, stained glass was another area, revitalized by the Arts

and Crafts Movement around the turn of the century, which provided new opportunities for women. Traditionally, women were excluded from the stained-glass trade apart from the occasional free-lance commission. However, as happened in other design areas, the Arts and Crafts rejection of commercialism and its emphasis on the individual designer-maker provided an alternative which facilitated women's work. Mary Lowndes, the Suffragist who had trained as a cartoon-maker with the designer Henry Holiday, had her own studio, first in Chelsea and then in 'The Glass House' in Fulham. There, through her firm Lowndes & Drury, she set up studios and workshops which had a permanent team of stained-glass craft workers on hand to work with independent designers who wanted to take an active part in the production of stained glass.[47]

Lowndes designed stained glass for domestic, commercial and ecclesiastical buildings, but her design skills were also dedicated to the service of the Women's Suffrage Movement and in 1909 she was responsible for the 'corporate image' of the Pageant of Women's Trades and Professions which was held at the Albert Hall in conjunction with the International Woman Suffrage Alliance Congress.[48]

With the support of Mary Lowndes, stained glass became an area which attracted other politically active women, most notably Mabel Esplin, who also contributed to the decoration of the 1909 IWSA, and Caroline Townshend, who was active in the women's movement and in the 1900s played a major role in the Fabian Society. She designed a stained-glass panel, 'Fabians at the Forge'.[49]

By 1910, roughly five times as many women designers exhibited at the Arts and Crafts Exhibition Society as in 1888, and it attracted about equal numbers of male and female participants. Importantly, women were now designers in their own right, and if they worked as executants it was usually either to make their own goods in an Arts and Crafts way or to work the designs of another woman. Thus by the end of the 1900s traditional male-female roles were challenged rather than merely recreated within the Arts and Crafts Movement. In the final analysis the Arts and Crafts Movement, while it may not have won a definitive victory against the dominant patriarchal ideology, did far more than simply reproduce and perpetuate it in a monolithic way. By 1910 the Arts and Crafts Movement had facilitated women's work by providing an alternative to the commercial system which excluded women, and in the harsh light of economic reality, it provided women with a role as designers that they could use to acquire both financial independence and personal fulfilment.

174. Caroline Townshend. *Fabians at the Forge.* 1910. Present whereabouts unknown. Photograph courtesy of The Fabian Society. The artist was an active member of the Fabian Society and its arts group. This stained-glass panel depicts Bernard Shaw and Sidney Webb hammering the world into shape, while the secretary of the Fabian Society applies the bellows to the furnace of Socialism. Below are a pile of Shaw's plays and Webb's reports, and the kneeling figures include Caroline Townshend herself and H.G. Wells, who thumbs his nose at the Society he left in 1908.

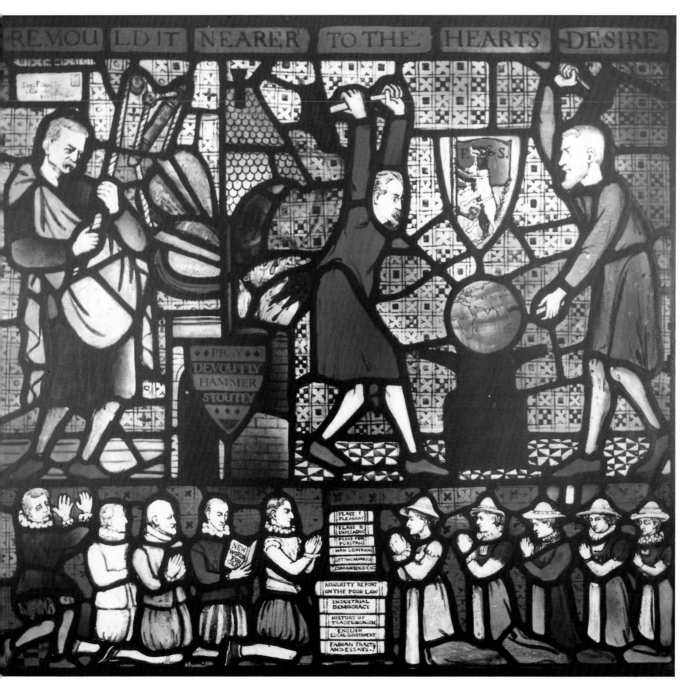

THE EDWARDIAN OFFICE

Rosemary Ind

The characteristic new buildings of the Edwardian era were town halls, insurance offices, banks, and government buildings. Offices themselves were not new. They had long been part of the manufacturing and trading sites, where the warehouse was the crucial component. But with the continuing expansion of commerce and the development of insurance, offices began to have a more public presence. Companies commissioned prestigious new buildings. Exuberant neo-classical and neo-baroque styles, reminiscent of sixteenth- and seventeenth-century Italy where the world of business and commerce started, symbolized the monetary stability of the Edwardian banking and insurance world.

But trading connections with America (via Liverpool) and with the Empire (via Southampton) were even more important than the old cultural connections with Europe. From America came a new commercial architecture, based on the steel frame, which enabled tall, well-lit buildings to be built on small sites. Steel-framed buildings appeared in the most dense centres of commerce: Liverpool, Glasgow, Birmingham, Manchester, London.

The increase in trade, and thus in paperwork, at the

176

175

turn of the century led to the employment of greater numbers of office workers. As a consequence of the late nineteenth-century Education Acts, more and more women had access to education, and more and more were becoming clerks. The *Englishwoman's Yearbook* (1909) stated that: 'Although the number of women of the educated classes who have turned their thoughts to secretarial work is greatly on the increase, there is evidence of an increase likewise in the demand for competent women as secretaries and clerks . . . that this may not at first give a "living wage" is true', but through a combination of training and application, 'the accurate, reliable, and competent clerk will secure reasonably good remuneration for her services.' In this profession, the writer warns, 'success cannot be reached without strain and struggle.'

It is rare to find illustrations of clerks, typists and secretaries at work in Edwardian offices. Published accounts of new office buildings show tiled floors, brass electric lights with green glass shades, and 'spe-

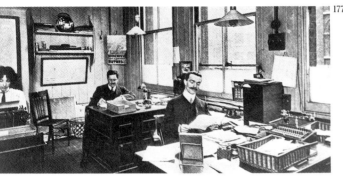

177

175. J. J. Burnet. 'General' Buildings, Aldwych, London. 1910-11. 'A main entrance that attracts the eye and the remainder of the entrance storey treated in a more or less liberal, expansive, sumptuous layer.'

176. J. Belcher and J. J. Joass. Mappin House, Oxford Street, London. 1908.

177. Manager's office of the motor accessory purchasing section of Brown Brothers, c.1910. Photograph by Thea Vigne. Offices provided new employment for women, but as service workers for male management.

178. H. Tanner. New Shipping Offices, Cockspur Street, London. 1906. Plans of the ground and second floors.

cially selected wax-polished mahogany desks'. Only the grandest offices were photographed and no people were there to complicate the photographer's task.

Contemporary descriptions of offices indicate that, like flats, they were arranged in small suites served by a common lift or staircase. A small office, often fitted into a narrow inner-city site, would consist of little more than a principal's room with a room for clerks opening off it, and possibly 'small telephone and typists' rooms'. A rectangular space was considered best to accommodate desks, 'tables and bookshelves; and every room should have ample window and wall space.' Larger schemes might accommodate several rooms for typists, with 'the Manager's room having doors . . . to both the general office and the clerks' room so that everything is under perfect control'. The manager was able to leave by a side door and could 'pass out any visitors who do not wish to leave through the waiting room'.

The architect Sir John Burnet, who favoured a grand, austere style, supplied a general assurance firm in the newly-opened Kingsway with a marble entrance screen supporting the figures (in white metal) of Strength, Prudence, Abundance and Prosperity, surmounted by Fire and Life. But Eastman Kodak, who wanted a new building on the other side of Kingsway, rejected Burnet's first design as not modern enough. Burnet went to America to study what was being built there, and came across Sullivan's office buildings.

For the American architect Louis Sullivan, 'offices are essentially like cells in a honeycomb, piled, layer on layer', until 'the attic, which, having no division into office cells . . . gives us the power to show . . . that the series of office tiers has come definitely to the end.' Burnet's Kodak House does just this: the entrance floor is expansive and sumptuous, clad in sculpted granite, from which the honeycomb cells rise four storeys to an attic floor above a severe Doric cornice. The bronze windows rise the full four storeys, with bronze spandrel panels ornamented with single rosettes, which act as air inlets behind the radiators.

The typical Edwardian magnate appears to have felt, like Arnold Bennett, that he had successfully put poverty behind him only when he had a pineapple on his dining-table. But these pineapples were built of marble and classical in flavour, and the most delicious are the buildings of Belcher and Joass in central London: Mappin House (1906–8) in Oxford Street, and the Royal Insurance building in Piccadilly (1907, Sir John Belcher). Both have steel frames clad in marble from the Athenian quarry on Pentelicon.

While the Royal Insurance has forms which shrink and stretch, Mappin House has a structure that visibly expands as it rises. Flowered columns begin at foot level with exquisitely finished bronze bases, and grow upwards, in complex fugue, on big hooped arches. Double columns of crisp, rain-washed marble droop with tassled garlands. It is complex and contradictory. The steel frame is employed, not functionally as the Modernists would later use it, but indulgently, to allow the extravagance of the composition. A pineapple among pineapples.

178

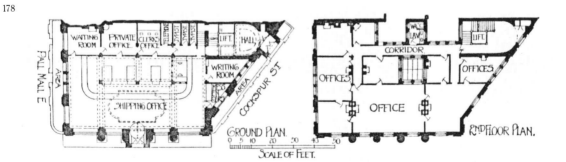

133

179. Barry Parker and
Raymond Unwin. *Proposed
Cottages for Garden City
Tenants.* Birds Hill, Letch-
worth, 1906. First Garden City
Heritage Museum, Letch-
worth.

180. The Three Magnets, from
*Tomorrow: A Peaceful Path to
Reform* (1898), by Ebenezer
Howard, reissued as *Garden
Cities of Tomorrow* in 1902.

181. First Garden City banner,
Letchworth. First Garden City
Heritage Museum, Letch-
worth.

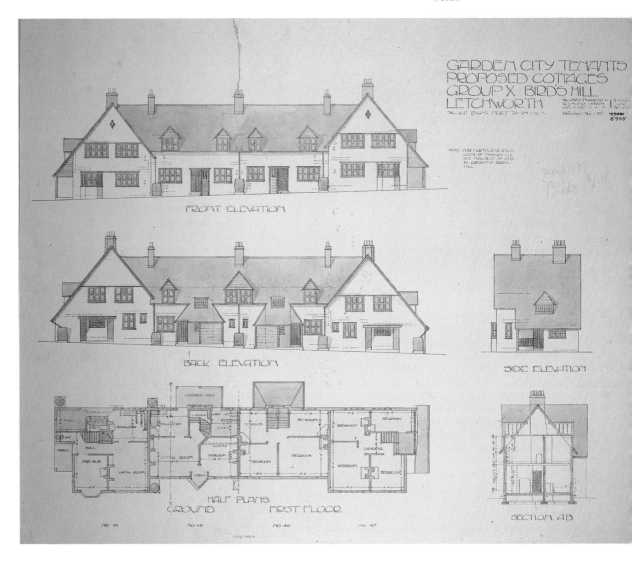

LETCHWORTH: TOWN PLANNING IN PRACTICE

Rosemary Ind

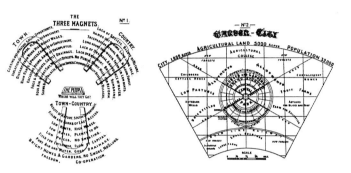

'It is quite a mistake', wrote Raymond Unwin, in *Town Planning in Practice,* 'to put the maximum number of houses which can be contrived in any place' and Letchworth (Garden City Ltd, as the first house-holders voted to call it) was the reaction to nineteenth-century development which had done just that. A fresh start was needed, declared the *Garden City Prospectus* of 1903, to solve the problems which beset overcrowded, unhealthy towns and an underpopulated countryside. This fresh start would take the form of 'Town-Country', the third of the 'Three Magnets' described by Ebenezer Howard in his book *Tomorrow: A Peaceful Path to Reform* (1898), which was reissued as *Garden Cities of Tomorrow* in 1902. Here the conflict between the features of Town ('High Wages, High Rents and Prices, Fogs and Droughts, Social Opportunity') and of Country ('Beauty of Nature, Lack of Society, Abundance of Water, Long Hours and Low Wages') would be resolved; and 'Low Rents and High Wages', together with 'Field for Enterprise' and 'Flow of Capital', would lead to 'Freedom and Co-operation'. Howard supplied a diagram of such a Garden City: 1000 acres, with a population of 32,000, set in 5000 acres of agricultural land. A loop of railway line enclosed houses and gardens, a circular Grand Avenue, and a central park. Outside the 'city wall' were cow pastures, new forests, allotments, smallholdings, large farms and an agricultural college, along with convalescent homes, children's homes, and homes for epileptics. This ideal city was the inspiration behind the planning and building of Letchworth.

Bird's Hill (architects Parker & Unwin, for Garden City Tenants) exemplifies the best of Letchworth. Groups of four and six cottages are carefully arranged around greens and separated from adjoining industrial zones by strips of planted woodland. Their gables, hips, dormers and small-paned windows have become the features now sought after and preserved by Letchworth conservationists.

Less successful was Parker & Unwin's layout for the township. Letchworth does not 'group': it is too spread out. Unwin was perhaps understandably suspicious of imitating the curvings and narrowings of the streets of old towns. There seems a certain sense in making the town centre formal and the residential quarters informal, taking their shape from prospect, access and orientation, but the centre of Letchworth is desolate. Howard's list of the advantages of 'Town' included 'Social Opportunity' and 'Places of Amusement', but Letchworth possessed no music halls, no theatres, no alcohol and, until 1909, no picture palace.

The bewildering list of directors, shareholders and vice-presidents of Letchworth Garden City Ltd ('their names guarantee practical philanthropic shrewd-

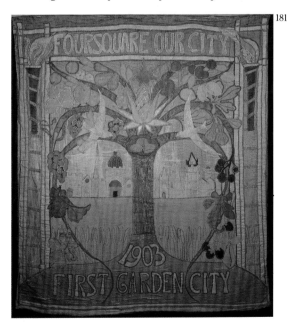

181

182

THE SKITTLES INN

Non-Alcoholic Public House — Non-Alcoholic Public House

BILLIARDS.
SKITTLES.
QUOITS.
READING
and
WRITING ROOMS.

WINES.
BEERS.
MINERALS.
DINNERS & TEAS.
LIGHT
REFRESHMENTS.

EXHIBITION ROAD, LETCHWORTH.

183

Camden Town to the industrial zone at Letchworth. The ineffectual struggles of his own father, a small farmer in Wales, to keep the wolf from the door had filled Idris with a determination never to be in debt. A philanthropic employer, he believed in profit sharing and gave company stock in payment of dividends. Idris products – Ginger Ale, Limejuice Champagne – were sold, along with cups of coffee, to the patrons of the 'non-tox' Skittles Inn, where customers also had the use of a billiards room, a writing room and a games room, in a strange, repressive English rural (or suburban) version of the Russian Constructivist Workers' Clubs.

Other early businesses established at Letchworth included the Garden City Press, which printed Co-operative and Suffrage literature; W. H. Smith's book-binders, Dent's the publishers; Heatley Gresham Engineering; the Lacre Motor Company; and Hunter's silk-weaving works.

Miss Annie Lawrence's open-air school, the Cloister, was opened in 1907. The central area was open to the sky and was hosed down regularly (books could be placed in water-tight cupboards).

ness') included reformers from all fields: the manufacturers Jos. Rowntree of York, George and Edward Cadbury of Birmingham and W. H. Lever of Port Sunlight (themselves all engaged in building model villages for their own workers); H. G. Wells and Walter Crane; clerics, like the Lord Bishop of Rochester; MPs, like Sir M. M. Bhownagree (a Tory) and the Hon. Dadabhai Naoroji (a Liberal); Franklin Thomas JP, a cotton-spinner from Bolton; T. P. Ritzema JP, a newspaper proprietor from Blackburn; and T. H. W. Idris JP LCC MP.

Idris moved part of his Table Water factory from

185

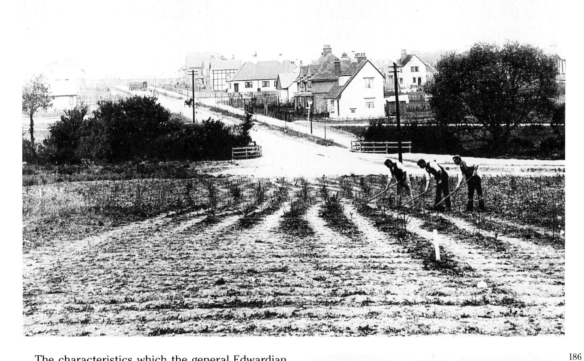

186

The characteristics which the general Edwardian public associated with Letchworth – vegetarianism, sandal-wearing, dress reform and temperance – were cheerfully acknowledged in the multitude of publicity pamphlets issued by the Garden City Company. 'Co-operation' was high on Ebenezer Howard's list of ideals, and Unwin's Fabian booklet of 1902, *Cottage Plans and Common Sense,* speaks of shared parlours, bakehouses and kitchens, along with 'small laundries, baths, reading rooms and other such . . . co-operative efforts'. But it must have been trying for those attempting to afford one of the 'Cheap Cottages', or to learn to live co-operatively and (almost) without servants, to have to endure the bleakness of the landscape before the trees grew, and the bleakness of suburban life unmitigated by a city centre (delayed by lack of funds); and the bleakness of Limejuice Champagne and skittles.

182. Advertisement for the Skittles Inn, Letchworth, from *Where Shall I Live* (1907). First Garden City Heritage Museum, Letchworth. The Skittles Inn was owned by Edward Cadbury and Aneurin Williams.

183. Cartoon no. 3, *What Some People Think of Us.* First Garden City Heritage Museum, Letchworth.

184. Advertisement for Idris Table Waters, from *Where Shall I Live* (1907). First Garden City Heritage Museum, Letchworth.

185. View of allotments, Nevells Road, Letchworth, 1905. North Hertfordshire Museums.

186. *Co-partnership Tenants Ltd, The Growing Tree.* 1909. John Johnson Collection. Bodleian Library, Oxford.

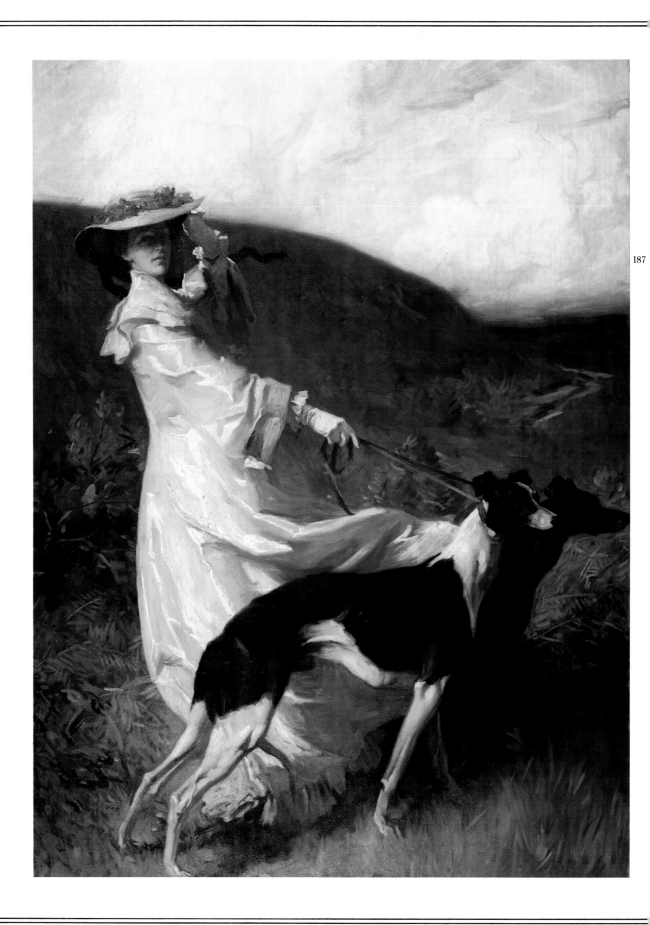

187

THE RURAL WORLD AND ITS REPRESENTATION

Alun Howkins

The practice of Agriculture – the primaeval occupation and the cleanest of them all – means more than the growing of grass and grain. It means, among other things, the engendering and achievement of patient, even minds and enduring bodies, gifts of which . . . the great towns rob those who swell and labour in them.

Henry Rider Haggard, 1899

These words come from the 'Author's Note' to *A Farmer's Year*, the book version of a series of articles published by Haggard in *Country Life* the previous year. Both the time and the place of publication are

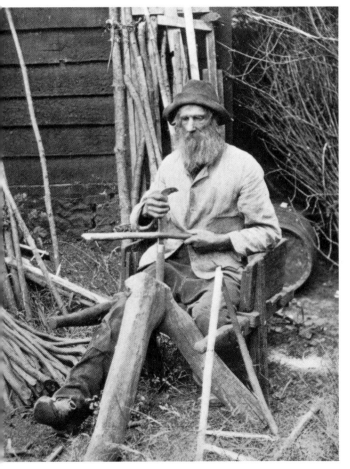

significant. By the late 1890s, enormous changes in the rural districts of England had produced what contemporaries began to call 'a rural crisis'. This was usually identified with the 'flight from the land', the failure of British agriculture during the depression of the previous twenty years, and an ill-defined sense that something was 'rotten' at the core of rural society.

Quite what was rotten depended on who you were. To the radicals, and the small but growing band of socialists, it was the 'tyranny of the countryside', the title of a famous early 1900s book. This was the exclusion of the poor from the land, the starvation wages and appalling conditions of most labourers and the dominance of the parson and the great landowners. At the other extreme, to conservatives like Haggard it was the decay of an old social order; the last round in the battle between city and country – which the city was to win, sapping the nation's racial stock and moral character in the process.

There was a third position, the one that produced *Country Life* – a growing identification of rural England, and southern rural England in particular, with some form of 'real' life. 'Back to Land' became the cry, not only of the radicals 'dispossessed' by enclosure of access to the soil, but of the clerks and shop-workers of the growing service sector. Like Leonard Bast in E.M. Forster's *Howards End* they were 'trapped' by the 'vulgarity' of the city, and reading Ruskin, and even sometimes Morris, they fled to the North Downs in search of a lost, rural, and 'real' world. *Country Life* was aimed exactly at them. It was a rural world written by supposed 'insiders' for 'outsiders', or rather those who might one day become 'insiders'.

From the start, as well as describing an idealized 'country house life', it produced a nostalgic and romanticized view of a vanishing rural England. In *A Farmer's Year*, Haggard wrote about 'Rough Jimmy', James Minns, 'the most expert woodman in the parish', extolling his stoicism in the face of old age, his maintenance of a lost craft and his pride in a son overseas, 'building the Empire'. In 1901 the same man was the subject of an illustrated article. Here is the carefully constructed image of the venerable countryman. His skill and craft are attested to by his age and by the archaic tools he is using, more even than by the description which accompanied the picture. He is a

189

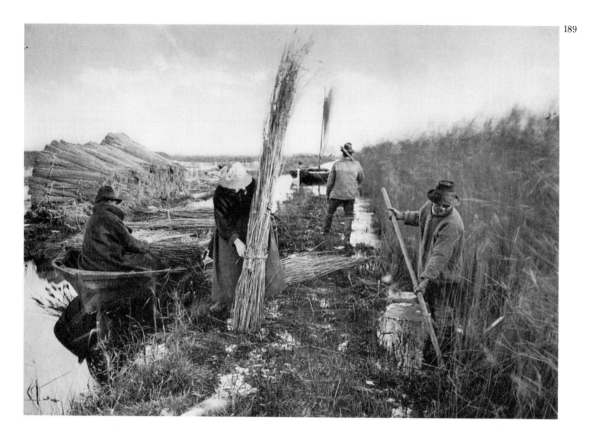

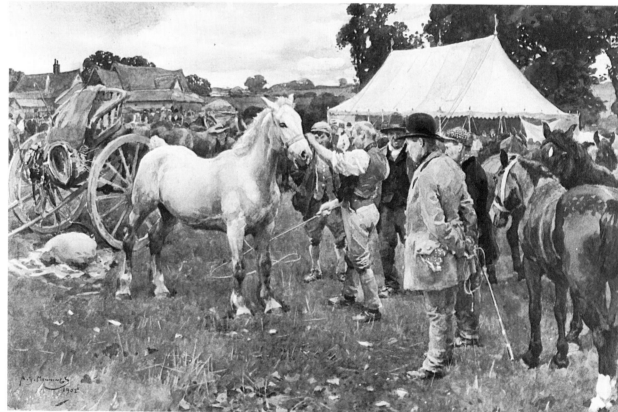

189. *During the Reed Harvest.* 1887. Photograph by P. H. Emerson. From P.H. Emerson and T.F. Goodall, *Life and Landscapes on the Norfolk Broads*, 1887. ' Picturesque labour' is what Emerson called this wet and weary work. Through it he showed a world of clean and decent work people. Poor but well fed, tough but honest, they are extras from a novel by Thomas Hardy.

190. Alfred Munnings. *Horse Sale.* 1902. Castle Museum, Norwich.

191. The Sand Pit, Swanton Morley, Norfolk, 1907. Photograph by Mr Nichols. Institute of Agricultural History and Museum of English Rural Life, University of Reading. Given by Mrs Rayner, Mr Nichols' daughter, of Swanton Morley. George Edwards (standing) and 'Jimma' Arnett (seated with beard) address a meeting called to found or refound the Union in this most radical of Norfolk villages.

192. The crowd at the meeting at Swanton Morley, 1907. Photograph by Mr Nichols. Institute of Agricultural History and Museum of English Rural Life, University of Reading. Dressed in their best, the men in stiff collars, some of them with their good hats and even handkerchief in pocket, the women in flowered bonnets, and the children dressed to the nines and as yet still clean: the rural poor as they saw themselves.

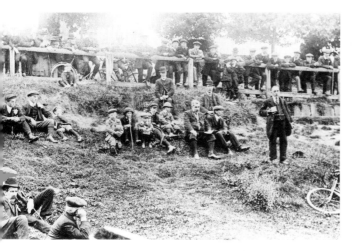

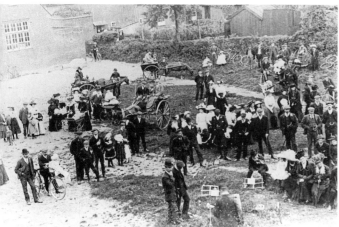

nence of rural England. As Aaron Scharf has written, 'Here . . . the interested public saw what they wanted to see; hard working men and women of field and fen, poor but good, honest folk content with their lot... "Picturesque labour" is the term Emerson used to describe the weary work of a Norfolk reed cutter.'

In Munnings we have an added dimension – 'olde England'. In his paintings, the brush, with its greater licence, exaggerates, but only slightly, the stance and dress of the country's rural inhabitants (or rather a section of them), for 'olde England' needed 'characters'. Characters were reassuring in that they clung to harmless eccentricities of dress or looked, like 'Rough Jimmy', vulnerable and deferential. Indeed, the horse itself was already acquiring an 'olde worlde' charm, although most farmers ploughed with a team until the mid-1930s. Yet by 1913 government reports noted that the 'agricultural motor' was making progress, even in England, where the steam engine had failed miserably.

But it was not only the 'agricultural motor' which threatened rural peace, nor for that matter some constructed racial crisis. In 1906 George Edwards refounded a farm labourers' union in Norfolk, which in the next five years was to prove militant and modestly successful. The democratic box camera, rather than Emerson's artistic photographic plates, is an appropriate medium to record 'old George' and James Arnett speaking in the 'Sand Pit' at Swanton Morley in Norfolk. The photographs show a world of difference. The photographer, who was a union man called Nichols, was concerned to record the event for himself, his friends and his family. Here we see country people the way they wanted to be seen, dressed in their best clothes, having marched through the village behind their band, listening to their leaders. To record and sentimentalize what was for them relentless toil would have been meaningless.

The rural England of the Edwardian period was for most of its inhabitants, the men, women and children who worked the land, a harsh world. Yet increasingly those outside it sought to represent it as the true heart of Empire. In photographs, paintings and poetry and more and more through popular media like the guide-book and the picture postcard, the countryside was made to stand for some reality of England and Englishness.

carrier of tradition, and hence of real England, as surely as the singers from whom Cecil Sharp collected country songs.

What *Country Life* was doing was popularizing a view of the countryman (and occasionally woman) which had already found a place in high art through the photographs of Emerson and the paintings of Munnings. In Emerson rural life was transformed from the backward to the mundane, and the mundane was lyricized. Work and the everyday doings of country folk came to symbolize the power and perma-

193

IDLE LAND MEANS IDLE MEN

The modern block of buildings marked "A," consisting of showrooms and ware-houses, forming No. 7, Aldersgate Street, is rated at £2,677 per annum. The vacant site marked "B," forming Nos. 4 & 5, Aldersgate Street, is rated at nothing. Block "A" occupies a site of about 10,000 sq. feet and pays £870 in rates. The vacant site "B" extends to 12,700 sq. feet, and pays nothing. It has been vacant for several years.

VOTE PROGRESSIVE
Rate Land Values and Prevent Unemployment.

Published by the United Committee for the Taxation of Land Values, 20, Tothill Street. Printed by VACHER & SONS, Westminster House, S.W. 25340.

193. *Idle Land Means Idle Men.* Published by the United Committee for the Taxation of Land Values, 1910. Institute of Agricultural History and Museum of English Rural Life University of Reading. Poster produced for the Progressive group of the LCC as part of the campaign to raise taxes on land, and so tax the wealthy landowners.

194. Poster produced for the London County Council by the United Committee for the Taxation of Land Values. 1910. Institute of Agricultural History and Museum of English Rural Life, University of Reading. The campaigns to raise taxes on land were designed to tax the wealthy landowners whose income came increasingly from letting their estates for hunting, shooting and fishing rather than agriculture.

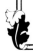

194

195. Jane B. Constable. *The Last Sheaves: October Harvest*. Ulster Museum, Belfast.

196. Photograph of women working in hayfields. Kodak Archive, National Museum of Photography, Film and Television, Bradford. In the transformation of an agriculturally based economy to one based on industry and commerce, and with the increasing mechanization of the agricultural industries, women were displaced from some of their traditional jobs on the land, particularly in harvesting.

196

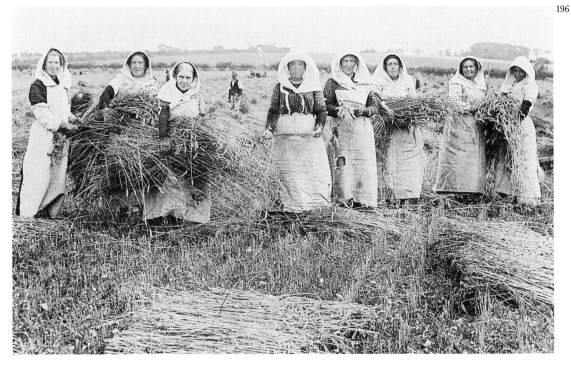

197

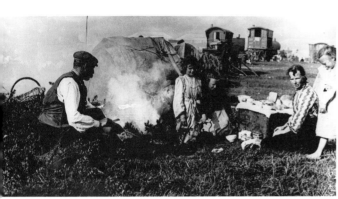

198. Elizabeth Adela Forbes. *The Ford.* 1908. Private collection (courtesy Whitford and Hughes).

197. Gypsies on Epsom Downs, 1910. Photograph by Horace W. Nicholls. Royal Photographic Society.

199. Augustus John. *Horse and figures.* 1909. British Museum, London.

198

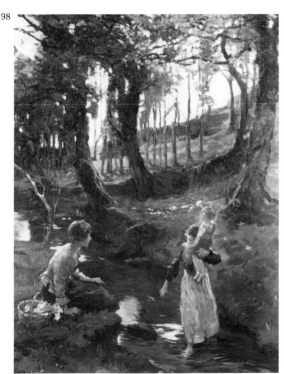

200

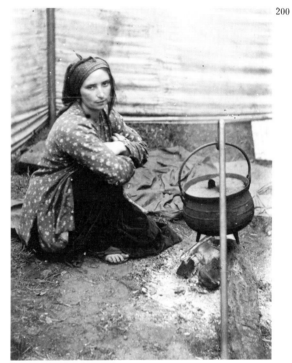

199

200. Dorothy McNeill (Dorelia), 1909. Photograph by Charles Slade. National Portrait Gallery, London. Augustus John played at being 'gypsy' in 1909, travelling by caravan, making camp and exhausting the horses by his lack of proper care. This journey and the 'bohemian' life-style which accompanied it were the products of middle-class male artists' beliefs in the primacy of their own creativity and its 'free' expression, unfettered by social or sexual restraints. They were also typical of this class's appropriation of the cultures and histories of the travellers, an appropriation also found in the 'scholarly' research done during the Edwardian period.

201

201. Cycling and motoring map with postcards of seaside and country. Private collections. Motoring was a pleasure conspicuously consumed by the wealthy, involving not only the expense of the car and petrol but that of the special clothing. No protection, however, was afforded to pedestrians who were showered with dust or deafened by the noise, or to the farmers whose crops were ruined.

202. Charles Conder. *Newquay*. 1906/7. National Museums and Galleries on Merseyside (Walker Art Gallery). Newquay, called 'the Biarritz of England' in Edwardian guidebooks, was a fashionable seaside resort, frequented by artists and middle-class holiday makers.

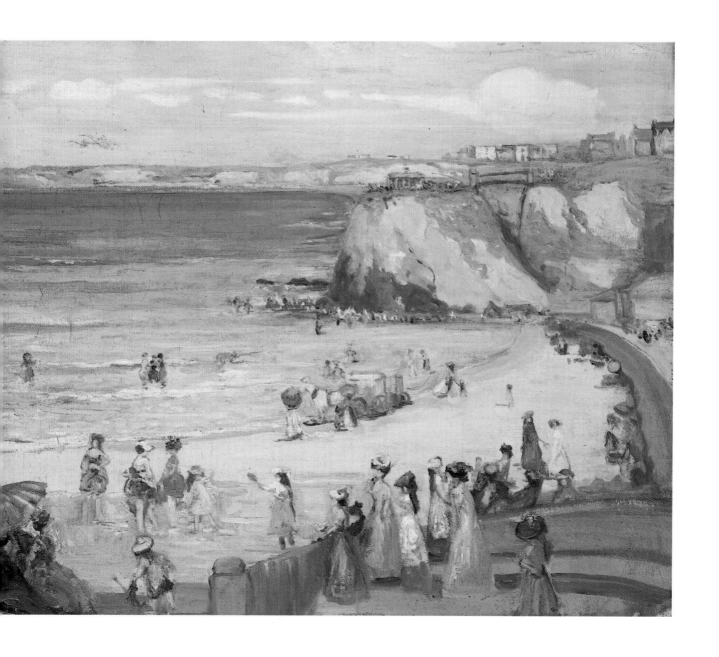

206. Embleton, c.1910. Photograph by A.H. Robinson. Impressions Gallery, York. Panoramic cameras were much in vogue during the Edwardian period with both amateur and professional photographers.

207–210. Snapshots by the Fisher family of Ryhill, Yorkshire. Private collection. These family snapshots, taken on holiday at Blackpool, were made into slides by local high-street photographers from the roll film negatives for projection at home in the winter evenings.

203–205. Herring market and fisherwomen, Lowestoft, 1901-10. Suffolk Record Office, Lowestoft. Many Scots women were employed to gut and cure the herring catch. Enduring terrible weather, they followed the fishing down the east coast, poorly paid and often living in squalid conditions.

THE SEASIDE

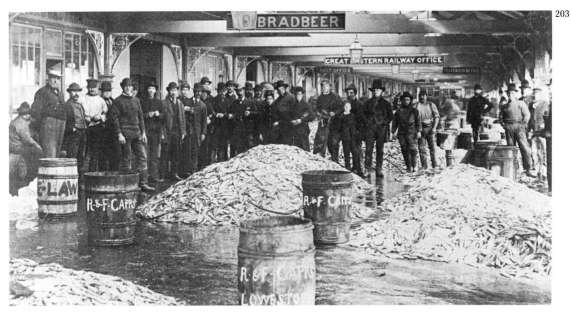

203

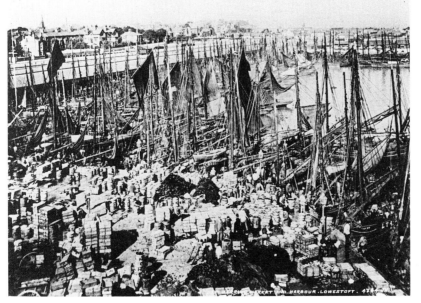

204

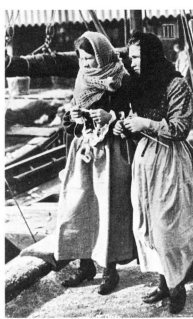

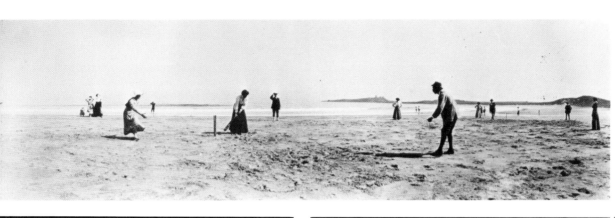

209

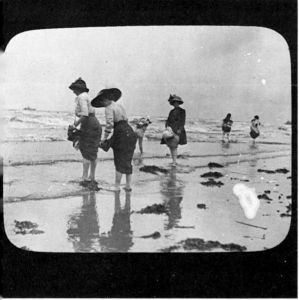

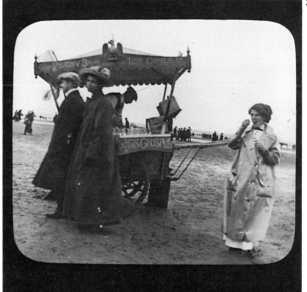

210

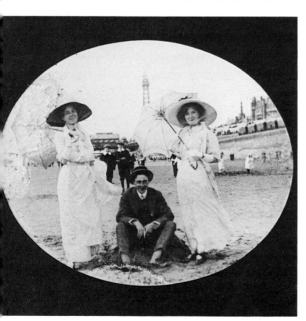

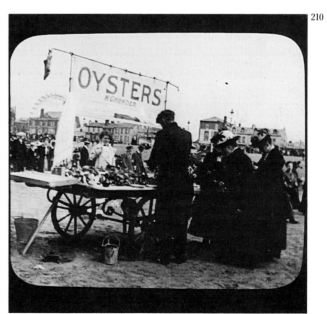

TRADE-UNION BANNERS

John Gorman

211. Twenty-nine Labour MPs were elected in 1906, forming the Labour Party from the Labour Representation Committee which had been founded in 1900. Seven were sponsored by the Independent Labour Party (ILP), the others by trade unions or local labour groups. Several of these were also members of the ILP and one was a member of the Social Democratic Federation (SDF). The Labour Party Library.

'No starving children in the Board Schools' was a slogan emblazoned on scores of trade-union banners in Edwardian Britain. It was a cogent demand in support of organized labour's campaign for free school dinners in a land where 'one penn'orth of brawn and a halfpenny-worth of pickles formed the daily dinner of thousands of children.' Women feeding babies on old bits of bread and cold potatoes while they themselves went without, children scrambling for garbage from street markets, dinners of bread and marge, breakfasts of stale bread and rancid dripping, skimmed milk, red herrings and adulterated food – this was the plight of millions in the richest Empire the world had ever known. Socialist 'Cinderella Clubs', *Clarion* soup kitchens, Church dinner funds and Salvation Army 'Farthing Breakfasts' were all born from the need to feed starving children. Led by Fred Jowett, an Independent Labour Party pioneer from Bradford, the campaign forced through the Education (Provision of meals) Act in 1906, though fierce opposition to school meals funded from the rates continued from Liberal and Tory councillors. It was not until 1945 that a full programme of school dinners and milk were implemented by the Labour government.

It was the struggle for social justice, for the eight-hour working day, for employers' liability, for universal suffrage, for the right to work and for trade-union rights that shaped the visual imagery of the labour movement. Banners, emblems, membership cards, badges, posters, ceramics and regalia were all used as vehicles of expression, a powerful and telling use of art in the fight for political and social freedom. Nowhere was it better demonstrated than on the giant, silken banners of the trade unions, where the images and slogans asserted a new militancy. The nineteenth-century union mottoes, 'Combined to protect, but not to injure' and 'Defence not defiance', gave way to 'An injury to one is an injury to all.' London dockers voiced the demand for social change, inscribing a banner with 'This is a holy war, we shall not cease until all destitution, prostitution and exploitation is swept away.'

If working-class struggles shaped the imagery, it was given form by socialist artists, the most influential of whom was Walter Crane. His 'cartoons', drawn for the leading socialist journals of the day, *Justice, Commonweal, Clarion* and the *Labour Leader*, were

the popular art of the labour movement, brightening the dreary walls of dingy meeting-rooms and bringing the message of hope wherever a few workers gathered together to plan the social revolution. His 'Cartoons for the cause', a folio edition of prints and poems first published in 1896 as a souvenir for the International Socialist Workers and Trades Union Congress, was reissued in 1907 and became a ready reference for banner painters. The imagery was simple, even when the drawings were elaborate. Capitalism was depicted as a serpent, a wolf or a dragon; the workers were men and women of William Morris's England, labourers and craftsmen, strong and determined, ever ready to slay the evil monster, the capitalist system. Socialism was depicted as a sunny future, the millennium, almost within the grasp of a Phrygian-capped representative of the proletariat.

The message of socialism was clearly spelt out, 'The co-operative commonwealth', 'Solidarity of labour', 'The land for the people' and Crane's own favourite, 'Socialism is the hope of the workers.'

As the unions grew in strength and militancy, the employers hit back. Following a strike of railwaymen at Taff Vale in August 1900, in support of a fellow worker victimized for leading a demand for more pay,

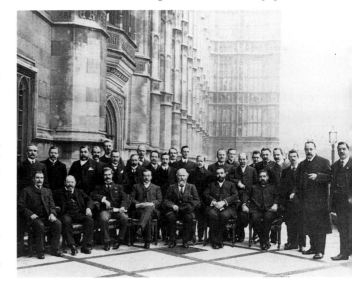

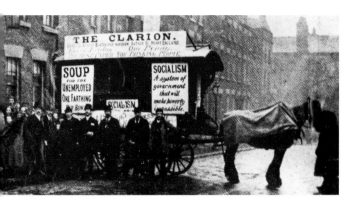

212. Organized by Robert Blatchford's newspaper, the *Clarion*, horse-drawn 'red' vans toured the country spreading the message of socialism and often feeding the poor. Liverpool, 1906. John Gorman/National Museum of Labour History.

213. Unemployed demonstration, Westminster, London, 28 November 1905. John Gorman Collection.

214. Banner of the Camlachie Branch of the Independent Labour Party. People's Palace, Glasgow.

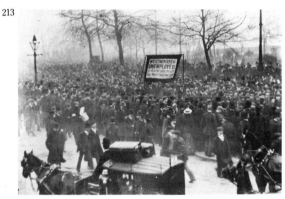

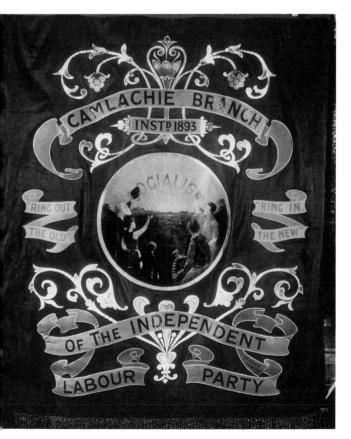

the employers obtained a House of Lords judgement that held trade unions responsible for damages arising from strike action. The Amalgamated Society of Railway Servants was ordered to pay the Taff Vale Railway Company £23,000, a fortune in 1900, filched from the pockets of men who toiled a sixty-hour week for a pound.

The Law Lords' decision deepened the awareness of trade unionists of the need for political representation and accelerated the metamorphosis of the Labour Representation Committee into a political party with parliamentary aims, the Labour Party. The imagery of labour encapsulated the demands for universal suffrage and the Textile Workers' Union expressed the changing claims of labour when they adorned their banner with the verse:

> The world is for the workers,
> We mean to have it too,
> Unite ye working comrades
> And claim what is your due.

In 1906, following the return of twenty-nine Labour members to Parliament, the Law Lords struck again, this time ruling illegal the trade unions' political levy that was the financial base of the Labour Party. Devastating as the blow was, it was a Canute-like decision that could not stem the rising tide of Labour, and by the end of the decade union membership had grown to almost two and a half million and the number of Labour MPs to forty-two.

While the iconography of the unions reflected the advance of Labour, their banners painted with illustrations of groups of workers shaking their hands in unity and looking towards the allegorical sunshine of the co-operative commonwealth, their basic demands remained, written bold, 'Production for use, not profit', 'Shorten the working day and lengthen life', 'No child toilers'. As the decade closed, twenty thousand unemployed, gaunt and shabby men shuffled into Hyde Park, their rough banners inscribed, 'Bread for our children.' For those who dwell on the 'good old days' of Edwardian elegance, the extant visual history of labour bears mute witness to the deprivation and social injustice endured by our grandparents as they sought to create a more just and equitable society for working people.

7

THE FRANCO-BRITISH EXHIBITION
Packaging Empire in Edwardian England

Annie E. Coombes

'It is quite evident that the spectatorial lust is a most serious factor in imperialism. The dramatic falsification, both of war and of the whole policy of imperial expansion required to feed this popular passion forms no small portion of the art of the real organizers of imperialist exploits, the small groups of businessmen and politicians who know what they want and how to get it...'[1]

J. A. Hobson, 1902

The 'spectatorial lust' that J. A. Hobson (that perceptive critic of Edwardian Empire) saw as an indispensable corollary of imperialism found its apotheosis in that phenomenon quintessentially dedicated to the era of high capitalism: the National and International Exhibition. By 1901 such events had reached new heights of entrepreneurial ingenuity, culminating in 1907 with the construction in London of a purpose-built site, later christened the 'White City', as an addition to the already well-established grounds at Earls Court and Crystal Palace. Since consolidation rather than expansion was at the heart of the imperial project during this period, the exhibition acquires a potent significance as the site where the ideal of a seamless and unproblematic national unity was consummated. Moreover, the ideal of a 'national' culture which accompanied this strategic attempt at unification was a feature of both Tory and Liberal administrations in the period from 1902 to 1910.

Paradoxically, the success of this ideal relied on the painstaking construction and elaboration of a series of 'differences'. Crucial in this respect was the biological and cultural difference set up between the colonizer and the colonized – particularly in relation to those races classified as 'black'. The role played by the various colonized peoples in the public exhibitions of the Edwardian era was essential to this process of constructing racial difference and consolidating a homogeneous national identity.

The power of these events resided not only in their pursuit of spectacle but, more specifically, in the constituting of this spectacle as simultaneously 'scientific observation' and 'mass entertainment'. This encouraged the blurring of the already tenuous boundary that divided the 'scientific' from the 'popular'. Anthropology, though fast acquiring a new professionalized status, was still a young discipline at this time and was particularly susceptible to this process. As a result these exhibitions were a powerful means of ensuring the longevity of a residual 'scientific racism' long after this had been discredited in academic circles.

Contrary to the usual practice in either America or France during the same period, successive British governments refused to finance these exhibitions directly. The King might well give his tacit approval by opening the proceedings and his government ministers might be on the Executive Committees, but the funding for such events had to come from precisely those sources indicated in Hobson's critique – 'small groups of businessmen and politicians who know what they want and how to get it'. Consequently, while the Executive Committee and the Honorary President were often members of the British Empire League, the chairpeople of the various sections were not always as wholeheartedly dedicated to the same concept of Empire, even while one vision might prevail.[2] While conflicts of interest sometimes produced rather idiosyncratic exhibits, the contradictory knowledges that resulted often set up an interesting dynamic within the exhibition. Clearly some of the altruistic ideals regarding educational benefits emerging from the 'official' publications were not always equally the concern of those who held the franchise for many of the 'attractions', despite their reiteration of similar objectives. While a publication produced in connection with one such attraction was at pains to reinforce the notion of 'a very serious exhibition where visitors come to study and be wise', a more sceptical reviewer remarked that despite a great deal of attention spent on the organizing of the education section, 'comparatively few visitors to an exhibition go to spend time on such a heavy subject'.[3]

An Empire For the 'People'?

One of the most successful and widely acclaimed exhibitions, which later served as a model for so many others on the same site, was the Franco-British Exhibition of 1908, held at the White City in London. While the declared occasion for *any* exhibition was generally a '. . . stock-taking of the resources of civilization . . . a periodical summing up of the achievements of a progressive age,' in the case of the Franco-British it also provided an opportunity to cement the *Entente Cordiale* between France and England.[4] A further clue to the show's objectives was the degree to which the ephemera deploys the language of racial determinism to assert a naturalized order. It was acknowledged here that:

> a 'natural fitness underlies the Entente Cordiale . . . the highest international results are obtained when leading racial characteristics and prominent industries are not opposed . . . when Anglo-Saxon energy blends with French *"savoir vivre"*, when British empiricism is ordered by French method, when British solidity is adorned by French grace, a combination is reached which embraces the highest achievements of the human race.'[5]

The rhetoric of racial fitness and the superiority of the specifically Caucasian races surface in different sections of the exhibition. This obsession with 'nationhood' was partly a response to the disturbingly obstinate threats to Britain's imperial supremacy from Germany, America and Japan.[6] But its persistence needs to be understood as the residual by-product of a ruling bloc anxiety over imperial decline in relation to the physical deterioration of the population. This was especially true since the Boer War recruitment drive for the armed forces had made it painfully clear that the working-class recruits were not physically 'fit' for active service in the defence of Empire. The findings of the social investigators Charles Booth and Seebohm Rowntree did nothing to allay these anxieties.[7]

For Edwardian England then, social decline and the industrial economy were inextricably linked to the concerns of Empire. And, while different factions proffered different solutions to such problems, one of those advocated in varying measure by them all was the doctrine of social imperialism. As a principle, this policy was designed to unite all classes in the defence of nation and empire mainly by convincing the *working classes* that *their* welfare depended on the development and expansion of the empire. It is within the context of this ideology, either in its more conservative guise of 'national efficiency' or in its more liberal cast as 'social reform', that the international and national exhibitions of 1901–1910 should be understood.[8] Under this brief Liberals, Tories and Radicals could all be comfortably accommodated at the Franco-British.

The appeal for national unity and working-class co-operation, both corollaries of this ideology, operated on several levels here. Excursion fares and tickets were arranged by employers with the co-operation of the exhibition committee, so that special provision was made for visiting parties of workers. By August a number of such excursions had visited the White City, including 3,500 employees from Lever Brothers at Port Sunlight and 1,100 from Messrs Bass, Ratcliffe and Grettons at Burton Brewery. Arrangements were even made to accommodate the former group after the rest of the public had left the exhibition at 11 p.m., since the six special trains for Port Sunlight left at midnight. On another occasion the Palace of Music was temporarily converted into a refreshment room to cater for these employees. In July, employees of Chubb and Sons Lock and Safe Company entertained their London workforce at the Franco-British. The meeting of 'East' and 'West', always a sensitive issue, was accomplished when the Queen paid the expenses of Lady Dudley to treat a party of about fifty children from the East End of London to a tour of the grounds. For those 'Eastenders' not fortunate enough to be the beneficiaries of such philanthropic concern, a scale model of

the White City, complete with Flip-Flap, was set up in Whitechapel.

One gets the sense, through the deliberate care with which such provision was made in the face of often quite baffling logistics, that the persistent inclusion of these working-class contingents was no afterthought. The degree of publicity that these outings attracted in the local and national press and in the illustrated weeklies supports the suggestion that their presence had other significances. Contemporary reports give the impression of a docile, happy-go-lucky workforce enjoying the benefits of their generous employers' thoughtful provision. Able, in fact, to profit from the accumulated wealth of the nation and the fruits of imperial endeavour. Their inclusion also indicates a growing awareness of the emergence of a working class of quite other dimensions and constitution: audible through increasing organized union activism, profiting from State educational initiatives but also instituting additional educational demands from within their own ranks. The concomitant rise of the Independent Labour Party during this period was another factor that helps to account for the deliberate inclusion of working-class participants at the Franco-British, and the high profile given to this policy.

What precisely was on offer, then, to this and other sectors of the massive crowds flooding in to the exhibition ground? What vision of Empire and of its inhabitants were they presented with? Furthermore, how did this vision enhance the ideal of a unified Britain?

Persuasion Through Spectacle

To answer these questions requires some analysis of the forms of representation available at the exhibition, and some account of its success as a type of popular spectacle appealing to a broad public. Certain features of the general layout of the exhibition contributed in no small measure to this appeal. In common with all national and international exhibitions during this period, the Franco-British had no central exhibition space. Its apparent lack of rigorously imposed control over the viewing space and the semblance of endless choice and unrestricted freedom was an important factor in its persuasiveness. Through the rhetoric of 'learning through pleasure', the exhibitions achieved a success that other cultural institutions could only dream of. Far more successfully than the national or local museum, for example, whose static exhibits could only *signify* the colonized subject, the exhibitions, with their model 'villages', literally *captured* this potentially dangerous subject and represented him or her tamed, in a contained and yet accessible and supposedly open environment. A sophisticated complex of railway and other transport networks within the exhibition grounds had the effect, reinforced by the text of the guidebooks, of allowing the visitor to 'travel' from one 'country' to another without ever having to leave the site.[9]

As a consequence, the appeal of these exhibitions can be said to reside in the message that those cultures represented could be both possessed and contained. The sense of being an 'active' rather than 'passive' consumer of the spectacle – of being in fact a participant at an *event* – was a further spin-off from the vicarious 'tourism' that was offered to all who passed the turnstile at one of the 'City' gates.

The explicit display of imperial and colonial interests at the Franco-British Exhibition is best explored through two aspects: displays of material culture from the colonies and dependent territories, and displays consisting of the peoples from these colonies in what are referred to in the guidebooks and official catalogues as 'villages'. The British section, under the guidance of the Hon. Sir John Cockburn K.C.M.G. (an active member of the British Empire League), featured displays from India, Gambia, the Gold Coast, Southern Nigeria, Fiji, Canada, Australia and New Zealand, in various purpose-built pavilions. It also included two 'villages', one Ceylonese and one Irish, and a feature known as the Indian Arena. French colonialism was represented by pavilions for Algeria,

215 John Singer Sargent. *Sir Frank Swettenham*. 1904. National Portrait Gallery, London. Swettenham joined the Straits Settlements in 1871 and was created Governor of Malaya in 1901, retiring in 1904. The painting is an imperialist image of white military rule and economic exploitation, created not only by the arrogant stance of the man in the white colonial uniform (kept white by the labour of others), but by his ownership of the beautiful Malayan brocades (now in Kuala Lumpur Museum).

Tunisia, French West Africa and Indo-China, together with a Senegalese Village. It is important to emphasize from the start the relative status assigned to the 'pavilions' and the 'villages'. The pavilions, because they were self-contained architectural structures, acquired an immediately elevated status by comparison to the 'villages', billed as 'daily life' and categorized in the guides as one of the 'attractions' of the exhibition. The meaning of this category becomes apparent when it is understood that both 'Flip-Flap' and 'Wiggle-Woggle' were also billed as 'attractions'. While the pavilions were evidently designed as the 'showcases' it is interesting that those aspects of the colonial sections that received the most attention in the local and national press in Britain (apart from the Indian Pavilion) were the Senegalese Village and the Irish Village.

One of the striking aspects of representation of the colonies and colonized races is the degree to which cultural production was used as a means of naturalizing an arbitrary hierarchy. This hierarchy effectively operated as the equivalent to an evolutionary scale, with the African colonies at the bottom and the Dominions of Canada, Australia and New Zealand at

216

THE CANADIAN ARCH;
WHITEHALL, 1902.

the top. Otherwise the paradigm which dominates the exhibition, not least through the architectural style adopted for the construction of most of the plaster buildings, was 'orientalist'.[10] The French packaged their 'Orient' as:

> ... agreeable places to stay during the cold season ... Algiers, Blidah, Biskra, Tunis, now provided with comfortable hotels, are well equipped for the reception of the globe-trotters, lovers of beautiful scenery and sunshine. It is chiefly in this respect that the Algerian and Tunisian exhibits will provide results.[11]

By contrast, the rhetoric of tourism employed in descriptions of the Indian Pavilion emphasizes not the physical comforts of a new resort but the cerebral pleasure of an old culture. Here

> ... the art of the land's dreamers, the joyful work of the land's craftsmen, were flung prodigal for your delight.[12]

Significantly, the items on display (some of which were even priced, to give the reader a more accurate appreciation of their worth) came predominantly from the art colleges set up by the British in Lahore, Bombay, Punjab and Madras. Their function at the exhibition was spelled out in no uncertain terms as demonstrating ' ... the watchful care of the Government that had fostered that genius', and ' ... the wisdom of the rulers of a strange land in encouraging all talent in the men they ruled'. Through this means the visitor was reminded of the 'splendid miracles' wrought by such benevolent colonialism.[13] In view of the rather disastrous record of British rule in India in the years directly preceding the exhibition – especially the famine and uprisings of 1907 – this was a very timely piece of propaganda.

Material culture from the crown colonies of Gambia, the Gold Coast and Southern Nigeria came in for rather different treatment in most of the exhibition reviews. We have only to look at the report of both exhibits in the special exhibition edition of the Daily Mail: 'Land of Marvels, Thrills and Wonders, from India and 'Crown Col-

216. Coronation souvenir: The Canadian Arch. 1902. Bodleian Library, Oxford. The Canadian Arch was constructed in Whitehall for the Coronation celebrations in 1902 to represent the cereal products of Canada, by now imported into Britain in large quantities as part of the economic links with the white Dominions.

217. John M. Swan. *Indian Leopards*. 1906. Bradford Art Galleries and Museums. The practice of collecting animals from Africa and Asia was well established by the Edwardian period, linked to imperialist and colonial expansion. This artist studied animals in zoos and located them in imaginary settings. Lions, tigers and leopards stood as signifiers of wildness, against perceptions of the order, docility and hard work of 'tamed' animals of the British countryside – the horses for example, featured in the paintings by Munnings.

218. Interior of the Indian Pavilion at the Franco-British Exhibition. From F.G. Dumas, *The Franco-British Exhibition Illustrated Review*, 1908. British Library. The Indian Pavilion was largely a showcase for products from the various art colleges set up by the British to promote certain forms of Indian craft and art work. It served also to demonstrate the supposedly benevolent generosity of the British administration in India.

219. Stage sets for *The Cingalee*, Daly's Theatre, London. 1904. Set in Sri Lanka, this musical comedy provided an ideological justification for British colonial exploitation, both economic and sexual, telling the story of a white man's rapacious desire for and possession of a woman tea picker, played by a white woman made up to appear 'black'. The stage sets were white men's fantasies, serving to exoticize Sri Lankan culture.

that 'Devil worship is associated with many of the curios. Sinister indeed is a triple-faced mask covered with human skin flayed from sacrificial victims.' Despite a mention of the 'artistic skill' visible in the Benin bronzes the final impression rests, predictably, with the 'cannibalism and other unpleasant habits' that were said to exist side by side with them.

'India's share of the attractions of the White City', on the other hand, 'is a remarkable one. The official Indian Palace with its wonderful arch of carved wood, its beautiful tableaux of ruby mines and teapicking, its treasures of silver and bronze, its silks and painted work, is in itself one of the most interesting buildings in the western end of the exhibition.' Even the Ceylon Village is 'filled with clever artistic craftsmen', comparing favourably with the superstitious 'curios' of African manufacture.[14] The nature of

THE TWO BEAUTIFUL SCENES IN "THE CINGALEE," AT DALY'S. 219
PAINTED BY HAWES CRAVEN

onies' Sinister Relics of the Savage King'. Here the coral cloak of the royal insignia from the court of Benin City, and Tippoo-Tib's war-horn (acknowledged as 'a fine piece of ivory carving') are nevertheless seen primarily as 'some of the strangest things in the exhibition'. Descriptions quickly give way to sensationalist accounts of the war drum captured by the Jebu expedition of 1892, whose 'associations are very gruesome, as it was used only at the execution of criminals or on the field of battle'. These 'associations' were then promptly cemented by the statement

220

220. Edward Atkinson Hornel. *Tea Pluckers, Ceylon.* 1908. Location unknown. Hornel visited Sri Lanka in 1907 with the white imperialist aim of painting 'Ceylon and its peoples'. By this date several British companies owned vast plantations in Sri Lanka. In Hornel's paintings Sri Lankan women are represented as child-like, and their work as easy and unlaborious. Such images and their reception in the British art press provided an ideological framework for the ruthless colonial and economic exploitation of Sri Lanka for white pleasures : tea, cocoa, pearls.

221. Picture postcards of the Franco-British Exhibition, 1908. Donald Knight Collection.

the spectacle ensured that it was precisely those sections of the Crown Colonies Pavilion that 'illustrate native manners and handicrafts' which were also generally observed as being more interesting to the 'casual' or 'ordinary' visitors. Their preference was for 'native curiosities' over those exhibits demonstrating the raw materials and other products supposedly so necessary to the well-being of the Briton at home and to the country's economy.[15]

Significantly, while previous exhibitions had pursued a policy of populating the 'villages' with Africans billed either as 'Zulus', 'Matebele' or 'Sudanese' (which groups were always topically associated with a recent act of subjugation by the British) this was not the case at the Franco-British exhibition, where they were Senegalese.[16] By this date most of the 'Africans' appearing in this capacity at exhibitions of this sort were supposedly from French colonies: Senegal, Somali and Dahomey being the most popular, although both Ashanti troupes and a 'Dinka' village made appearances at Crystal Palace, Earls Court and Liverpool.[17]

Anxieties had already been aroused in the House of Commons regarding the representation of British colonies through such 'sideshows'. Consequently, in the case of the representation of the British West African colonies at the Franco-British any sense of 'spectacle' had to be constituted solely through material culture. The exhibits functioned on one level as signifiers of British sovereignty, and this was especially the case because of the organizers' highly selective concentration on those prestigious kingships that had eventually been forced, after bloody confrontations, to succumb to British conquest. On another level the attribu-

tion of such significance to ethnographic material at this time can only be fully appreciated in the light of other initiatives from within the professional and semi-professional bodies that were responsible for the public presentation of such material outside of the exhibition context.

'Science' and the Popular Presentation of Empire

By 1908 anthropology in Britain was still negotiating its status as an academic discipline. Its tenuous position made it expedient to promote as wide a relevance as possible for its work. Consequently, the professional mouthpiece for academic anthropology, the now *Royal Anthropological Institute* (1907), had for some time been at pains to justify its existence as readily accessible on a broad-based popular educational level, a rigorous scientific level *and* on a practical level as the helpmate of the state, 'because the proper understanding of native races and their relationship to each other is a matter of vital interest to us, if we are to govern justly and intelligently.'[18] By 1908 the Journal of the Institute is even more pragmatic in its desperation to appear indispensable to the colonial government. 'Several of our distinguished administrators, both in the colonies and in India, have pointed out that most of the mistakes made by officials in dealing with natives are due to the lack of training in the rudiments of ethnology, primitive sociology and primitive religion. Numerous instances of the troubles arising from this cause can easily be adduced.'[19] The earlier humanitarian sentiments and the idea that anthropological knowledge would facilitate passive consent from subject races for British colonization co-exist in the official discourse of the Institute by 1908. This uneasy alliance was further complicated by the desire to maintain a degree of professional autonomy through the production of 'objective' scientific knowledge as well as a public profile that encouraged the production of material 'of a character readily followed and understood without any special acquaintance with the mysteries

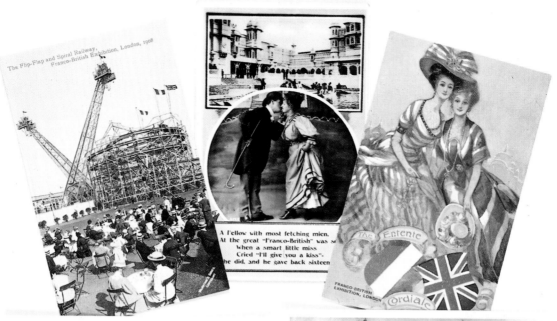

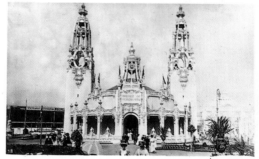

The Senegalese Village.

THE FRANCO-BRITISH EXHIBITION.

THE PALACE OF WOMEN'S WORK.
FRANCO-BRITISH EXHIBITION.

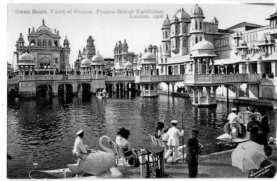

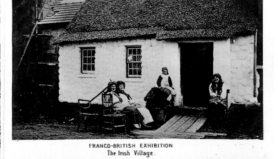

FRANCO-BRITISH EXHIBITION
The Irish Village.

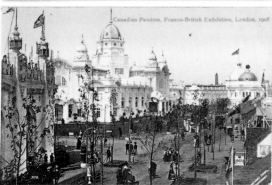

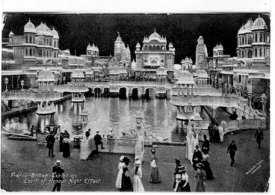

of anthropological science'.[20] Furthermore, anthropologists' appeals for support for the discipline were often framed as a response to the competition posed by a now familiar imperial threat: Germany. The spate of anthropological texts that came out after 1906 sporting the motto 'accurate but readable' and written by such eminent representatives of the science as Alice Werner, T. A. Joyce and Northcote Thomas frequently railed against the British government's indifference by comparison to the German government's expansive support and recognition for German anthropologists.[21]

A more pernicious result of anthropology's campaign of popularization was that a highly selective version of anthropological theory was thus available to be appropriated by parties with diverse interests in colonization. As a version it owed more to the racial determinism which was a product of the evolutionary theory of the nineteenth century than to the comparative methodology of Tylor and Haddon or the later functionalism of Malinowski and Radcliffe-Brown. Paradoxically, anthropology's accessibility speeded the disintegration of a division it sought to maintain between the popular and the scientific. At the same time this ensured that popular racial stereotypes were able to derive more credibility through their relationship to the supposedly separate sphere of scientific knowledge. By 1908 any difference between the supposedly distinct domains of 'scientific' and 'popular' knowledge regarding the colonized subject had been effectively obscured for a large proportion of the public who visited these exhibitions. It was an elision accomplished partly through the agency of texts describing and defining the colonized subject. Although some were described as 'fiction' and others as 'objective scientific truth', both categories of text often shared the same author. For example, John Buchan, better known as author of 'Prester John' (1910), also wrote a handbook for the student colonial administrator in South Africa ('The African Colony', 1909).[22]

On another level, this elision was reinforced

through certain initiatives taken by the museums establishment in general, as a means of popularizing their collections. Ethnographic collections were designated as having a particular role to play here. Furthermore, the museum as a prime cultural institution proclaimed itself altruistically to be 'the most democratic and socialistic possession of the people. All have equal access to them, peer and peasant receive the same privileges and treatment, each one contributes in direct proportion to his means to their maintenance and each has a feeling of individual proprietorship.'[23] This vision of a cultural institution capable of transcending class barriers echoes the rhetoric of the Franco-British. It was a rhetoric further mobilized by the many organizations dedicated to educating the 'masses' in the ideals of Empire, such as the Primrose League and the Empire Educational League. One such group, which included on its executive committee many museum directors, was the League of the Empire, which had been founded in 1903 in order to bring children from different parts of the empire into contact with one another through correspondence, lectures and exchanges. By 1907 the Museums Association was claiming 'splendid success in educating and refining the masses of the population'.[24] Regardless of whether this was true, the fact that both these public institutions, museums and national and international exhibitions, felt in some way obligated to emphasize their educational potential and to define their public as containing a large working-class component is significant.

Furthermore, by 1908 any interpretation of this educative principle as a benevolent paternalism making use of Empire as a potential 'living' geography lesson should be put aside. By now, it had been transformed into a more specific call for the recognition of the superiority of the European races. In the words of the President of the Museums Association, 'The progress of colonization and commerce makes it every year increasingly evident that European races and especially those of our own islands

160

222

22. *Boer or Briton, a new South African War Game,* 1900. National Army Museum, London. The brutality and violence of the South African War was turned into a popular game.

23. An early training in militarism for the middle-class boy. Kodak Archive, National Museum of Photography, Film and Television, Bradford.

223

are destined to assume a position in part one of authority, in part of light and leading, in all regions of the world.'[25] If the British were to assume the ambitious position of the world's teachers, it was essential that they were themselves well taught.

As late as 1909, the relevance for the working classes of education through the use of ethnographic collections was as persistent a theme in the Museums Association discourse as it was in the discourse of the Royal Anthropological Institute. (Indeed both bodies shared many members.) 'Heaven-born Cadets are not the only Englishmen who are placed in authority over native races . . . There are Engine Drivers, Inspectors of Police . . . Civil Engineers of various denominations . . . to mention only a few whose sole opportunity of imbibing scientific knowledge is from the local museum of the town or city in which they have been brought up.'[26]

Eugenics and Evolution

The public faces of anthropology were represented at the Franco-British Exhibition by four different aspects, three of which were present in the British Science Pavilion. In 1903, the Physical Deterioration Committee had recommended the setting up of an Imperial Bureau of Anthropology, whose anthropometry section was to be responsible for the collating of data on the physical measurements of those races coming under the jurisdiction of the British Empire.[27]

Despite the fact that by 1908 the Royal Anthropological Institute was still fighting for some government support for the scheme, anthropometry had already been put to considerable use by anthropologists working within the British Isles. Instruments, statistics and a set of charts were prominently displayed at the exhibition 'to demonstrate how measurement of physical and mental characteristics' through anthropometry was 'a reliable test of physical deterioration and progress'.[28] The Physical Deterioration Committee, under whose aegis anthropometry came into its own in following years, had originally been set up in response to medical reports on the poor state of health of the working class. While this generated concern about the social circumstances of the mass of the population, the ensuing debate around the issues of deterioration versus degeneration was

224

fuelled by the eugenists, who were still mostly convinced of the biological and inherited, rather than environmental, determinants of such a deterioration. The complexity of this 'scientific philosophy' and its ambiguous implications for the working classes are covered elsewhere in this book.[29] Its implications for colonized peoples were as insidious.

Museum ethnography's links with certain aspects of eugenic theory are clearly evident by 1907. By now, the principle that physiognomic characteristics were accurate indicators of intellect and morality (early ingested as a tenet of certain anthropological theses) had acquired new potency through its association with the eugenics movement, since eugenic philosophy had been marshalled to the aid of the state. If evolutionism had ever looked like wavering, it was now here to stay. In museum displays of material culture from the colonies, it was common practice to include drawings, photographs, casts of the face or of the figure to enhance the exhibit. These were supposed to demonstrate more nearly the relationship between the inherited and cultural features of any race, since

> The man himself as he appears in his everyday life, is the best illustration of his own place in history, for his physical aspect, the expression of his face, the care of his person, his clothes, his occupations . . . tell the story with much clearness.[30]

That the 1907 Presidential Address of the Museums Association reads like a eugenics tract, therefore, comes as no surprise. The address, which was a proposal for an Institute of Museums, states that

> of equal importance would be a regard for Heredity teaching, seeing that the teaching of evolution must be based upon it. Here the endeavour would be to instruct the public in the part that inherited traits, character, virtues, vices, capabilities, temper, diseases, play in the destinies of men . . . and to popularize such branches of the subject of heredity as selection, variation and immunity.[31]

If there were any doubts in the viewer's mind about the mutual dependence of anthropometry, anthropology, eugenics, evolution and the colonized subject, another display in the Franco-British Exhibition was calculated to dispel them: 'The Life of Primitive Man with Particular Reference to the Stone-Age Peoples Pre-historic and Contemporary'. Here, the explicit evolutionism of the doctrine of 'the past in the present', with its resonant racism, complemented the implicit racial hierarchy already operating on other levels at the exhibition. The display of fingerprinting apparatus and other items relating to the sphere of criminal anthropology also had resonances in relation to colonized races. While not necessarily intentional, connections had already been suggested in the middle-class illustrated press. For example, the juxtaposition of material culture from certain African societies with a text on a deviant, criminal and specifically working-class element represented as biologically flawed, reinforced the notion that both were fundamen-

224. *Illustrated London News*, 15 August 1908. Britis[h] Library. Distinctions betwee[n] the different spheres of anthropological enquiry (physical, social and criminal) were blurred by such popular juxtapositions. These were further collapse[d] by eugenic theory, which maintained that certain raci[al] and social categories were more susceptible to devianc[e]. By association the illustrati[on] demonstrates the popular assumption that both Africa[n] and criminal were congenitally deviant.

tally *disgenic* (racially unfit) as opposed to *eugenic*.[32]

It is symptomatic of anthropology's entry into a broader 'popular' consciousness by this time that the explicit demonstration of anthropology at the exhibition in the Science Pavilion attracted little attention from the reviewers, even while anthropological theory permeated so many aspects of the exhibition as a whole. It remains the implicit rather than explicit organizing principle.

Racial Stereotypes

As a hierarchical distinction existed in relation to the material culture displays, so it was also the case with the 'attractions'. In the case of the Senegalese Village, 'The home industries carried on in the stockade, though numerous, cannot approach those of Ceylon and India in variety, extent, and merit.'[33] The distinction was further made that 'if the negroes fall far behind the Tamils and Ceylonese in artistic culture and skill, and in agility of mind, they are undoubtedly superior to them in physical strength and muscular development'.[34] The ubiquitous wrestling match between the men was designed to seal this comparison. This was the visual image most frequently used to encapsulate the spirit of any African 'village'. Presented as 'fine exhibitions of untiring and determined natural force', these qualities became a naturalized racial characteristic attributed to the African male.[35] While the focus on the physicality of the men of the specifically black colonized races is a common device of colonial discourse, in relation to the Black African in particular it had the added function of suggesting a lack of intellectual acumen. So pervasive is this image of uniformly athletic warlike black males that it persists despite the contradictions to it offered by the illustrations in the guide.

These texts literally objectified the men through the adoption of adjectives like 'ebony', 'jet black' and 'polished', an analogy that was destined to be preserved for posterity in such works as the *Harmsworth History of the World*, a

tome in the mould of the 'popular educators' (1909–10). Here the influential statesman Sir Harry Johnston could categorically state that: 'In no part of the British Dominions are there more handsome men, *from the sculptor's point of view*, than among certain types of Nilotic negro or Negroid, Bantu or Fulbe.'[36] Previously the terms used to describe these inhabitants of the 'villages' had been more sexually explicit. But anxieties over inter-racial union (which had erupted in the wake of an earlier exhibition and had never quite abated) made the adoption of the sculptural analogy a safe way of maintaining the requisite distancing between viewed and viewer.[37] Consequently, while the men are described as 'throwing themselves into the exercise with warlike and unbridled energy, displaying in their steps their exuberant and primitive natures', the guide was also at pains to reassure the visitor that, 'in all their dances the natives of the village observe the greatest decency and good conduct, naturally and without prompting'.[38] Wrestling took place at the exhibition supposedly on the slightest pretext, and at times when 'typical scenes from daily life' were said to be being enacted. Physical prowess had already become a naturalized condition of blackness, and the concept of 'natural' racial characteristics, biologically determined, is consistent with that emphatic preoccupation with the 'body' and with details of black and white physiognomy to which I have already alluded.

The Ideal Woman

The female equivalent to the wrestling black man is the dancer. In the Franco-British , while the perennial 'dancers' are still present, these are described as 'girls' rather than 'women' in order to play down any hint of unregulated sexuality. Previously in exhibitions where the Senegalese populated a 'village', the women's most prominent role had been as mothers and, as if to reinforce this image of the 'good' mother, many of the illustrations in the guides of the scenes from 'villages' depicted the archetypal mother and child. Frequent references to the

AN AFRICAN ZULU GIRL AN ENGLISH BEAUTY

A FRENCH-CANADIAN GENTLEMAN A CENTRAL AFRICAN DANDY

Photos Valentine, R. Martin, and E.N.A.

RACIAL CONTRASTS UNDER THE BRITISH FLAG

A VEDDAH WOMAN OF CEYLON AN EGYPTIAN BEAUTY

A NUBIAN NEGRESS SUDANESE OF UPPER NILE WOMAN OF EASTERN SUDAN

Photo of Veddah by Drs. Fritz and Sarasin

DUSKY BEAUTY AND UGLINESS UNDER THE BRITISH FLAG

women's position in many African societies as little short of slavery, coupled with details such as 'the king has had a regular allowance of 3,333 wives', were as significant in their implications for white middle-class women viewers as they were in relation to the supposed status of the African woman in her own society. There were lessons to be learnt here by British womanhood (and in particular by feminists) from such dedication to 'duty' in the face of adversity – in this case in the form of polygamy. In the 1908 exhibition the Senegalese women seem to have served a different, though no less significant, ideological function in their capacity as 'cooks', this time in relation to discourses around health and cleanliness. Any lessons for feminists in this section of the exhibition came rather from the display of Irish 'colleens' in the Irish 'village' of Ballymaclinton. The amount of attention paid to this 'attraction' not only in the press but also in terms of the space it occupied in relation to the rest of the exhibition indicates that this exhibit was clearly intended to be a particularly memorable showcase.

While the 'village' boasted several noteworthy features, such as the Donegal carpet-weaving factory, a linen-loom, soap-making, lace-making and embroidery, the real stars of the show were the 150 colleens employed to populate the site. The national and local press are full of illustrations of these women: laughing, smiling and working. Few representations of the 'village' exist without these women prominently displayed. The commentator who had pronounced the African woman irredeemably ugly also declared that, 'The same flag covers what we believe to be the handsomest people in the world to-day – English and Irish – who seem to have acquired by some mysterious process of transmission or of independent development, the physical beauty of the old Greeks.'[39]

The colleens at the Irish Village, then, served to solidify a whole set of ideologies. They were the compliant beneficiaries of the philanthropy of the British aristocracy, in the form of the Countess of Aberdeen's Irish Tuberculosis Fund, to which all proceeds from the franchise would be going since, as it was pointed out, so many

225. *Harmsworth History of the World* (1909). British Library. This illustration in a popular educator sought to derive credibility for its racist stereotypes by taking its format from pseudo-scientific manuals of racial 'types'.

lost their lives from consumption in Ireland. To this effect there was also a comparative display of a hygienic and unhygienic living space and an exhibition on TB. To complete this image of a rigorous regime of health and hygiene, the women rose at the crack of dawn for spartan cold baths to keep the TB at bay![40] The women were thus living proof of a supposedly successfully implemented government health programme.

Their presence also reinforced the ideology that philanthropy was the proper avenue of public service open to British women. In the light of an increasingly militant suffragette activism, it is significant that so much store was set on an appeal to British womanhood, or rather middle-class white women, based on an appeal to philanthropy rather than on a discourse of women's rights or 'equality'.

In the official catalogue for the exhibition the Palace of Women's Work is described as including 'everything which concerns the eternal feminine'.[41] The items which are singled out for attention here are telling: despite the fact that:

There is hardly any form of activity that has not been attempted by women, with varying degrees of success . . . The 'Nursery' . . . illustrates woman's true vocation in the home . . . It is in this power of organizing . . . that women of the present day appear to have made a great stride forward. An illustration of this is the Bureau run under the superintendence of Miss Spencer, where information on everything connected with Philanthropy and women's work, can be obtained, and where every would-be philanthropist can be directed in his or her efforts. There is no nation in the world perhaps, where the women are so determined in their efforts to solve social problems by the institution of every kind of home, hospital, club, creche and industrial enterprise . . .[42]

Described in wistfully nostalgic terms, Ballymaclinton served another crucial function in the exhibition. It was a period of confused and unsuccessful initiatives in Ireland made by the Liberal Unionists. Through the living out of a Celtic tradition, eulogized in the guidebooks as it was in the press, the village served as irrefutable proof of the possibility of a unified Ireland with Protestant and Catholic peacefully cohabiting. One notable review in the local press went to some lengths to assist this mythology. Reporting the Sunday service at the village, it described 'a unique gathering representative of every part of Ireland . . . The quiet peacefulness of the Irish Village and Protestant and Roman Catholic, stern Orangemen and laughing colleen were united in appreciation of fruit and nut butter.'[43]

Furthermore, the Irish village made a particular contribution to that larger objective of national unity, so much a feature of the Franco-British Exhibition.

A National Culture

A necessary corollary to the ideology of national unity was the construction of a National Culture. In this respect the 'village' played an important role. The rhetoric of extinction and preservation, applied by academic anthropologists to specifically colonized races, was now systematically applied to certain communities within the British Isles. This concept of a national British culture as a resilient 'folk' culture surviving in rural communities (and Ireland was included here) was a popular fantasy shared by those at both ends of the political spectrum.

Since 1905 supposed 'folk' culture had been officially mobilized in juvenile education to instil the correct patriotic spirit.[44] By October 1907 Cecil Sharp, that untiring middle-class campaigner for the revival of 'folk song', had published his collection of what he defined as 'authentic' folk music. His definition is a telling one. The true folk song was 'not the composition of an individual and as such, limited in outlook and appeal, but a communal and racial product, the expression, in musical idiom, of aims and ideas that are primarily national in character'.

165

226. William Strang. *Rudyard Kipling*. Frontispiece to Kipling's *Short Stories*, Macmillan and Co., 1901.

The equivalent qualities are to be found in the exhibition, expressed in the 'villages'.[45]

Here the Senegalese and Ceylonese Villages on the one hand and the Irish Villages on the other are all represented in the official guidebooks as quaint 'survivals' in the anthropological sense. But while both European and African villages were produced as 'primitive', it was a 'primitiveness' that had already been clearly qualified in both cases in terms that would have been familiar to a large proportion of the exhibition public. Consequently, the proximity of these 'villages' on site had the effect of *accentuating* the distance between the European 'primitive' and its colonial counterpart. The suggestion in the guidebooks was that even in these supposedly simple European communities there was evidence of an inherent superiority in relation to the colonized races represented. Adjectives like 'spick and span' and 'wide and white and clean' as well as 'healthy', 'beautiful' and 'industrious' predominate in descriptions of the Irish Village; and they can be compared to the constantly reiterated assurances that the Africans are in fact much cleaner than they look! In this respect the emphasis on food preparation by the women of the Senegalese Village serves as a case in point. Here the spectator was reassured by the guidebook: 'It is quite curious to watch her black hands, and if you saw the same in the kitchen of a London restaurant you might be disturbed. I assure you the colour of those hands, like her smile, is one that "won't come off".' In view of the anxieties over health and racial deterioration such qualifications served only to reinforce popular conflations of 'blackness' with 'dirt'.

Consequently, what may appear to constitute an irreconcilable contradiction (the construction of certain communities claimed as 'British' as simultaneously 'primitive') should be recognized as a means of establishing the notion of an intrinsically 'national' culture. The National and International Exhibitions' concentration on the essential 'difference' of the colonized subject further reinforced this illusion of a homogeneous British culture. As a spectacle of both leisure and learning, the exhibitions provided the perfect vehicle for confirming the mythology of a British colonial power, benevolent and paternal, ruling over a peaceful and prosperous but more importantly, *compliant*, empire.

Notes

1. Health and Hygiene
Frank Mort

1. The whole account of the Dronfield health education case is preserved in the Public Record Office at PRO ED 50/185.
2. See Mort, Frank, *Dangerous Sexualities. Medico-Moral Politics in England Since 1830*, London, Routledge and Kegan Paul, 1987, part 3.
3. *British Medical Journal*, 19 June 1897, vol.1, p.1571.
4. For an account of these medical developments see Newman, Sir George, *An Outline of the Practice of Preventive Medicine*, 1919, *Parliamentary Papers*, 1919, vol.1, XXXIX, p.681.
5. *Ibid.*, p.695.
6. See: The Sale of Food and Drugs Acts, 1879 and 1899; The Factory and Workshops Acts, 1901 and 1907; The Housing of the Working Classes Acts, 1900 and 1903; The National Insurance Acts, 1911, 1917 and 1918.
7. See for example Brand, Jeanne, *Doctors and the State: The British Medical Profession and Government Action in Public Health, 1870-1912*, Baltimore, Johns Hopkins, 1965. For a more complex reading of the medical profession see Davin, Anna, 'Imperialism and Motherhood', *History Workshop Journal*, 1978, no. 5, pp. 9-12.
8. See Hoare, Quinton, and Nowell-Smith, Geoffrey (eds.), *Selections from the Prison Notebooks of Antonia Gramsci*, London, Lawrence and Wishart, 1971. For an analysis of this period which makes use of Gramscian concepts see Langan, Mary, and Schwarz, Bill (eds.), *Crises in the British State 1880-1930*, London, Hutchinson, 1985.
9. See especially the *Annual Reports of Inspector General of Recruiting*, 1900-1903; *Parliamentary Papers* 1901, vol.IX, 1902, vol.X, 1903, vol.XXXVIII. Also Arnold White, *Efficiency and Empire*, London, 1901.
10. *British Medical Journal*, 20 February 1904, vol.1, pp.445-6.
11. *British Medical Journal*, 12 March 1904, vol.1, pp.622-3
12. Board of Education, *Syllabus of Physical Exercises for Use in Public Elementary Schools*, 1904, and *Report on the Interdepartmental Committee of Physical Exercises*, 1904; *Parliamentary Papers* 1904, vol. XIX.
13. *Annual Report for 1910 of the Chief Medical Officer of the Board of Education*; *Parliamentary Papers* 1910, vol.XXIII, pp.359-61.
14. Board of Education, *Syllabus*, 1909, p.vii.
15. See Davin, op. cit; Lewis, Jane,, *The Politics of Motherhood: Maternal and Child Welfare in England 1900-39*, London, 1980; Dyhouse, Carol, 'Working Class Mothers and Infant Morality in England, 1895-1914', *Journal of Social History*, 1978, vol.12, no.2, pp. 248-67.
16. Newsholme, Arthur, *The Declining Birth Rate: its National and International Significance*, London, New Tracts for the Times Series, 1911.
17. Ballantyne, Dr John, *Manual of Ante-natal Pathology and Hygiene: The Embryo*, Edinburgh, W. Green, 1904. See also Newsholme, 'Infant Morality - A Statistical Study from the Public Health Standpoint', *The Practitioner*, October 1905, pp.489-500.
18. Newsholme, *The Declining Birth Rate*, op. cit., p.57.
19. Quoted in Pearson, Karl, *Darwinism, Medical Progress and Eugenics*, London, University College, pp.4-5.
20. See Pearson, Karl, *Eugenics and Public Health*, London, University College, 1912, pp.32-4.
21. Ellis, Henry Havelock, *The Task of Social Hygiene*, London, Constable, 1912, p.15.
22. Saleeby, Caleb, *The Methods of Race-Regeneration*, London, New Tracts for the Times Series, 1911, p.63.
23. See: *Report of the Inter-departmental Committee on Physical Deterioration*, 1904; *Parliamentary Papers* 1904, vol.XXXII, pp.44-5; *Report of the Royal Commission on the Care and Control of the Feeble-Minded*, 1908; *Parliamentary Papers*, 1908, vol.XXXIX, pp.363-86; *Report of the Royal Commission on Divorce and Matrimonial Causes*, 1912; *Parliamentary Papers*, 1912-1913, vol.XVIII, p.313; Royal Commission on Venereal Diseases, *Final Report on the Commissioners*, 1916; *Parliamentary Papers*, 1916, vol.XVI, pp.49-56.
24. See Rentoul, Dr Robert, *Race Culture or Race Suicide? A Plea for the Unborn*, London, 1906. For medical attacks see *British Medical Journal*, 12 March 1904, vol.1, pp.625-6.
25. *British Medical Journal*, 23 August 1913, vol.2, pp.508-9.
26. Newman, *An Outline*, op. cit., p.682.
27. Marchant, Rev James, *The Master Problem*, London, Stanley Paul, 1917, pp.128-9.
28. The Contagious Diseases Acts of 1864, 1866 and 1869 applied to a number of naval ports and garrison towns in England and Ireland and were aimed to halt the spread of VD among the men of the armed forces. But their method of prevention was the stricter surveillance of female prostitutes. Any woman suspected of being a 'common prostitute' could be taken to a certified hospital for forced medical inspection. If she was found to be suffering from infection she could be detained for up to three months.
29. See Searle, Geoffrey, *The Quest for National Efficiency: a Study of British Politics and Political Thought*, Oxford, Blackwell, 1971, p.97.
30. Newman, *An Outline*, op. cit., p.692.
31. See Addison, Christopher, *Politics from Within, 1911-1918*, London, 1924, vol.1, pp.221-2.
32. The People's League of Health, *Second Report for the Years 1922, 1923, 1924 and 1925*.
33. Ibid.
34. For moralists' continuing suspicion of the medical profession see 'The Need for Watchfulness',The *Shield*, October 1909, p.1.
35. Leppington, Blanche, 'Public Morals and the Public Health', in James Marchant (ed.), *Public Morals*, London, Morgan Scott, 1902, p.229.
36. The *Shield*, October 1913, p.69.
37. The *Shield*, October 1915, p.63.
38. The *Vote*, 20 January 1912, p.155.
39. Scharlieb, Mary, *Womanhood and Race Regeneration*, London, New Tracts for the Times Series, 1912, p.7.
40. Ravenhill, Alice, 'Eugenic Ideals for Womanhood', *Eugenics Review*, April 1909-January 1910, vol.1, no.4, pp.267-73.
41. Swiney, Frances, *Women and Natural Law*, London, C.W. Daniel, 1912, p.12.
42. Swiney, *The Mystery of the Circle and the Cross; or the Interpretation of Sex*, London, Open Road Publishing, 1908, p.27.
43. *Reynold's Newspaper*, 6 January 1907.
44. The *Daily Mirror*, 12 January 1909.
45. *Reynold's Newspaper*, 6 January 1907.
46. The *Daily Mirror*, 13 March 1909.

3. Working Women
Jane Beckett and Deborah Cherry

1. *House of Lords Select Committee on the Sweating System*, London, 1890.
2. Mudie Smith, R., *Sweated Industries : being a Handbook of the 'Daily News' Exhibition*, London, 1906, gives a full account of the exhibition, the workers (including two men), the stalls and the goods on show. 5000 copies of the first edition sold out in ten days, and a revised edition was quickly issued. Lectures on different aspects of sweating were given in the afternoons , and every evening 'Sweated Home Industries' were illustrated with lantern slides. The exhibition received extensive coverage in the Daily News and other leading newspapers throughout May 1906, and was reported in magazines such as *Woman* (16 May 1906 and 23 May 1906).
3. The housing of the working classes had been an issue since the mid-nineteenth century, and middle-class investigators, philanthropic workers and institutions concerned themselves with regulating working-class households and communities. See Jones, K., and Williamson, K., 'The Birth of the Schoolroom', *Ideology and Consciousness*, 6, Autumn 1979, pp.59-110.
4. Mudie Smith, R., *Sweated Industries*, p.113.
5. Mudie Smith, R., *Sweated Industries*, p.35.
6. Suthers, R.B., 'The Cannibal Exhibition', *The Clarion*, 18 May 1906, p.5.

7. Gavan-Duffy, T., 'Two May Day Exhibitions: Princess, Pampered Dogs and the Sweated Poor', *The Labour Leader*, May 1906, p.744.

8. Gardiner, A.G., 'Introduction', in Clementina Black, *Sweated Industry and the Minimum Wage*, London, 1907, p.xv.

9. The press reported women working machinery, the 'bonnie Highland lassies' and 'strapping young women' at the Sutherland and Harris spinners stall, and the disabled women giving training and work through middle-class women's charitable activities. Middle-class women and students from the Glasgow School of Art demonstrated women's handicrafts, such as book binding, basket making, weaving, and woodcarving, several of which were, for working-class women, sweated industries. See *Glasgow News*, 8 May 1901, 15 May 1901, 1 October 1901; *Glasgow Citizen*, 23 May 1901; *Glasgow Herald*, 4 July 1901, 9 August 1901. Cuttings books for the Glasgow International Exhibition, 1901, are held in the Library, Kelvingrove Art Gallery, Glasgow.

10. Tuckwell, Gertrude, 'Preface', *Sweated Industries*, p.13.

11. Suthers, R.B., op. cit., p.5.

12. There were many professsional and amateur women photographers in the Edwardian era and their work was featured in the women's magazines of the period. Several worked particularly for the women's movement, photographing women campaigners and events. See Williams, Valerie, *Women Photographers: The Other Observers 1900 to the Present*, London, Virago, 1987.

13. Edge, Sarah, 'Our Past, Our Struggle, Images of Women in Lancashire Coalmines 1860-1880', *Spare Rib* , March 1987, pp.35-7; John Tagg, 'Power and Photography: A Means of Surveillance: The Photographs as Evidence in Law', *Screen Education*, vol. 36, Autumn 1980, pp.17-25.

14. Joseph Rowntree and George Cadbury were Quaker manufacturers of cocoa. Both moved their works to country estates in the 1890s, building factories and dwellings organized on 'Garden City' principles: Rowntree's was situated at New Earswick, near York, and Cadbury's at Bourneville, near Birmingham. Both instituted a 48-hour week and provided educational, sports and medical facilities for their workers. George Cadbury was also chair of the *Daily News* Publishing Co.

15. Several conferences were held on sweating in 1907: at the Guildhall in London, in Glasgow and in Manchester; and it was raised by the National Conference on the Employment of Women, organized by the Women's Industrial Council (WIC) at the Guildhall, London, the same year. Publications on sweating included Black, C., *Sweated Industry and the Minimum Wage*; WIC, *The Case for and against a Legal Minimum Wage for Sweated Workers*, 1909; Cadbury, E., Matheson, C. and Shann, G., *Women's Work and Wages*, 1906; and Cadbury, E. and Shann, G., *Sweating*, 1907.

16. The issue of the international exploitation by white Europeans and Americans of black women working as home workers is discussed in: 'Textile Workers' Union Grows', *Outwrite* 56, March 1987, p.9; Waging Battles in Thailand, *Outwrite* 57, April 1987, p.10.

17. Liddington, Jill, and Norris, Jill, *One Hand Tied Behind Us: the Rise of the Women's Suffrage Movement*, London, Virago 1978.

18. The Women's Provident and Protective League was formed in 1874; it changed its name in 1889 to the Women's Provident Trade Union League and was the Women's Trade Union League from 1891. See Lewenhak, Sheila, *Women and Trade Unions*, London, 1977; Boston, Sarah, *Women Workers and the Trades Union Movement*, London, 1980; Drake, Barbara, *Women in Trade Unions*, London, 1920, 1984; *Women in Industry from Seven Points of View*, 1908, pp.63-83; Olcott, Teresa, 'Dead Centre: The Women's Trade Union Movement in London 1874-1914,' *The London Journal*, pp.33-50; also Liddington, J. and Norris, J., op. cit.

19. The NFWW's aims were to unite women in the unorganized trades; improve conditions of employment; secure redress of grievances; secure regulation of employee-employer relations; secure fair payment; provide legal aid for members; provide weekly allowance for members when ill or out of work; give financial support to sanctioned disputes. The entrance fee was 6d., and there were different classes of membership at 1d., 3d. and 4½d. From a membership of 2000 at the end of its first year, the NFWW grew to 20,000 by 1914.

20. *The Woman Worker*, October 1907; March 1908; 18 September 1908. From 1906 to 1909 the NFWW supported

strikes, all successful, at the CWS factories, a tin-box works, a cardboard box factory, a show card firm and a munitions factory.

21. 'Knowledge is power. Organisation is power. Knowledge and organisation mean the right to life, liberty and the pursuit of happiness. Knowledge and organisation mean the opening of the cage door.' Macarthur, Mary, *The Woman Worker*, June 1908.

22. Mappen, Ellen, *Helping Women at Work: The Women's Industrial Council 1889-1914*, London, Virago 1985.

23. Tuckwell, Gertrude, 'Preface' *Sweated Industries*, p.11.

24. An exhibition of 30 sweated workers was organized by the Manchester, Salford and District Women's Trades Union Council at Downing Street, Co-operative Hall, Manchester in October 1906, see *Manchester Weekly Times*, 22 September 1906. In October 1907 Margaret Macdonald and The Women's Labour League organized an exhibition of sweated workers in conjunction with Julia Dawson's exhibition of the work of the Clarion Handicraft Guild at the Bishopsgate Institute, London (see *Woman Worker*, October 1907, November 1907).

25. WIC, *Home Industries of Women in London: Interim Report*, London, 1906, pp. 35 and 44-5.

26. See, for example, Elliston, M., 'Are there no White Slaves in London?', *Daily Mirror*, 20 January 1906, p.5.

27. Davin, Anna, 'Imperialism and Motherhood', *History Workshop Journal*, 5, Spring 1978, pp.9-65.

28. Black, C. (ed.), *Married Women's Work*, London, 1915, 1983; *The Woman Worker*, March 1908; Liddington, J. and Norris, J., op. cit., p.238ff.

29. Black, C. and Meyer, Mrs Carl, *Makers of Our Clothes*, London, 1909, p.16.

30. Hamilton, Cicely, *Marriage as a Trade*, London, 1909, 1981, pp.96-8.

31. Jeffreys, Sheila, *The Spinster and her Enemies: Feminism and Sexuality 1880-1930*, London, Pandora Press, 1985, pp.86-101.

32. Women worked in the Civil Service from the 1870s and were appointed to School Boards from 1870 when Lydia Becker (recalled in Suffrage banners in 1908) became the first woman appointed to a School Board in Manchester. From the 1890s women were active in setting up settlements for women and girls. In 1894 Margaret MacMillan set up the first settlement in Bradford.

33. Bosanquet, Helen, *The Family*, London 1906, pp.291-4.

34. *Dictionary of Employments open to Women*, London, 1898, p.50.

35. MacKenzie, J.M., *Propaganda and Empire: The Manipulation of British Public Opinion 1880-1960*, London, 1984, pp.20-30.

36. Black. C., *Sweated Industry and the Minimum Wage*, p.26.

37. Low wages were further reduced by deductions made in factories for power for machines and the use of kitchen facilities: both home workers and factory workers had to pay for thread.

38. Neal, Mary, 'Dressmaking', *Sweated Industries*, p.56.

39. Black, C. and Meyer, Mrs Carl, op. cit., pp.15-16.

40. White, Cynthia L., *Women's Magazines 1693-1968*, pp.63-8.

41. Adburgham, Alison, *Shops and Shopping 1800-1914*, London, 1967, pp.220-70.

42. Pankhurst, R., *Sylvia Pankhurst: Artist and Crusader*, London, 1979, pp.75-99.

4. Sex and Morality
Lucy Bland

1. Glyn, Elinor, *Three Weeks*, London, Duckworth and Co., 1907, p.13.

2. Creighton, Louise, *The Social Disease and How to Fight It*, London, Longmans, Green and Co., 1914, p.74.

3. Ellis, Henry Havelock, *The Task of Social Hygiene*, London, Constable, 1912, p.29.

4. For example see Geddes, P. and Thomas, J.A., *Sex*, London, William and Norgate, 1914.

5. Coote, W., in Marchant, James (ed.), *Public Morals*, London, 1902.

6. London Council for the Promotion of Public Morality, *Annual Report*, 3, 12, 1907, p.3.

7. Cooper, Diana, *The Rainbow Comes and Goes*, London, Penguin, 1961, p.77-8.

8. NVA Executive Committee, 30 June 1908.

9. *Vigilance Record*, January 1909, p.3.

10. Wales, Hubert, *The Yoke*, London, John Long, 1907, p.16 and p.12.

11. Hynes, Samuel, *The Edwardian Turn of Mind*, London, Oxford University Press, 1968, p.291.

12. Letter in *The Lancet*, December 1910.

13. Ellis, op. cit., 1912, p.292.

14. Ellis, Henry Havelock, *The Problem of Race Regeneration*, London, National Council for Public Morals, 1911, p.67.

15. Kirk, E.B., *A Talk with Girls about Themselves*, 1905, p.51.

16. Stephens, Margaret, *Woman and Marriage: a handbook*, London, T. Fisher and Unwin, 1910, p.v.

17. Trench, Violet, *Queens: A Book for Girls about Themselves*, London, 1912.

18. Bulley, Louise, *A Pamphlet for Girls and Boys of 14*, London, 1911.

19. Scharlieb, Mary, and Sibly, F.A., *Youth and Sex*, London, 1913.

20. Pankhurst, Christabel, *The Great Scourge and How To End It*, London, E. Pankhurst, 1913.

21. Swiney, Frances, *The Bar of Isis*, London, C.W. Daniel, 1907, p.39.

22. Pankhurst, ibid.

23. See Vicinus, Martha, *Independent Women*, London, Virago, 1985, chapter 7.

24. Thompson, Paul, *The Edwardians*, London, Weidenfeld and Nicolson, 1975, p.72.

25. See Knight, Patricia, 'Women and Abortion in Victorian and Edwardian England', *History Workshop Journal*, no.4, Autumn 1977.

26. See Banks, J.A., *Victorian Values: Secularism and the Size of Families*, London, Routledge and Kegan Paul, 1981.

27. Jeffreys, Sheila, *The Spinster and her Enemies*, London, Pandora Press, 1985.

5. Suffrage Campaigns
Lisa Tickner

1. Hamilton, Cicely, *A Pageant of Great Women*. Foreword to the reprint for The Suffragette Fellowship, London, 1948.

2. Pethick-Lawrence, Emmeline, 'An Army with Banners', *Votes for Women*, 15 July 1910, p. 689.

3. On the nineteenth-century women's movement Ray Strachey, *The Cause*, London, G. Bell & Sons, 1928 (republished Virago, 1978) is still relevant; and Olive Banks, *Faces of Feminism*, Oxford, Martin Robertson, 1981, provides a useful overview. Of the many books on the political history of the later suffrage campaign the most recent and scholarly are Andrew Rosen, *Rise Up Women! The Militant Campaign of the Women's Social and Political Union 1903-1914*, London, 1974; Jill Liddington and Jill Norris, *One Hand Tied Behind Us: The Rise of the Women's Suffrage Movement*, London, Virago, 1978; and Leslie Parker Hume, *The National Union of Women's Suffrage Societies 1897-1914*, New York, Garland, 1982. Martin Pugh, *Electoral Reform in War and Peace, 1906-1918*, London, Routledge and Kegan Paul, 1978, and *Women's Suffrage in Britain 1867-1928* [pamphlet], London, The Historical Association, 1980, are also useful. Brian Harrison, *Separate Spheres: The Opposition to Women's Suffrage in Britain*, London, Croom Helm, 1978, is essential for the other side of the picture. Further information on the Artists' Suffrage League, the Suffrage Atelier, the major demonstrations of the campaign and its use of imagery in general, can be found in my book on *The Spectacle of Women*, London, Chatto and Windus, 1987.

4. Fawcett, Millicent, quoted in Barbara Taylor, *Eve and the New Jerusalem*, London, Virago, 1983, p. 279. On the nineteenth-century pressure groups see Patricia Hollis (ed.), *Pressure from Without in Early Victorian England*, London, Edward Arnold, 1974.

5. See *The Debate, 1892, in the House of Commons on Women's Suffrage* London, 1892, p. 45. Special report published by the Central National Society for Women's Suffrage (Fawcett Library).

6. Pankhurst, Emmeline, *My Own Story*, London, Eveleigh Nash, 1914, p. 116.

7. See the Executive Committee Minutes of the Central Society for Women's Suffrage, May 1906-October 1907 (Fawcett Library). Entries related to the 1907 march occur from 21 November 1906.

8. *The Suffrage Annual and Women's Who's Who*, A.J.K. (ed.), London, Stanley Paul, 1913, p. 12. See also the NUWSS *Annual Report*, 1907 (Fawcett Library, Box 145), and the *Memento of the Women's Coronation Processsion Saturday June 17th 1911* (Museum of London).

9. *Manchester Guardian*, 11 February 1907. Various other reports may be found in the Sunday papers for the 10th, and in daily papers for 11 February 1907.

10. The 1907 procession became known as the Mud March because of the rain and the state of the roads.

11. See *The Invention of Tradition*, Eric Hobsbawm and Terence Ranger (eds.), Cambridge, Cambridge University Press, 1983.

12. Quoted in Pankhurst, E. Sylvia, *The Suffragette Movement*, London, Longman, 1931, p. 278. See also the *Third Annual Report* of the WSPU, 1908/9, p. 7.

13. Pankhurst, *The Suffragette Movement*, pp. 278-9.

14. The *Women's Franchise*, 25 June 1908, p. 615.

15. The *Referee*, 18 October 1908, clipping in the Maud Arncliffe-Sennett Albums, vol. 5, p. 63 (British Library).

16. Ferguson, Rachel, *Victorian Bouquet*, London, Ernest Benn. [1931], p. 21.

17. Pethick-Lawrence, Emmeline, *My Part in a Changing World*, London, Victor Gollancz, 1938, p. 215.

18. On the mutually determining relations between an ideology of femininity and the practice of embroidery see Parker, Rozsika, *The Subversive Stitch: Embroidery and the Making of the Feminine*, London, The Women's Press, 1984. At a conservative estimate at least 150 banners were produced between the NUWSS demonstrations of 1908 and the NUWSS Pilgrimage of 1913, most of them by the Artists' Suffrage League or the Suffrage Atelier.

19. *The Times*, 12 June 1908. Press reports consistently emphasized the status of the banners as works of art.

20. All quotations from Mary Lowndes are taken from her article 'On Banners and Banner-Making', reprinted from the *Englishwoman*, September 1909. (There is a copy inserted in her album of designs in the Fawcett Library.)

21. See the *Common Cause*, 16 February 1911, p. 727: 'when we find the civic consciousness of women expressing itself through needlework, we may be sure that this consciousness has become part of the "WOMANLY WOMAN", and that its force is overwhelming'. Also the *Women's Franchise*, quoted in the NUWSS circular 'Press Reports of the Banners': 'the excellence of the needlework ... disposes for ever of the taunt that Suffragists do not care for womanly occupations'.

22. More than 75 per cent of all trade-union banners between 1837 and 1914 were made by the firm of George Tutill's. See John Gorman, *Banner Bright: An Illustrated History of the Banners of the British Trade Union Movement*, London, Allen Lane, 1973. The 'corner-man' was the specialist who filled in the designs of scrolling foliage around the central motif.

23. This is a leit-motif of press comment in 1908. See particularly the *Daily News*, the *Daily Chronicle*, the *Daily Telegraph*, and the *Manchester Guardian*, 15 June 1908.

24. The 'ten great silk banners' the WSPU had made in a hurry for 21 June 1908 *were* made by a commercial manufacturer (probably Tutill's or Toye's), four of them to designs by Sylvia Pankhurst. See 'Unfurling the Banners', *Votes for Women*, 25 June 1908, and Pankhurst *The Suffragette Movement*, pp. 284-5.

25. Pankhurst, *The Suffragette Movement*, pp. 283-4, and *Votes for Women*, chiefly 14 May and 4 June 1908. On the WSPU colours see Emmeline Pethick-Lawrence in the *Programme* of the WSPU exhibition at the Prince's Skating Rink, 1909 (Museum of London). Each suffrage society had its own distinctive colours. Those of the NUWSS were red and white until 1909, when green was added; those of the Women's Freedom League green, white and gold; those of the Artists' Suffrage League blue and silver; those of the Suffrage Atelier blue, orange, and black.

26. *Votes for Women*, 25 June 1908.

27. *The Times*, 22 June 1908.

28. *The Times*, 22 June 1908.

29. *Votes for Women*, 25 June 1908.

30. On the constitutional crisis see 'The Right Dishonourable Double-Face Asquith', and on forcible feeding 'The Modern Inquisition' (both by Alfred Pearse). Following the example of the artist and WSPU member Marion Wallace Dunlop, militant suffragettes began to terminate their prison sentences by hunger striking in 1909. Forcible feeding – a painful and tortuous proceeding – was brought in by the Government to deal with this. The controversy that it provoked was fuelled by the sense of a sexual and sadistic element in the instrumental invasion of women's bodies by force.

31. Figures given in the *Common Cause*, 3 February 1910, p. 599. According to their *Annual Report* for 1910 the Artists' Suffrage League had by the end of the year printed 7000 postcards, 25,000 pictorial leaflets, 6000 Christmas cards, and 4000 posters.

32. Rosen, *Rise Up Women!*, pp. 134-5, gives details of the membership of the Conciliation Committee and the terms of its Bill. See also Pugh, *Women's Suffrage in Britain*, p. 15.

33. In *Votes for Women*, 23 July 1911, quoted in Rosen, *Rise Up Women!*, p. 150, and Hume, *The National Union of Women's Suffrage Societies*, p. 109.

34. There were two further demonstrations of considerable importance but of a very different kind: the funeral of Emily Wilding Davison (the suffragette who died after running on to the Derby racecourse and colliding with the King's horse), 14 June 1913, and the NUWSS 'Pilgrimage' of June and July 1913, during which constitutional suffragists converged on London from all parts of the country, holding meetings at all opportunities but avoiding the pageantry and display of 1908, 1910 and 1911.

35. From an American postcard citing Charlotte Perkins Gilman in the collection of the Division of Political History, the Smithsonian Institution, Washington DC.

36. Hamilton, Cicely, *Marriage as a Trade*, 1909, reprinted by The Women's Press, London, 1981, p. 84.

37. On the power of the 'physical force' argument, especially among the imperialists prominent in the leadership of the anti-suffrage leagues, see Harrison, *Separate Spheres*.

38. Clark, T. J., *The Painting of Modern Life*, Thames and Hudson, London, 1985, p. 6.

39. House of Commons Debates, 11 July 1910, c.99, quoted in Harrison, *Separate Spheres*, p. 138.

40. See 'Essence of Parliament', *Punch*, 3 May 1871, on the debate on Bright's Women Suffrage Bill.

41. W. F. Winter, 'Votes for Women', published by the Artists' Suffrage League, 1909. There is little emphasis in suffrage imagery on *domestic* labour, perhaps because it seemed so 'natural'. Although the numbers were declining (33 per cent of the female workforce in 1901, 27 per cent in 1911), more women were employed in domestic service than in any other occupation before the First World War.

42. See Webb, Beatrice, *Women and the Factory Acts*, Fabian Tract No. 67, 1896.

43. John Hassall's 1912 poster 'A Suffragette's Home' for the National League for Opposing Woman Suffrage needs to be understood in relation to pamphlets such as the Men's League for Opposing Woman Suffrage tract 'Power and Responsibility': 'Resent this attempted *tyranny* and let the Suffragists know that you simply will not have *petticoat government* . . . Look round you as you read this leaflet. On every side you see THE RESULT OF MASCULINE LABOUR . . . The whole fabric of material life has to be brought into existence, and to be maintained by men.'

44. See for example the Suffrage Atelier postcards 'The Scylla and Charybdis of the Working Woman' and 'Waiting for a Living Wage'. The militant workers of Sylvia Pankhurst's early membership card for the WSPU are a rare exception here. As it severed its links with the Independent Labour Party the WSPU turned instead to the allegorical and sub-Pre-Raphaelite strand in her work.

45. *The Times*, 11 December 1908. See also 'Suffrage Hysteria', the *Daily Chronicle*, 16 November 1908.

46. Michel Foucault, *The History of Sexuality, vol. 1: An Introduction*, London, Pelican Books edition, 1981, pp. 146-7.

47. 'On Militant Hysteria', letter to *The Times*, 28 March 1912.

Reprinted with additional material in *The Unexpurgated Case Against Women's Suffrage*, London Constable, 1913.

48. Graphically depicted in 'No Votes Thank You', Harold Bird's poster for the National League for Opposing Woman Suffrage, 1912 (John Johnson Collection, Box 3, Bodleian Library).

49. Almroth Wright, *The Unexpurgated Case Against Women's Suffrage*, p. 71.

50. Maud Arncliffe-Sennett Albums, vol. 3, p. 53 (British Library). See also vol. 3, p. 1: 'Please note that in all the *Allegories* the woman is omnipotent and politically imposing – in *Real Life* – she is politically helpless and impotent.'

51. Discussed by Marina Warner, *Monuments and Maidens: The Allegory of the Female Form*, London, Weidenfeld and Nicolson, 1985.

52. For 'womanliness' as it was discussed in the suffrage movement see Laurence Housman, 'What is Womanly?' from *Articles of Faith in the Freedom of Women*, London, A. C. Fifield, 1911 (2nd ed., Museum of London). There is a great deal of material on the development of nineteenth-century definitions of womanliness and its relation to changes in production and the sexual division of labour. See Catherine Hall, 'The early formation of Victorian Domestic Ideology' in S. Burman (ed.), *Fit Work for Women*, London, Croom Helm, 1979; Nancy Cott, *The Bonds of Womanhood: 'Women's Sphere' in New England, 1780-1835*, New Haven, Yale University Press, 1977; Françoise Basch, *Relative Creatures: Victorian Women in Society and the Novel 1837-67*, London, Allen Lane, 1974. Lynda Nead discusses the visual construction of womanliness in works such as George Elgar Hicks' 'Woman's Mission' in *Representation and Regulation: Women and Sexuality in English Art c.1840-1870*, unpublished Ph.D. thesis, University College London, 1985. See also Deborah Cherry, 'Picturing the Private Sphere', *Feminist Art News*, No. 9,. 1983.

53. Millicent Fawcett, letter in the *Daily Graphic*, undated cutting from her scrapbook in the Fawcett Library,

54. 'The Appeal of Womanhood' was designed by Louise Jacobs of the Suffrage Atelier in response to Harold Bird's 'No Votes Thank You' of 1912. 'Mrs How Martyn Makes Jam' is no. 3 in a series of 'Suffragettes at Home', published in the *Vote* and independently by the Women's Freedom League.

55. The 'Women's Right to Work' procession of 30,000 women was organized by the WSPU for Lloyd George on a Government grant of £2000. It took place on 17 July 1915. The patriotic fervour of the WSPU and women's war work in general undoubtedly contributed to women's inclusion in the Reform Bill of 1918. Historians are, however, divided in their assessment of the factors involved, and often reluctant to accept at face value the verdict of contemporary news stands – 'The Nation Thanks the Women'.

6. Architecture and Design
Lynne Walker

1. For a survey of the full range of classical themes in Edwardian architecture, see, for instance, *AD Profiles 13, London 1900*, Gavin Stamp (ed.), vol.48, 1978.

2. Blomfield Reginald, *The Mistress Art*, London, Edward Arnold, 1908, p.268.

3. For the significance of the Franco-British Exhibition of 1908, see pp. 152-66.

4. Beavan, Arthur H., *Imperial London*, London, J.M. Dent & Co., and New York, E.P. Dutton & Co., 1901, preface.

5. *The Times*, 1 October 1910.

6. Masterman, C.F.G. (ed.), *The Heart of the Empire: Discussions of Problems of Modern City Life* (reprint of 1901 edition), Gilbert, B.B. (ed.), Harvester Press, 1973; see especially, Lawrence, F.W. (later Pethick-Lawrence), 'The Housing Problem', pp. 53-110.

7. Masterman, op. cit., Lawrence, op. cit.; p.57.

8. Letter from William Morris to Mrs Alfred Baldwin, 26 March 1876, in Briggs, Asa (ed.), *William Morris: Selected Writings and Designs*, Harmondsworth, Pelican, 1973, p.81.

9. For a contemporary account, see, Riley, W.E., 'The Architectural Work of the London County Council', *Journal of the Royal Institute of British Architects*, 1909, Vol.XVI, pp.413-42.

10. Thorne, R. and Saint, A., 'LCC Housing Tour', unpublished notes, Victorian Society, 1981.

11. *The Times*, 19 October 1905.

12. Beattie, Susan, *A Revolution in London Housing: LCC Housing Architects & Their Work 1893-1914*, London, Architectural Press, 1980, pp.85-120.

13. Victorian Society notes, pp.12-13.

14. Jekyll, Gertrude, *Wall and Water Gardens* (1901); *Roses for English Gardens* (1902); *Some English Gardens* (1904); *Flower Decoration in the House* (1907); *Colour in the Flower Garden* (1908); and *Children and Gardens* (1908). Perhaps her most important book of this period was not on gardens; it was, however, very significant for the popularization of the vernacular: *Old West Surrey: Some Notes and Memories* (1904).

15 For a social and architectural history of Edwardian country houses, see Aslet, Clive, *The Last Country Houses*, New Haven and London, Yale University Press, 1982.

16 Elder-Duncan, J.H., *Country Cottages and Week-End Homes*, London, New York, Paris and Melbourne, Cassell, 1906, p.11. For bungalows, see Anthony King, *The Bungalow: The Production of a Global Culture*, London, RKP, 1984, especially pp.91-126.

17. Saville, John, *Rural Depopulation in England and Wales 1851-1951*, 1957; quoted in Pamela Horn *The Changing Countryside in Victorian and Edwardian England and Wales*, Athlone Press, 1984, p.224.

18. Elder-Duncan, op. cit., p.12.

19. Morris, George Ll., and Wood, Esther, *The Country Cottage*, London and New York, John Lane, 1906, p.3.

20. Morris and Wood, op. cit., pp.3-4.

21. See, for example, Parker, Barry, and Unwin, Raymond, *The Art of Building a Home*, London, New York and Bombay, Longmans, Green & Co., 1901.

22. Morris and Wood, op. cit., p.10.

23. Esther Wood, 'Some Modern Cottages', *Studio*, 1901, vol.22, p.112.

24. Adrian Forty, *Objects of Desire: Design & Society from Wedgwood to IBM*, New York, Pantheon Books, 1986, pp.113-15; also published in London, Thames and Hudson, 1986.

25. Parker and Unwin, *The Art of Building a Home*, 1901, p.105.

26. Ibid., p.129.

27. Ibid., p.105.

28. Letter to the Editor of the *Journal of the Royal Institute of British Architects*, from Lander's former assistant, 21 January 1937, in H. Clapham Lander's Biography File, British Architectural Library.

29. *Builder*, 10 July 1909, vol.96, p.48.

30. Information from Heide Moldenhauer, Internationale Bauausstellung, Berlin.

31. Bingham, Neil (intro.), *Who's Who in Architecture*, 1914, 1926, 1928 (reprint 1987), London, World Microfilms.

32. Walker, Lynne (ed.), *Women Architects: Their Work*, London, Sorella Press, 1984.

33. 'The Admission of Lady Associates', *Journal of the Royal Institute of British Architects*, 10 December 1898, vol.VI, p.78; and ibid., 11 March 1899, p.281.

34. *Parliamentary Papers*, 1893, vol.cvi, p.1; ibid., Population, 1903, vol.lxxxiv, p.202; and ibid., Occupations and Industries, vol.lxxviii, p.321 & vol.lxxix, p.1.

35. Schultz, R. Weir, 'Architecture for Women', a paper read at a conference on the Employmnent of Women, Caxton Hall, Westminster, reprinted in *Architectural Review*, September 1908, vol.24, pp.153-4.

36. *Catalogue of the RIBA Drawing Collection*, vol.C-F, Farnborough, Gregg Press, 1972, pp.22-3.

37. For example, Creswell, H.B., 'The Admission of Women to the Profession of Architecture', *British Architect*, 10 February 1899, vol.50, p.104.

38. Charles, Ethel, 'A Plea for Women Practising Architecture', *Builder*, 22 February 1902, vol.82, p.179.

39. Reason, G. Ernest, report of Ethel Charles' paper, 'Modern Architecture in London', *Journal of the Royal Institute of British Architects*, 25 February 1905, vol.XII, p.259.

40. Smyth, Dame Ethel, 'Mrs Percy Feilding: An Appreciation', *The Times*, 3 March 1937. Brewster's probationary work for the Royal Academy Schools was thought 'the best ever sent in by a student' (Schultz, 'Architecture for Women' p.154.).

Dame Ethel saw much of herself in Clotilde Kate Feilding whom she described as: 'Gifted, generous, big in every way, blessedly indifferent to what the world thinks.' In addition to the Roman municipal palazzo, Fielding designed 'several small houses in England before she abandoned her profession in favour of domesticity'.

41. Postcard to Ethel Charles from Joseph Fauder (?), Berlin, 8 May 1909; now in the possession of Ethel Charles' family.

42. *Catalogue of the Arts & Crafts Exhibition Society*, 1888, 1896, 1910.

43. Vallance, Aymer, *Studio*, 1901, vol.24, p.75.

44. Watson, Walter, 'Miss Jessie M. King and Her Work', *Studio*, 1902, vol.26, pp.177ff.

45. Bird, Liz, 'Threading the Beads: Women in Art in Glasgow, 1870-1920', *Uncharted Lives: Extracts from Scottish Women's Experiences, 1850-1982*, Glasgow Women's Studies Group (ed.), Glasgow, Pressgang, 1983, p.102.

46. For Glasgow embroidery, see Parker, Rozsika, *The Subversive Stitch: Embroidery and the Making of the Feminine*, London, Women's Press, 1984, pp.184-188.

47. Miller, Fred, 'Women in the Art Crafts', *Art Journal*, 1896, pp.116-18.

48. Cormack, Peter, *Women Stained Glass Artists of the Arts and Crafts Movement*, London Borough of Waltham Forest, 1985, p.5.

49. Cormack, ibid., p.10f.

7. The Franco-British Exhibition
Annie E. Coombes

1. Hobson, J. A., *Imperialism: A Study*, London, 1902, third revised edition, 1938, reprinted 1968, p.215.

2. See Freeman Murray, C., 'The British Empire League', *United Empire*, V1, 1916, pp.431-9, for the stated aims and objectives of the League. The executive committee for the Franco-British Exhibition included the Earl of Derby (President of the League), the Viscount Selby (Chairman of the League) and Lord Blyth and Sir John Cockburn, both active members of the League. For an account of similar exhibitions in America see, Rydell, Robert W., *All the World's a Fair*, Chicago and London, 1984, and in France see Schneider, William H., *An Empire for the Masses*, Westport and London, 1982.

3. *The Franco-British Exhibition Official Guide to the Senegal Village*, London, 1908, p.11; and Dumas, F.G. (ed.), *The Franco-British Illustrated Review 1908*, London, 1909.

4. *Official Guide to the Franco-British Exhibition*, London, 1908, p.1.

5. Ibid., p.2.

6. For an example of this in the ephemera produced for the exhibition, see *The Franco-British Pictorial (Black and White Special)*, London, 1908, p.34.

7. There were a number of social surveys completed during the Edwardian era which brought to public attention the appalling living conditions of the urban working classes Charles Booth and Seebohm Rowntree's surveys are two of the best known: see Booth, Charles, *Life and Labour of the People in London*, London, 1892-1903; and Rowntree, B.S., *Poverty, a Study of Town Life*, London, 1901.

8. For a thorough exposition of the ideologies of both social imperialism and national efficiency, see Searle, G.R., *The Quest for National Efficiency, a Study in British Political Thought, 1899-1914*, Berkeley and Los Angeles, 1971, and Semmel, B., *Imperialism and Social Reform, English Social-Imperial Thought 1895-1914*, London, 1960.
The ideology of social imperialism was one whereby a certain sector of the working class was wooed by both Liberal and Tory, on two fronts: imperialism and social reform. As a principle, this policy was designed to unite all classes in the defence of nation and Empire by focusing its campaign on convincing the working classes that improvements in their standard of living were best served by the development of Empire.

9. See my article, 'Museums and the Formation of National and Cultural Identities', *Oxford Art Journal*, May 1988, for a comparative analysis of the use of ethnography in museums and national and international exhibitions in Britain, 1902-10.

10. See Greenhalgh, Paul, 'Art, Politics and Society at the Franco-British Exhibition of 1908', *Art History*, vol.8, No. 4,

Dec. 1985, for an analysis of the possible significance of some of the architectural features.

11. Dumas, F.G., (ed.), op, cit., p.277.

12. Ibid., p.267

13. Ibid., p.268

14. The *Daily Mail Special Exhibition Number*, July-October, 1908, p.5, *The Times* and other reviewers of these exhibits make similar comparisons, and the *Official Guide to the Exhibition* states on p.46, 'On entering the Indian Pavilion the visitor is at once in the midst of a profusion of the best examples of the renowned sumptuary artistic wares of our great Asiatic possessions.'

15. *The Times*, 13 August and 4 July, 1908.

16. See MacKenzie, John M., *Propaganda and Empire: The manipulation of British public opinion 1880-1960*, Manchester, 1984.

17. See my article, '"For God and For England": Contributions to an Image of Africa in the First Decade of the Twentieth Century', *Art History*, vol.8, no.4, Dec.1985, for a discussion on the use of African 'villages' by missionary societies in England.

18. *Journal of the Anthropological Institute*, XXXIV, 1904, p.14.

19. *Journal of the Royal Anthropological Institute*, XXXVIII, 1908, p.489. The Institute's title was augmented in 1907.

20. *Journal of the Anthropological Institute*, XXX, 1900, p.9.

21. A case in point is the volume, Werner, A., *The Natives of British Central Africa*, London, 1906. The preface by Northcote W. Thomas reiterates these grievances.

22. A. Lang and H. Rider Haggard are other authors whose work falls into this category.

23. *Museums Journal*, vol.2, Sept. 1902, p.75.

24. Ibid., vol.7, July 1907, p.8.

25. Ibid., vol.8, July 1908, p.12

26. Ibid., vol.9, Nov. 1909, p.202.

27. *Man*, 11-12, 1911, p.157.

28. Ibid., 9-10, 1909, p.28.

29. For a detailed discussion of eugenics policy during this period, see Searle, G.R., *Eugenics and Politics in Britain 1900-1914*, Leyden, 1976; Searle, G.R., 'Eugenics and Class', in Webster, Charles, (ed.), *Biology, Medicine and Society 1840-1940*, Cambridge, 1981, and Green, David, 'Veins of Resemblance: Francis Galton, Photography and Eugenics',

Oxford Art Journal, vol.7, no.2, 1984. Davin, Anna, 'Imperialism and Motherhood', *History Workshop Journal*, 5, 1978, pp.9-65, gives an excellent analysis of the implications of these theories for British women.

30. Holmes, W.H., 'The Classification and Arrangement of the Exhibits of an Anthropological Museum', *Journal of the Anthropological Institute* XXXII, 1902, p.356.

31. *Museums Journal*, vol.7, Dec. 1907, p.203.

32. Illustrated London News, 15 August 1908, p.232. Green, David, op. cit., also discusses the use of criminal anthropology in relation to definitions of deviancy and the working class.

33. *The Times*, 12 June, 1908.

34. Ibid.

35. *The Franco-British Exhibition Official Guide to the Senegal Village*, op.cit., p.11.

36. Mee, Arthur, Hammerton, J.A. and Innes, A.D. (eds.), *Harmsworth History of the World*, vol.7, London, 1909, p.5548.

37. See for example, Shepherd, Ben, 'Showbiz Imperialism, The Case of Peter Lobengula', in MacKenzie, John M. (ed.), *Imperialism and Popular Culture*, Manchester, 1986.

38. *The Franco-British Exhibition Official Guide to the Senegal Village*, op.cit., p.9, my emphasis. As a further means of ensuring this, the descriptions of these and other occupants of the 'village' are couched in the pseudo-scientific jargon of 'types', which had the added advantage of authenticating the display.

39. Mee, Arthur, Hammerton, J.A., and Innes, A.D. (eds.), op.cit., p.5548.

40. *The Standard*, 10 August 1908.

41. *The Franco-British Exhibition Official Catalogue to the Palace of Women's Work, Women's Section*, London, 1908, pp.XII-XIV. See also *The Times*, 29 May, 1908, which defines the female spectator of the French exhibits totally in terms of middle-class philanthropy.

42. *Daily Chronicle*, 10 August, 1908.

43. Harker, D.C., 'May Cecil Sharp Be Praised?', *History Workshop Journal*, vol.14, Autumn 1982, p.54.

44. Sharp, C., *English Folk Song: Some Conclusions*, privately printed, 1907, p.x, quoted in D. Harker, op.cit., p.55.

45. *The Franco-British Exhibition Official Guide to the Senegal Village*, op.cit., p.8.

Photographic Acknowledgements

The publishers and Barbican Art Gallery would like to thank all those lenders of works from both private and public collections who have supplied photographic material for the exhibition and the book or who have given permission for its use.

Several photographs have been taken from: George R. Sims, *Living London* (London, 3 vols, 1901–3).

A number of institutions merit special thanks for allowing us to reproduce from original negatives or photographs: Greater London Record Office; Hammersmith & Fulham Archives; Labour Party Archives; Mary Evans Picture Library for the Fawcett Library; Mitchell Library, Glasgow; Museum of London: National Museum of Photography, Film and Television, Bradford; National Portrait Gallery; People's Palace, Glasgow; Royal Archives; Royal Photographic Society; Suffolk Archives; Ulster Museum.

We are most grateful to the following photographers, who undertook considerable work for use in the book: Michael Brandon-Jones, School of Art History, University of East Anglia; Peter Burton and Michael Pollard from the Department of the History of Art, University of Manchester; Prudence Cummings Associates Ltd; John R. Freeman & Co; John Gorman; Cliff Middleton, Norwich County Library; Jonathan Morris Ebbs.

The following people have been most helpful and shown great patience in arranging photographic orders for us, and we would like to extend to them a well-earned thank you: Frances Dimond of the Royal Archives, Windsor Castle; Gilian Edwardes Jones of Mander and Mitchenson Theatre Collection; Anne Flavell, Kathy Furkin and Sarah Street of the Bodleian Library, Oxford; Mr J. Fisher of the Mitchell Library, Glasgow; Catherine Ireland of the Fawcett Library; Elspeth King of the People's Palace, Glasgow; Gavin Morgan of the Museum of London; the staff of the National Museum of Photography, Film and Television, Bradford; Sheila Taylor of London Transport Museum.